THE DRAWINGS OF ANTOINE WATTEAU

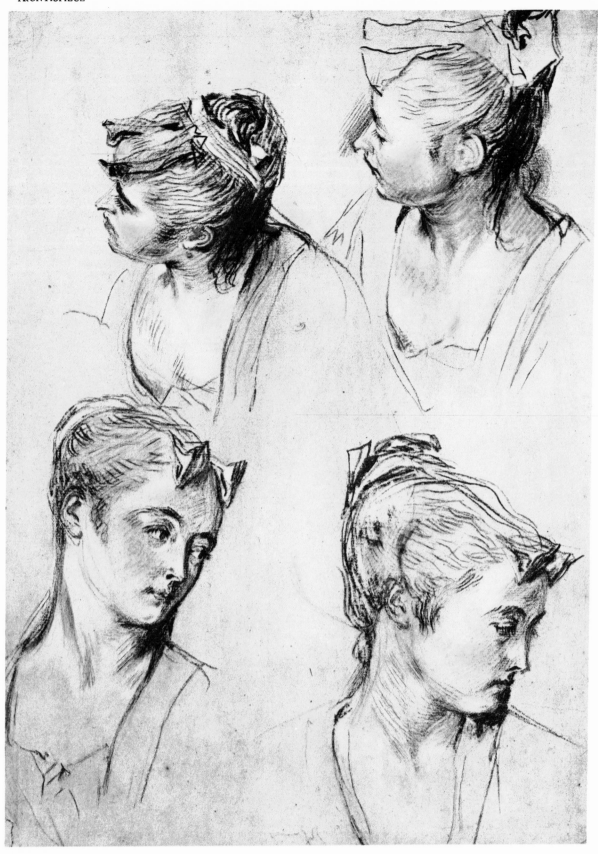

STUDIES OF HEADS
(British Museum)

THE DRAWINGS OF
ANTOINE WATTEAU

By

K. T. PARKER

of the British Museum

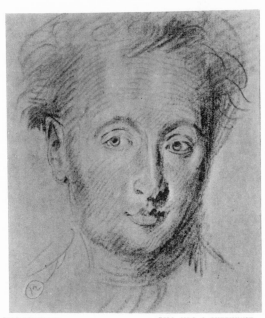

SELF-PORTRAIT COLL. MRS. O. GUTEKUNST

HACKER ART BOOKS

NEW YORK

1970

First Published in London, 1931
by B. T. Batsford, Ltd.

Reprinted by Hacker Art Books
New York, 1970

Library of Congress Catalog Card Number 77-116365
SBN: 0-87817-050-2

FOREWORD

\mathcal{A}T various times and in various ways a number of people have contributed to the task of locating, compiling and elucidating the widely scattered materials of this volume. To name them all—collectors, custodians and fellow-students—would hardly be possible; to name none would be unpardonable. At the risk, therefore, of rendering but incomplete thanks, the author wishes to acknowledge his indebtedness for at least some of their friendly offices. In the first place, perhaps, the Witt Library should be referred to; the assistance, and readiness to assist, which the researcher invariably meets with in that quarter cannot but evoke his sincere gratitude. Among those who have furthermore rendered valuable services, the following in particular deserve mention: in France, M. Jules Strauss, M. Lucien Guiraud and M. Adolphe Lefrancq; in Sweden, Mr. Ragnar Hoppe and Mr. Gunnar Jungmarker; in Germany, Professor Elfried Bock and Dr. Edmund Schilling; in Holland, Mr. H. Buisman and Dr. Helmuth Lütjens; in America, Miss Belle Green; in Russia, Professor M. Dobroklonsky; in various countries in which he has travelled, Mr. J. Byam Shaw. That the Keeper and Deputy Keepers of the Print Room of the British Museum have likewise been helpful goes almost without saying; but a word of special thanks is due to Mr. A. E. Popham. He not only undertook to read and revise the finished manuscript, but encouraged and furthered the work in all its successive stages.

Certain acknowledgements to photographers for the use of prints from their negatives have also to be made. The author and publishers are indebted for Plates 7, 11, 24, 26, 27, 31, 42, 73 and Figure 4 to the *Archives photographiques d'Art et d'Histoire;* for Plates 1, 45, 49, 50, 59, 63, 70, 71, 84, 100 to Messrs. Bulloz; for Plate 30 to Messrs. Braun; for Plates 19, 21, 29, 35, 39, 46-48, 68, 72, 85, 87, 89, 93 to Messrs. Giraudon; for Figures 2, 9, 15 to the *Staatliche Bildstelle, Berlin;* for Figure 5 to Messrs. Annan, Glasgow. In each case thanks are hereby gratefully tendered.

The abbreviations used in the ensuing pages are hardly such as to require special elucidation, but for convenience and safety the following points may be mentioned. Most frequent are the references *F.d.d.C.*, *D. & V.*, *H. & D.* and *K.d.K.*: these refer respectively to Jullienne's *Figures de différents Caractères;* the re-edition of the *Œuvre gravé* edited by MM. Dacier and Vuaflart, and the introductory volume to this work, by MM. Herold and Vuaflart; and the Watteau volume, by E. H. Zimmermann, in the *Klassiker der Kunst* series. M. Octave Uzanne's *Drawings of Watteau* (published by Newnes), and the portfolios introduced by M. Georges Lafenestre (Piazza & Co.) and M. Émile Dacier (Helleu & Co.), are quoted as *Uzanne*, *Piazza* and *Helleu* respectively. Goncourt's *Catalogue raisonné* is cited with the reference *G*, the author's catalogue of Watteau's drawings in the British Museum with the reference *P*, and the periodical *Old Master Drawings,* in which this catalogue appeared, with the reference *O.M.D.* Finally, the privately printed catalogue (in French) of the French eighteenth-century drawings collected by Mr. J. P. Heseltine has been referred to under the name of its compiler, M. *Guiraud.* Such other abbreviations as occur are hardly liable to be misinterpreted.

K. T. P.

November 1931

THE DRAWINGS
OF ANTOINE WATTEAU

TO the casual observer, Watteau's personality seems composed of elements mutually exclusive; the man and the artist contrast so strangely that to reconcile them appears at first sight almost impossible. Count Caylus, it is true, speaks of an aspect of his friend that was "agreeable, tender, and even a little Arcadian." But such traits, he tells us, were rarely in evidence; more often the painter of amorous dalliance showed the very reverse of a joyous nature. His usual demeanour was morose and abrupt; a prey to changing moods and sudden impulses, he shunned the company of his fellow beings, spoke little and bitterly, ever dissatisfied with himself and at variance with others.

The life of this man was one of the briefest in which any great artist has achieved immortality. Incredible as it may seem in view of the volume of his output, his entire working career lasted little more than a decade. Born in 1684, almost exactly two centuries after Raphael, he died in 1721, at practically the same age as the most short-lived of the great Renaissance masters. Thus, at Watteau's death, the eighteenth century had barely come of age; the Grand Monarque had been dead for only a few years; Madame de Pompadour was not yet born. Valenciennes, his native city, was still a comparatively new accession to the kingdom of France. It had been ceded, to be exact, in 1678, and it was to an event so recent as the Treaty of Nymegen that Watteau owed his birthright as a Frenchman.

The events of his life are now tolerably well known, but of all that has hitherto been brought to light, little has deeper significance in relation to his art. His youth we may pass over; his early employment in Paris as the drudge of a dealer in cheap pictures has indeed human interest but little more. As an artist Watteau emerges about 1705, when he enters the studio of Claude Gillot, a painter of fertile imagination, curiously versatile, and with a strong leaning to the stage and to theatrical subjects. While with Gillot, Watteau may truly be said to have discovered himself; their connection, however, was short: differences soon arose between them, and Watteau passed to the studio of Claude Audran, in the Luxembourg, there to be fired by Rubens and to gain his real stride. In 1709, after failing for the Prix de Rome, he retired for a while to Valenciennes, painted his early pictures of military subjects, then returned to Paris. An Associate of the Academy in 1712, he could afford, such already was his reputation, to tarry five whole years before qualifying for membership. Repeated protests from the authorities at length took effect, and in 1717 he submitted as his belated diploma picture one of the great masterpieces of French painting: *L'Embarquement pour Cythère*. Soon we hear of failing health, a growing restlessness and constant removals, and finally, in 1719, of an ill-advised journey to England. Watteau was a doomed man on his return, though pathetically unaware of it; death came to him some months later at Nogent-sur-Marne.

Contemporary writers leave no doubt as to the cause of Watteau's frailty: more than one of them refer to it explicitly as consumption—*la maladie de langueur*, as it

I

was then generally termed. There is no need here to enter into clinical particulars; it is sufficient to say that so far as Watteau the man is concerned, his restless personality, his acute sensitiveness and proneness to depression, are thereby in some measure explained. But what is more important, what is, indeed, a point of fundamental significance for the understanding of the artist, is that his genius is typically that of the consumptive. If doubt there can be as to the real existence of such a type in art, it should be enough to cite Keats and Chopin from among those who were similarly afflicted. In their time and sphere the works of each of these men show remarkable affinities; they are characterized by a feverish pulse-beat, a heightened sensibility, a tendency to sublimate reality into something higher and more remote. If finally blighted by the disease, their genius was in the meantime quickened and refined by it. It has been said of Watteau, and nothing could be more apposite: *En bonne santé, il n'eut été peut-être qu'un Lancret.*

Another point on which it is essential, however briefly, to touch is that of the artist's connection with Flanders. Its importance as such is obvious enough; but was it the ties of blood that linked Watteau with Rubens, or only a more distant relationship, an outward influence? The former opinion has not infrequently been upheld: a number of writers have affirmed or implied that Watteau himself was a Fleming by extraction, and thence derived one of the main sources of his inspiration. And, indeed, did not Jullienne speak of him outright as *peintre flamand*? Was it not by the mere fortunes of war that his native Hainaut had become part of France? Was not his wonderful faculty of expressing the fullness and immediacy of life a true heritage of the Low Countries, quite apart from their influence of colour and composition? Such reflections, if specious, carry little conviction; whatever the national status of the Valenciennes of Watteau's forbears, the fact remains that her language and mentality were definitely French. Moreover, the general trend of Watteau's art, though a reaction from the spirit of the great era of Versailles, was by no means divergent from that of his immediate contemporaries. We must not forget that even while outwardly the old regime lasted the whole structure of the French school was undergoing a profound change. For a number of years the *Rubénistes* had gradually been gaining influence against the *Poussinistes*, and long before Watteau's emergence the struggle had finally turned in their favour. When in 1699 Roger de Pilles was accorded academical honours, the defeat of Félibien and the classical party was to all intents and purposes officially decreed. Thenceforth the whole of the younger generation of painters turned to the Médicis Gallery for its inspiration; the Farnesina was virtually superseded by the Luxembourg. Thus, as regards the general orientation of his art, Watteau was anything but a stranger to his own times; if nevertheless he appears an isolated figure, this is because he stood above, not apart from, his contemporaries. The dearth of real genius during the latter phases of the reign of Louis XIV continued, with the one exception which he forms, during the period of the Regency. It was not until the coming of such men as Chardin, La Tour and Fragonard that the eighteenth century produced painters of comparable merit.

During the two centuries that have elapsed since Watteau's death, his reputation has passed through successive phases of lustre and eclipse. Lauded by his contemporaries, the dominant influence of European art of the mid-eighteenth century, he became the object of derision to the classicists of the school of David, and then, indeed, lapsed into almost total oblivion. It remained for such collectors as Saint and La Caze to rediscover his beauties, and then, above all others, for the brothers

Goncourt to reinstate him among the greatest of his nation. To-day his name is a byword for French perfection, and few artists enjoy homage so universal and sincere. Strange to say, however, scholarship has not kept abreast with popular appreciation; though much has been written about him, little systematic study has been devoted to his works. For his drawings, in particular, though admittedly his supreme achievement, it is no exaggeration to say that neither methodical criticism nor a comprehensive survey has ever seriously been attempted. Content to submit to his singular fascination, students have neglected what is certainly one of the most urgent tasks of artistic research.

<p style="text-align:center">* * *</p>

For a systematic investigation of Watteau's work as a draughtsman, it is not enough to concentrate on the originals still in existence and accessible for study. Valuable information can be derived from outside sources, and this it is essential to take into account in order to obtain anything approaching a comprehensive knowledge of the subject. The sources referred to are twofold, pictorial and literary. The former class comprises a quantity of reproductive material, that is of prints by various eighteenth-century engravers after Watteau's drawings; the latter consists of the testimony of certain more or less contemporary writers, whose statements, though not always reliable, are yet in many cases of real importance and interest.

PICTORIAL SOURCES

Foremost among the documents of this class bearing closely on the study of Watteau's drawings stands Jean de Jullienne's *Figures de différents Caractères, de Paysages et d'Études*, a work in two folio volumes, compiled under the auspices of a close friend of the artist, and published soon after the latter's death, in 1726 and 1728 respectively. Besides the earliest and in its way the most authoritative biographical sketch of Watteau's life, this work contains no less than 351 etchings after his drawings, a body of material on which all specialized research may be said virtually to rest. Compiled, as it was, on eminently critical lines, it is, so far as any such work can be, an infallible attestation of genuineness, and provides an invaluable supplement to the original material available for study at the present day. A general survey of the contents of these two volumes is included in Edmond de Goncourt's *Catalogue raisonné de l'Œuvre d'Antoine Watteau*, published in 1875; but although this work, the first of its kind to appear, is still indispensable to the student, the critical remarks on the drawings themselves are by no means complete or in all cases reliable. A new edition of the *Figures de différents Caractères* is at present still lacking, in spite of the fact that the original publication is so rare as to be available only in the richer collections. There are, however, two modern volumes comprising a selection of reduced reproductions of the etched plates. The first, edited by Paul Mantz and published at Paris in 1892, contains one hundred (out of a total of 105) of the plates executed by François Boucher, one of the most extensively employed of Jullienne's staff of artists; the other is a general selection amounting to rather more than a third part of the whole, published at a very low price in 1926 in the series *Les Grands Ornemanistes* (H. Laurens, Paris), with a useful introduction by Émile Dacier.

Though in its general conception as a corpus of reproductions the *Figures de différents Caractères* is astonishingly modern in character, it differs materially from present-day publications, quite apart from the technique of its reproductions. Of

<p style="text-align:center">3</p>

particular importance is that while the etchings in most cases approximate in size to the original drawings, the subjects are almost invariably rendered in reverse. It is quite the exception to meet with cases in which the engraver has troubled to invert the design on the copper plate, that is to say to perform his handiwork with a view to reproducing the original aspect of the drawing in the printed impression. A few such cases, however, can be instanced, for example No. 70, which is after a drawing, in the Louvre,[1] representing a seated woman in profile to the left; No. 178, a study for *L'Amour paisible*, at Potsdam, which is readily recognizable as a direct rendering since the guitarist is playing his instrument with his right hand; No. 253, which corresponds in the same direction to the drawing at Bayonne (Plate 11); and Nos. 174, 175 and 243, all of which connect with the same sheet of studies, this likewise included among the illustrations of this volume (Plate 6).

The three last mentioned etchings are also characteristic examples of another constant practice on the part of Jullienne's engravers: that of rendering on separate plates the various detached studies which it was Watteau's habit to unite on a single sheet. The number of etchings contained in the two volumes of Jullienne's publication is therefore considerably in excess of the actual total of drawings selected for reproduction. In a few cases, it is true, the original collocations were retained: thus the two heads in No. 41 correspond exactly to the drawing formerly in the Heseltine collection,[2] while No. 285 shows an even more exceptional combination of unrelated sketches. Broadly speaking, however, no serious attempt is made in the *Figures de différents Caractères* to render the true appearance of the original sheets of studies; their beauty of arrangement and placing is a thing almost entirely ignored, and we have often to turn to as many as three or four different etchings to reconstruct the original aspect of a drawing.

How little importance was attached to this point by Jullienne is further shown by his arrangement of the plates in the two volumes. Their sequence is, in fact, purely arbitrary, and shows no consistent attention either to the original inter-relation of the studies, to their chronology or to their subject. As actual renderings, however, they are in most cases close and faithful, although again exceptions can be instanced in which a certain licence on the part of the engravers is discernible. This applies particularly to the shading of the backgrounds, which is not infrequently introduced to set off the figures; but on some occasions it involves the omission, addition or modification of more or less prominent accessories. Thus, for example, the headdress worn by the figure on the right of Plate 76 is eliminated in Boucher's etching (F.d.d.C. 198); the woman on Plate 269 of the *Différents Caractères* holds a dagger which does not occur in the original drawing in the Louvre;[3] and minor differences of costume become apparent on comparing the study for the Louvre *Indifférent* (Plate 30) and the corresponding etching by Boucher (F.d.d.C. 102). These modifications, it should be noted, are a matter entirely apart from the reworking of the plates subsequent to their first publication in 1726 and 1728. In their later states, after the engraver Huquier had added fanciful landscape backgrounds, they cease to have any direct documentary value for the study of Watteau's drawings.

As to the principles on which Jullienne's compilation was made, it is hard to trace any consistent system either as regards the importance or accessibility of the specimens selected. The title-page of the work gives only the general indication that the material was drawn *des plus beaux Cabinets de Paris*. A large number of the originals

<hr>

[1] Uzanne, Pl. 40. [2] Guiraud, Pl. 93. A copy at Darmstadt, *Stift u. Feder*, 1929, 32.
[3] Repr. Guiffrey-Marcel, VII, p. 97, No. 5639.

4

was in Jullienne's own possession; but it would be easy to quote examples of conspicuous excellence which, although under his very hand, were not included in the selection. The mere fact, therefore, that a drawing was omitted gives no reason to question either its authenticity or quality. Inclusion, on the other hand, is evidence of the strongest sort, and may be taken as an infallible proof of the genuineness of a drawing, provided, of course, that it be the original and not a copy. The most searching scrutiny of Jullienne's volumes has failed to detect even a single example of doubtful authorship.

An important supplement to the normal edition of the *Différents Caractères* is provided by a number of interpolated plates in a copy belonging to the Bibliothèque de l'Arsenal at Paris. From annotations on these etchings in the writing of Mariette and other contemporary collectors, we learn that this additional material consists largely of proof impressions which, for one reason or another, were not approved by Jullienne, and were consequently omitted from the final selection. In certain cases the same figures were later repeated, and thus, after all, found their way into the published volumes. The majority, however, was simply left aside, and thus the Arsenal copy provides a definite addition to the normal contingent, the supplementary plates being, of course, in no way less authoritative than the rest. These rejected plates are included in Goncourt's lists, and certain others preserved elsewhere in unique impressions are described in a recent publication of the "Société pour l'Étude de la Gravure française," to which further reference has shortly to be made (I, pp. 129 ff.).

We owe to Jean de Jullienne not only the mass of reproductive matter comprising the *Différents Caractères*—two further volumes, known as the *Œuvre gravé de Watteau*, were likewise produced under his auspices, and have bearing, though more remote, on the subject of our research. This latter work, it need hardly be said, consists mainly of engravings after the master's pictures. Issued in book form in 1735, it completed the monumental undertaking of Watteau's friend and patron to perpetuate his memory in a comprehensive publication of his artistic remains. A critical re-edition of the *Œuvre gravé*, giving exhaustive information as to its origins and history, its participants and other details, was jointly prepared by MM. Dacier, Vuaflart and Herold, and published in four sections by the Society named in the preceding paragraph. Fundamentally important as is the *Œuvre gravé*, we have here only to consider the small contingent of reproductions of drawings, which was, somewhat illogically, interspersed in its pages. Among them a clearly marked group comprises the so-called *Figures de Modes* and *Figures françaises et comiques*, in all twenty small plates that had previously been published as independent sets, and had partly been etched by Watteau himself. A number of the artist's drawings for these figures are preserved at Stockholm,[1] in the Louis Clarke collection, at Avignon and elsewhere (Plates 4, 5). Another distinct group is that of some dozen sketches of decorative designs which, freely elaborated by the engravers, are included among the master's finished ornamental panels (Plate 15). Furthermore, the *Œuvre gravé* contains three important drawings of a more or less pictorial class: the splendid portrait of the musician, Rebel, now in the Weill collection (Plate 75); an allegorical composition, in the Ashmolean Museum,[2] relating to the financial crisis of the year 1720, occasioned by the collapse of the banker, John Law; and a theatrical subject entitled *La Troupe Italienne*, of which Watteau himself made an etching.

For practical purposes little more need be added on the pictorial documentation

[1] Schönbrunner-Meder 1122. [2] Colvin, III, 39.

5

of Watteau's drawings, more especially as such further material as is available has for the most part been listed either by Goncourt or MM. Herold and Vuaflart. To complete our survey, however, we may briefly refer to certain smaller volumes of engraved or etched reproductions, and a group of single prints belonging to the class of engraved facsimiles, which were much in vogue about the middle of the eighteenth century. A volume comprising thirty somewhat indifferently executed engravings by Pierre Filleul bears the title, obviously inspired by that of Jullienne's work, *Livre de différents Caractères de Têtes*. Its date of publication is not recorded. Not a few of these heads are of doubtful authenticity; two others correspond to plates in the Jullienne corpus, but at least one of the remaining claims our special attention, this being after a self-portrait of the artist which was not otherwise engraved. The original drawing is in the collection of Mrs. Otto Gutekunst (see title-page). A similar volume is that comprising a set of twenty-four small etchings by Count Caylus under the title *Suite de Figures inventées par Watteau*. The majority of these occurs on a somewhat larger scale in Jullienne's work, but a few are new, and the whole series bears titles, which, though fanciful, are not without interest. Other etchings by Caylus after Watteau's drawings (apart from those included in Jullienne's *Recueil*) are found in the two comprehensive collections of his work in the Bibliothèque Nationale and the Dresden Print Room. They include two interesting *Fête galante* compositions of a type rarely met with among the master's originals,[1] and certain early sketches in the manner of Gillot, enabling one to identify, for example, an otherwise so uncertain drawing as that of two standing Comedy figures in the Koenigs collection. A careful study of Caylus's etched work after Watteau was published by E. Dacier in *L'Amateur d'Estampes* (1926-7), and to this the reader may be referred for more detailed information, though it should be remarked that the drawings themselves are not exhaustively dealt with. The earliest example of a facsimile of a Watteau drawing is Arthur Pond's *Dr. Misaubin*, a satirical sketch drawn by the artist on a table-top during his sojourn in England. Of greater practical importance to the student are the plates of Jean-Charles François, Demarteau, Bonnet and Gonord, the last-mentioned being chiefly notable for the supplementary material which he provides to the extant body of Watteau's copies after Rubens (see below, page 24). But interesting as the works of these engravers are, it should not be overlooked that they gradually lead away from the class of strictly reliable documents. Indeed, of these emulators of Jullienne, only Caylus, another of the artist's personal friends with first-hand knowledge of the successive phases of his activity, can claim anything approaching an equal authority.

LITERARY SOURCES

In the class of literary documents connected with the study of Watteau's drawings, there is, of course, no single work of a comprehensive nature comparable with the *Différents Caractères* in scope and individual importance. Such passages as will claim our notice are included in the writings of the four principal authorities for Watteau's biography in general, Jullienne, Gersaint, Caylus and Dezallier d'Argenville. With more or less detail and critical acumen, all these refer to Watteau's drawings and draughtsmanship; but their remarks are naturally incidental and scattered, and need to be extracted from other matter with which we are not here concerned. A critical

[1] There are examples in the Louvre (Helleu, Pl. 34) and the Ricketts and Shannon collection.

re-edition of the early biographical sketches of Watteau was published by Pierre Champion in 1921, and it is to this work that the student will do best to refer to amplify the passages quoted below.

Jean de Jullienne. The *Abrégé de la Vie d'Antoine Watteau*, which is prefaced by Jullienne to the first volume of the *Différents Caractères*, makes only passing mention of the master's drawings. One passage alludes to his assimilation of Gillot's style (Champion, page 47), but its tenor is too general to claim attention here. More important is a reference to Watteau's diligence in the study of nature:

> Quoique la vie de Watteau ait été fort courte, le grand nombre de ses ouvrages pourroit faire croire qu'elle auroit été très longue, au lieu qu'il montre seulement qu'il étoit très laborieux. En effet ses heures même de récréation et de promenade ne se passoient point sans qu'il étudiât la nature et qu'il la dessinât dans les situations ou elle luy paroissoit plus admirable. (Champion, p. 52.)

Edme-François Gersaint. To the picture-dealer, Gersaint, the son-in-law of Sirois, and, like him, an intimate and devoted companion of the artist, we owe some singularly important remarks on Watteau's draughtsmanship. The references in question are contained in two sale catalogues compiled under Gersaint's direction, that of the collection Quentin de Lorangère, dispersed in 1744, and that of Augran de Fonspertius, dispersed in 1747-8. One passage in the former refers to Watteau's earliest beginnings as a draughtsman, and takes us back to the time when he was still residing at Valenciennes:

> Le goût qu'il eut pour l'art de la peinture se déclara dès sa plus tendre jeunesse; il profitoit dans ce tems de ses moments de liberté pour aller dessiner sur la place les différentes scènes comiques que donnent ordinairement au public les marchands d'orviétan et les charlatans qui courent le pays. (Champion, pp. 54-5.)

Elsewhere Gersaint refers, in much the same sense as Jullienne, to Watteau's assiduity in drawing from nature during his leisure hours (Champion, page 56), and what is of more specific interest, to his copying the drawings of older masters in the collection of Pierre Crozat (Champion, page 59). Further on is a passage giving interesting information on the dispersal of Watteau's drawings after his death:[1]

> Il me donna, quelque temps avant sa mort, des preuves d'amitié et de confiance, en me mettant au nombre de ses meilleurs amis, qui etoient M. de Julienne, feu M. l'abbé Haranger, chanoine de Saint-Germain-l'Auxerrois, et feu M. Hénin, et voulut que ses desseins, dont il me fit le dépositaire, fussent partagés également entre nous quatre; ce qui fut exécuté suivant ses intentions. (Champion, p. 64.)

The most important of Gersaint's statements appears in the Augran de Fonspertuis catalogue, and shows conclusively that Watteau rated his own powers as a draughtsman more highly than his qualities as a painter:

> . . . Je donne une grande préférence à ses desseins sur ses tableaux. Watteau pensoit de même a son égard. Il étoit plus content de ses desseins que de ses tableaux et je puis assurer que de ce côté-là l'amour propre ne lui cachoit rien de ses défauts. Il trouvoit plus d'agrément à dessiner qu'à peindre. Je l'ai vu souvent se dépiter contre lui-même, de ce qu'il ne pouvoit rendre, en peinture, l'esprit et la vérité qu'il sçavoit donner à son crayon. (Herold and Vuaflart, I, p. 141.)

Dezallier d'Argenville. In the second volume of his *Abrégé de la Vie des plus fameux Peintres*, published in 1745, d'Argenville makes similar references to Watteau's

[1] To the names mentioned by Gersaint two others should be added: Caylus, who annotated several drawings as having been bequeathed to him by the artist (see below, p. 14), and Crozat, in the catalogue of whose sale (1741, p. 129, lot 1063) a similar reference is found.

bequests of drawings, and to his copying the Old Masters, as those quoted above (Champion, page 72). In the second edition of his book he adds a further remark of circumstantial interest to the effect that the artist was in the habit of using his maid-servant as a model. The chief interest of the passage, however, lies in the summary which he gives of Watteau's mediums and technique:

> Les desseins de Wateau sont estimés des curieux; le crayon rouge étoit celui dont il se servoit le plus souvent sur du papier blanc, afin d'avoir des contre-épreuves, ce qui lui rendoit son sujet des deux côtés; il a rarement relevé ses desseins de blanc, le fond du papier faisoit cet effet: on en voit beaucoup aux deux crayons de pierre noire et de sanguine, ou de mine de plomb et de san-guine qu'il employoit dans les têtes, les mains et les chairs; quelquefois les trois crayons étoient mis en usage; une autre fois il se servoit de pastel, de couleurs à l'huile, à gouache; enfin tout lui étoit bon, excepté la plume, pourvu que cela fit l'effet qu'il souhaitoit: les hachures de ses desseins étoient presque perpendiculaires, quelquefois un peu couchés de droite à gauche, d'autres es-tompés avec quelques lavis legers et des coups ressentis: la liberté de la main, la légèreté de la touche . . . apprennent aux curieux le nom de Wateau. (Champion, pp. 73-4.)

Anne-Claude-Phillippe de Thubières, comte de Caylus. In 1748, rather more than a quarter of a century after Watteau's death, Count Caylus composed an address to the Academy which, on its rediscovery by the brothers Goncourt, was acclaimed as the fundamentally important document on the artist's life and works. In recent times its authority has suffered something of an eclipse, the fact having gradually been realized that Caylus was in no small measure dependent on earlier writers, and more-over strongly biased in his outlook and judgment. The fact remains, nevertheless, that this discourse contains a quantity of original and highly important matter, and that in particular for Watteau's drawings it is still an indispensable source of in-formation.

An interesting reference is that in which Caylus speaks of the rooms in various quarters of Paris, which he shared with Watteau for working from the model (Champion, p. 94). He goes on to say that Watteau rarely made drawings from the nude, and was never proficient in that branch of art (see below, p. 22). Speaking of his application to the study of nature, Caylus adds an interesting detail to those given by Jullienne, saying that Watteau rigorously avoided the use of a lay-figure (Cham-pion, p. 96). He also gives particulars about the copies which Watteau made in the Crozat collection (see below, p. 25), and alludes to similar copies by himself and Hénin *que nous avancions assés, pour qu'en y donnant quatre coups, il* [Watteau] *en avoit l'effet* (Champion, pp. 96-7). Elsewhere he speaks of Watteau's copies after Rubens dating from the period when he was residing at the Luxembourg as the apprentice of Audran, also of his landscape drawings made in the Luxembourg garden, *qui brût et moins peigné que ceux des autres maisons roïales, lui fournissoit des points de vue infinis . . .* (Champion, pp. 83-4).

The most important, however, of Caylus's utterances deals with Watteau's funda-mental attitude to the practice of drawing, to his methods and certain of his studio usages:

> La plupart du tems la figure qu'il dessinoit d'après le naturel n'avoit aucune destination dé-terminée. . . . Car jamais il n'a fait ni esquisse ni pensée pour aucun de ses tableaux, quelque légères et quelque peu arretées que ç'a pu être. Sa coutume étoit de dessiner ses études dans un livre relié, de façon qu'il en avoit toujours un grand nombre sous sa main. Il avoit des habits galans, quelques uns de comiques, dont il revêtoit les personnes de l'un et l'autre sexe, selon qu'il en trouvoit qui vouloit bien se tenir. . . . Quand il lui prenoit en gré de faire un tableau il en avoit recours à son recueil. Il y choisissoit les figures qui lui convenoient le mieux pour le moment. Il en formoit ses groupes, le plus souvent en conséquence d'un fonds de paysage qu'il avoit conçu ou préparé. Il étoit rare même qu'il en usât autrement. (Champion, pp. 100-1.)

8

In addition to the sources mentioned above, there are certain letters, published in the *Archives de l'Art français* (III-II, pp. 210 ff.), which purport to be originals of Watteau addressed to Jullienne, and, if genuine, are not without interest in relation to the master's drawings. On one occasion Watteau expresses his dissatisfaction with his work *en ce que la pierre grise et la pierre de sanguine sont fort dures en ce moment— je n'en puis avoir d'autres*. Elsewhere he speaks of devoting his mornings to his *pensées à la sanguine*, this being apparently the term that he applied to his sketches in red chalk. Bottari's *Raccolta di lettere* (quoted by Herold and Vuaflart, I, pp. 137-8) also contains allusions to Watteau's drawings in the correspondence between the Florentine collector, Gaburri, and Étienne Jeaurat and Mariette. *Io fo tutto il possibile*, writes Jeaurat in 1731, *per trovarvi qualche disegno di Vato; ma chi gli ha, ne fa tanto caso, che è difficile l'avergli. Egli non ha fatti disegni grandi, e storiati, ma d'una figura sola, e delle teste, e delle mani*. Mariette likewise refers to the lack of subject drawings: *Appena si ha notizia di qualche disegno storiato di Vatto. Egli non ha fatto altri disegni, se non per li studi de quadri, che di poi inventava, e componeva sulle tele*. A further letter of Mariette enables us, as will be shown later, to identify a drawing, now in the British Museum, as being the one presented to Gaburri on behalf of Count Caylus (below, p. 49, Plate 97).

<p style="text-align:center">*　　*　　*</p>

Watteau's original drawings are to-day widely scattered, and if we venture to put their present total at about 300, this is naturally but a rough estimate, and one that may later need correction. Of the public collections, the richest and most representative is that in the British Museum; it illustrates the whole of the master's career as an independent artist, and includes, with few exceptions, all the more important types of his work. Conspicuous also is the collection in the Louvre; if in certain respects less impressive than that in the British Museum, this is partly due to the fact that here the drawings are distributed between the Cabinet des Dessins, the Salle du Mobilier and the Salle Camondo, to say nothing of the Musée des Arts Décoratifs in the adjoining wing of the Pavillon de Marsan. Again, while in London only a few isolated specimens have found their way into the Victoria and Albert Museum, in Paris there are various subsidiary collections more or less richly endowed. Among these the Palais des Beaux-Arts (Dutuit collection) and the Musée Cognacq-Jay are the most important; but the École des Beaux-Arts, Musée Jacquemart-André and Musée Carnavalet have also to be taken into account. Of the provincial museums of France those richest in Watteau's drawings are at Bayonne, Chantilly and Rouen; less important collections are at Valenciennes, Lyons, Besançon, Orleans, Rennes and elsewhere. An interesting collection, comprising some half-dozen originals and a quantity of offsets, is at Stockholm. In Germany it is only at Berlin and Frankfurt that the artist is well represented, while at Munich, Dresden, Bremen and Weimar only a few stray specimens are preserved. Among other public collections in Europe the museums of Vienna, Budapest, Haarlem, Florence, Oxford, Dublin and Leningrad may be mentioned. In America the richest is that of the Morgan Library at New York, but the artist is also represented at Cleveland, Boston and Cambridge. In America, too, a number of private collections contain fine examples, but for the present by far the greatest part of the material in private ownership is still in France. In Paris alone there are more than a dozen private collections in which Watteau is well, and in some cases superbly, represented. English private owners are fewer in number, many fine examples having left the country during the last few decades. In Germany very little is in private hands, but some

<p style="text-align:center">9</p>

important specimens, as will be seen from the plates, are now preserved in Dutch collections.

Reproductions of Watteau's drawings are, of course, scattered over the general monographs on the artist, the Museum publications devoted to drawings, the catalogues of sales and private collections, and the various art periodicals. As stated above, however, a comprehensive corpus, apart from Jullienne's work, is lacking, indeed, specialized publications, even on more restricted lines, are curiously few. Useful comparative material is available in a portfolio published by Piazza & Co., in 1907 (50 plates), and another, more recently issued by Helleu & Co. (52 plates), also in a volume compiled by Octave Uzanne in Newnes's series of *Drawings of the Great Masters* (50 plates). All these publications, however, have to be used with great caution. A scarce portfolio of photographic reproductions of twenty-six drawings from the collection of Miss James, exhibited at the Bethnal Green Museum in 1876, was issued by the Arundel Society. A critical catalogue, with illustrations, of the drawings by Watteau in the British Museum appeared in *Old Master Drawings* (Vol. V, part 17).

<p style="text-align:center">* * *</p>

These preliminaries finished, we must begin a more detailed study of the drawings themselves by gaining clearer insight into the fundamental principles of Watteau's draughtsmanship, and its relative position to his art as a painter. These points, it will be remembered, have already been touched upon in the passages quoted from contemporary writers; Caylus, in particular, shows himself fully conscious of the main problems to be considered, and provides a valuable line of guidance for further enquiry. It is common knowledge that a very large number of Watteau's drawings served as the preparatory material for his pictures; many, indeed, as we shall constantly have occasion to observe, were used more than once for different compositions. Nevertheless, there is every reason to believe that, as Caylus states, the great majority was conceived without any definite ulterior purpose. They were, no doubt, intended from the start to be used for pictures should occasion arise, but it was not in relation to a specific and prearranged composition that they came into being; they were drawn in the first place simply for the pleasure of drawing. If this is perhaps the most essential point to grasp, what is hardly less important to bear in mind is that, however remote from everyday reality the general character of Watteau's art may be, as a draughtsman his attitude was essentially that of a realist: by far the greater part of his sketches was visually conceived, not like, for example, Lancret's or Boucher's, imagined as opposed to seen, and improvised as opposed to studied.

Both the foregoing statements—that for Watteau drawing was an end entirely in itself, and fundamentally dependent on visual impressions—both these statements are clearly generalizations, to which, it goes without saying, exceptions are not lacking. Among the artist's earliest productions, in particular, many are easily recognizable as improvisations made from memory (Plate I); then there is the whole class of his decorative designs, for which the possibility of a visual conception does not arise at all. Again, in the case of such specific subjects as the *Embarquement*, the *Enseigne* or the Crozat *Seasons*, there can be small doubt that the majority of drawings connected with them was made in direct anticipation of their ultimate use. Another of Caylus's statements which, though substantially correct, can be refuted with at least a few definite exceptions is that the artist dispensed with general compositional

studies. Nothing could be more striking than the extreme scarcity of drawings of this class; but one need only compare the sketch of a *Fête galante* subject, in the Fenaille collection (Plate 68), with the Dresden *Plaisirs d'Amour* (Figure 12), to perceive that we have here an example of precisely that type of a preparatory *mise-en-place* which is otherwise so conspicuous by its absence. The Cleveland drawing (Plate 40), corresponding to *Le Conteur* (D. & V. 4), is essentially of the same class. It differs, however, from the other in that it is probably a group constructed from other drawings of single figures, not the first spontaneous notation of an idea freshly conceived.

To illustrate another of the primary characteristics of Watteau's draughtsmanship, one cannot do better than discuss certain concrete examples. The point in question is the artist's partiality for drawing his figures, or parts of figures, as detached studies, without any indication of their correlation in space. A typical case is the sheet of two figures, in the Cognacq Museum, which is one of the rare drawings connected with the celebrated *Enseigne* (Figure 16; Plate 100). Though in the finished composition these same figures are united in a single group, in the drawing they are studied altogether independently of one another; they are juxtaposed on the paper but in no way spacially related. Next let us consider the group occurring in *Le Plaisir Pastoral* (D. & V. 209) and repeated in a later work entitled *Les Bergers* (Figure 2)— the group representing a man embracing a woman. So closely are the two figures in this case knit together that it would seem hardly possible that they were studied separately. The fact is, however, that two distinct drawings were combined on the canvas; one, for the male figure, is also in the Cognacq Museum,[1] the other, for the female figure, was recently in the Varennes collection.[2] While both, clearly enough, anticipate the ultimate grouping, they are yet originally disconnected and independent of each other. Generally speaking, in fact, a type of drawing almost as rare as the compositional study referred to in the previous paragraph is that representing the correlation of figures, in other words of groups as a unit, spacially connected. In this light such a drawing as the one in the British Museum representing a pilgrim of the *Embarquement* assisting his lady to rise from the ground (Plate 55) has the definite interest of anomaly. Here we have just the opposite of the two preceding cases; the figures are already united in the sketch to a single group. Whether they had previously been studied independently is a matter of conjecture; a drawing in the École des Beaux-Arts does indeed correspond to the female figure by itself, but apart from the fact that it is in the reverse direction, its authenticity is not above suspicion. It is probable, however, that the artist was not drawing, as was his usual habit, from the life, but was combining two separate studies analogous to those used for *Le Plaisir Pastoral* and *Les Bergers*. Be that as it may, Watteau's normal type of drawing may definitely be described as the sheet comprised either of a single study or of miscellaneous independent studies, juxtaposed but not related. As a final illustration of this point a drawing of two musicians, at Oxford (Plate 67), has a particular interest. These figures, similarly placed, recur in the picture *La Contredanse* (D. & V. 177); but here it is almost certain that a casual juxtaposition was retained in the composition merely because it proved serviceable for the purpose required. Though in its ultimate use it is exceptional, indeed unique, the drawing yet belongs, in all probability, to the ordinary type exemplified by the one connected with the *Enseigne*.

The various mediums used by Watteau are, on the whole, well summarized by Dezallier d'Argenville. As he rightly remarks, the artist's favourite vehicle was

[1] Cat. H. Michel-Lévy Sale (1919), Pl. 118.　　[2] Cat. Varennes Sale (1922), Pl. 144.

red chalk; there are but few examples in which it is not more or less prominent. Obvious as this must be to anyone acquainted with the originals, the point needs to be stressed in a volume of monochrome reproductions. As examples in which red chalk is definitely subordinated to black, Plates 11, 35 and 71 may first be quoted; but much more exceptional is a drawing, in the British Museum (Plate 36), done in black chalk and pencil, to the complete exclusion of sanguine. The use of pencil with red chalk is duly mentioned by d'Argenville, and it also occurs, though more rarely, with a combination of red and black (Plates 69, 70). His statement that Watteau rarely heightened his sanguine sketches with white[1] is not wholly accurate; examples are by no means of infrequent occurrence (Plates 47, 66, 93, etc.), and while it is also common to find black chalk, either in touches or more freely applied, combined with red, the trio of red, black and white is as typical as any of the other methods. It was in this technique, *aux trois crayons*, that the majority of Watteau's more elaborate and important drawings were made. The red chalk which he uses is mostly of a rich crimson colour readily distinguishable from the yellower shade used in the seventeenth century; but a browner tint also occurs, and there are instances when two such shades of sanguine are combined with black and white chalks to what is virtually a technique *aux quatre crayons* (Frontispiece). In referring to the occurrence of pastel chalks, d'Argenville touches on an exceptional medium; but not only do examples of its use for subsidiary effects occur (Plate 75), there are two studies of a negro's head in the British Museum that are entirely drawn in this way.[2] There is no known example of the use of gouache; but it is interesting to find that d'Argenville's reference to this medium is corroborated by the catalogue of the Jullienne Sale, which mentions *un œuillet et une rose peints à gouazze* (lot 801). Both these drawings are for the present lost, but it is not impossible, in view of their altogether exceptional character, that they may yet come to light under a wrong name. What cannot have failed to strike the reader is that with the mention of gouache we for the first time come upon a brush medium. In fact, the absence of the use of wash in Watteau's drawings is one of the most noticeable features of his technique. Among the rare exceptions are the studies of female heads (one for the *Leçon d'Amour*), in the Teyler Museum, the well-known figure of a shepherd at Chantilly,[3] and a study of plants in the British Museum.[4] Rarer still is the use of the pen: as d'Argenville remarked, *tout lui était bon excepté la plume.* Nothing shows this more clearly than the fact that even when copying the pen drawings of Titian, Campagnola and others, Watteau invariably resorted to his favourite medium of red chalk. Still, we learn, again on the authority of the Jullienne catalogue (lot 812), that a finished design (in itself an anomaly) of the composition entitled *Recrue allant joindre le Régiment* was drawn with the pen; and for at least one extant sketch of this class, Watteau's authorship has seriously to be considered. It corresponds to a group in the *Rendezvous de Chasse* of a man assisting a lady to dismount from horseback, a motive clearly derived from some earlier Flemish prototype. It is now in private ownership in Germany, and may prove valuable for further identifications.

The subject of Watteau's papers has yet to be closely studied. It is one that presents its special difficulties, so many of the drawings being fixed down or glazed. For the present little more can be said than that a considerable diversity of tone and

[1] An interesting feature, plainly visible in Pl. 67, is the application of white chalk *before* commencing the drawing in sanguine. [2] Uzanne, Pl. VI. [3] Piazza, Pl. 30. [4] O.M.D., Part 17, Fig. 5. This example is altogether exceptional, the passages in chalk being entirely black.

texture occurs, ranging from a smooth pure white over a coarser grey to paper of a light brown shade and distinct roughness of surface. Frequent and characteristic is the *chamois* paper of a delicate creamy tint; on this the artist produced some of his most magical effects. Blue-grey is not known to have been used by Watteau, let alone blue. As to the special question of watermarks, it should be noted that an English paper is by no means irreconcilable with Watteau's authorship of a drawing, though naturally it cannot be otherwise than exceptional. The watermark of a sheet of studies in the British Museum (Plate 97) shows the coat-of-arms of the City of London, and can thus definitely be connected with the artist's period of residence in England. Other drawings, however, probably of the same period, are on French paper, and it can only be supposed, if the date assumed be correct, that Watteau either brought French materials along with him, or was able to procure them in this country.[1]

D'Argenville completes his account of the technique of Watteau's drawings with the mention of certain characteristics of handling with which we have still briefly to deal. The most apposite reference is to his *coups ressentis*, those curiously emphatic strokes without which no drawing of Watteau can be truly typical or convincing. Much as he was imitated by such men as Lancret, Pater and Quillard, his ability to combine a soft caressing touch with an incisive firmness of accent in appropriate passages is a thing which no other hand has effectively reproduced. A few instances confirming d'Argenville's statement about his use of the stump can be mentioned (Plate 75). Much commoner and more characteristic, however, is the fusion of red and white chalks produced by wiping lightly with the moistened finger-tip: it is with the use of this simplest of all devices that the artist acquired an almost unrivalled faculty for suggesting the warmth and bloom of human flesh (Frontispiece). A curious observation put forward by d'Argenville refers to the perpendicular cast of Watteau's hatchings. This feature is strikingly illustrated in certain individual examples (Plate 27), but it is, of course, altogether erroneous to describe it as a definite characteristic. Equally open to question is the assertion that the artist's preference for chalks was due to his intention of making offsets, and thus of duplicating his figures in opposite directions. There exists, of course, a quantity of such squeezes of drawings by Watteau, but they are by no means more numerous than those of other artists esteemed by eighteenth-century collectors, and there is but slender evidence that they were actually made by the master himself. An offset, at Stockholm, of the sketches of a negro's head, in the Weill collection (Plate 51), seems, it is true, to precede the final touches given to the original; and there is at least one case where definitely the same figure occurs in pictures both in the original sense and in reverse to the drawing. This is the figure of a child on a sheet of miscellaneous studies in the Louvre (Plate 47); it is met with altogether in three different compositions, twice in the same direction as the original drawing (D. & V. 139 and 183), and once in reverse (D. & V. 185). Likewise reversed is *La Marmotte* of the Hermitage Gallery (D. & V. 122), as compared with a drawing of the same figure in the Dutuit collection (Plate 10), and the same applies to an adaptation from Veronese occurring in the Dulwich *Plaisirs du Bal* (D. & V. 114; see below, p. 35). Broadly speaking, however, the making and using of counterproofs is not, as d'Argenville suggests, an important feature in Watteau's artistic usage. Another statement made by certain writers which is also definitely incorrect is that Watteau, when taking over a figure from his sketch-book

[1] It may be worth adding that a few drawings are known that are squared by indentation for transfer. This occurs on the originals of F.d.d.C. 346 (formerly in the Léon Michel-Lévy collection) and of D. & V. 43 and 55 (at Avignon and Stockholm respectively).

for use in a picture, would rigorously avoid even minor modifications. In point of fact, that is far from true; slight alterations of attitude, of costume, headdress, and the like, are frequent, and several instances will be given in the appended catalogue of plates (*cf.* also F.d.d.C. 324 and D. & V. 95).

Akin to the ordinary class of counterproofs of chalk drawings are certain off-prints in oily pigment, of which a number of examples are in public and private collections.[1] Opinions have differed as to their precise nature, but it is now certain that they are in no sense either drawings or monotypes. They were definitely made as rubbings from paintings, but whether from finished works, specially prepared, or possibly by the artist himself in the early stages of setting down a composition on the canvas, is a point still subject to certain doubts. Two examples differ in type from the rest: one, in the Louvre, corresponds to the entire left-hand section of the picture entitled *L'Aventurière* (D. & V. 12), not merely to figures extracted from a composition; the other, a negro's head, in Sir Max Bonn's possession, corresponds to a drawing in the British Museum (P. 18), but shows no correspondence to any known picture.

Of the various outward characteristics of Watteau's drawings, one in particular, the total absence of original signatures and dates, deserves to be emphasized. In a number of examples the artist's name has been added, but these inscriptions have rarely even a semblance of originality. Among the few cases in which the use of red chalk gives a certain verisimilitude, one may quote a landscape, in the British Museum,[2] and two early sketches, in the Louvre, representing a barber's and a wig-maker's shops.[3] A closer scrutiny, however, reveals even these to be subsequent additions. It should be noted, however, that among these later inscriptions of Watteau's name, some are not lacking in documentary value. This applies in particular to a rather large, slanting script, which suggests a nineteenth-century hand, but is probably that of no less a person than Jullienne (Plate 83). Not only are dates lacking inscribed by the artist himself; these do not even occur, as in the case of so many other artists' work, as additions by later hands. One or two instances are met with of original inscriptions other than signatures (Plate 66), but their number is so small as to be almost negligible. Finally, it is of interest to mention that the reverse sides of Watteau's drawings are, so far as could be ascertained, in most cases blank. A notable exception is the brilliant study of a man raising a curtain, in the British Museum (Plate 60). Furthermore, landscapes and studies of trees and plants are occasionally found on the backs of other drawings; there are also a number of cases of letters drafted by Watteau himself, also several annotations by Caylus, stating that the respective sheets were bequeathed to him by the artist. Such examples occur in the British Museum,[4] on the studies of a *décrotteur* in the Koenigs collection,[5] and on the head of a flute-player, afterwards in Mariette's possession, now in the Louvre.[6] A singularly interesting and pathetic document has recently come to light on the back of another drawing in the British Museum:[7] it is a mutilated medical prescription which evidently records the orders of the physician who was treating Watteau for the complaint to which he finally succumbed.

* * *

Owing to the entire lack of dated examples, it is impracticable, if not impossible, to attempt a chronological arrangement of Watteau's drawings. Not that such an

[1] Vasari Society, III, 33, 34; VII, 30. [2] Uzanne, Pl. 31. [3] Chennevières, Pl. 11.
[4] Uzanne, Pl. 13, 20. [5] O.M.D., XVII, Fig. 12. [6] Piazza, Pl. 50. [7] Piazza, Pl. 40.

arrangement, based on stylistic and other evidence, would be hard to carry through for certain sections of the material. Both in subject and handling a typical early work differs appreciably, indeed unmistakably, from a fully mature one; but what remains a fundamental difficulty is that the great mass is more or less uniform in character, without special affinity to either extreme, and that it spreads itself over all but a few years of Watteau's working life. The chronology of the pictures, too, though on the whole less problematical, is far from obvious or exempt from controversy. Here, again, dated specimens are not known to exist, and there is no great amount of circumstantial evidence to reinforce the evidence of style and treatment. The fact, moreover, that a drawing was used for a certain picture is by no means indicative of its simultaneous execution. As we know from Caylus, it was the artist's habit to collect his sketches in bound volumes, and to refer back to these when making his compositions, selecting the figures best suited to his requirements. In view of this practice it is in no way surprising that in some cases an interval of close upon a decade almost certainly separates the original conception of a motive and its ultimate use (see below, p. 26).

What is definitely characteristic of Watteau's last phase of work is a feverish sensitiveness combined with a broader and more summary treatment than theretofore—features which betray at once his abnormal physical condition and that accumulated experience and knowledge of form to which his mature mastery had by degrees attained. Representative examples of this class are the sheet of studies of female heads in the British Museum (Plate 97), for the dating of which the evidence of an English watermark provides, as we have seen, a positive clue; and that of two figures connected with the *Enseigne* (Plate 100), also definitely dateable, since the picture was painted on the artist's return from England, and the drawing (unlike a sketch of a female figure used for the same work[1]) must almost certainly have been made directly for this composition.

Turning from these to the earliest known examples—they date presumably from about 1705 or 1706—we observe a similar but inverse relation to what may for convenience be termed the master's normal style. They are obviously the tentative beginnings of a yet unpractised draughtsman, fresh, spirited, but lacking constructive solidity, above all the amplitude and elevation of genius which under Rubens's influence Watteau was soon to develop. A ready, but not wholly satisfactory characterization of this early style is to describe it as Gillotesque. We know on positive evidence that the influence of Gillot was paramount in the initial period of Watteau's independent activity; Gillot's "modern" subjects and mannerisms of drawing (most striking among these a tendency to elongate the figures and point the extremities) were eagerly adopted by the younger man. For the present, however, too little is known of the chronology of Gillot, too little attention has been paid to the possibility of an inverse influence, to enable one to speak confidently of Watteau's Gillotesque manner. Little assistance, incidentally, can be derived from the Jullienne volumes, in which but few examples definitely of the earliest style are included. One of the best thus documented is the rustic love-scene of the Musée Jacquemart (Plate 1). Two allegories of Summer and Autumn, in the collection of M. Jules Strauss and the Louvre respectively, have likewise the attestation of contemporary prints, the latter appearing among the *Différents Caractères* (181), the former among the rejected plates of the Arsenal Library. A unique etching by Caylus, in the Dresden Print Room,[2] establishes Watteau's authorship of a drawing of two theatrical figures,

[1] Cat. H. Michel-Lévy, Pl. 126 (F.d.d.C. 121). [2] Amateur d'Estampes, VI, p. 71.

15

in the Koenigs collection, which might otherwise well have been credited to his master. Two similar sketches, exhibited in the Louvre in the Salle du Mobilier,[1] are thus also authenticated. The two shop scenes,[2] mentioned in connection with the subject of signatures (above, p. 14), are likewise clearly of Watteau's first period.

The following further points of chronology, based on certain data compiled by MM. Herold and Vuaflart, are of importance. From the publisher's address on the set of engravings known as the *Figures de Modes*, these prints must be before 1710, and the drawings connected with them (Plates 4, 5) of a correspondingly early date. They form a link between Watteau's earliest works and his studies of soldiers (below, p. 17), the majority of which were probably drawn at Valenciennes, whither the artist returned for some months on leaving the studio of Audran. The copies after Rubens's pictures in the Luxembourg palace (below, p. 24) are probably, but not definitely, of about the years 1707-1709; those after drawings by Titian and Campagnola are more certainly of 1714 or a little later, Crozat, from whose collection they were taken, having in that year returned from Italy with a quantity of drawings of the type copied. The studies of Turks (below, p. 20) are connected by MM. Herold and Vuaflart with the embassy of Mehemet Effendi to the Court of France in 1721 —a plausible but not altogether convincing suggestion. The portraits of Italian comedians must be later than 1716, in which year that troupe of players was recalled from banishment. Pictures definitely dateable are *Les Jaloux* (1712), the Louvre version of *L'Embarquement pour Cythère* (1717), and the *Enseigne* (1720). Of these the first gained for Watteau his inscription as an Associate of the Academy, the second his final diploma, while the third he painted for Gersaint, on his return from England, *pour se dégourdir les doigts*. It so happens, however, that (quite apart from the danger of assuming that pictures and their preparatory studies were more or less contemporary) there is little to be inferred from these data. With *Les Jaloux* (D. & V. 127), and its immediate derivatives *Pierrot content*, *Harlequin jaloux* and *La Partie quarrée* (D. & V. 180, 169, 77), only two drawings (one at Bremen,[3] the other corresponding to F.d.d.C. 339) can be definitely connected, while a third, at Berlin,[4] there ascribed to Lancret, is possibly, but not certainly, of the group. Those, again, which have to do with the *Enseigne* are very few, while the growth and development of the *Embarquement* theme (below, p. 32) were so gradual and protracted that no precise conclusions can be drawn. While on this subject it may be mentioned that the satirical composition entitled *Qu'ai-je fait assassins maudits?* (D. & V. 150) provides a striking example of the dangers of hasty inference in regard to date. A mordant attack on the incompetence of doctors, it has always been associated with the last stages of Watteau's illness; the style of the picture, however, is manifestly early, as is also the drawing connected with it, in the British Museum.[5] Far from belonging to the end of the master's activity, as the subject might appear to suggest, it is absolutely typical of his early maturity, the period when Gillot's teaching was still near at hand.

For practical purposes, a classification of Watteau's drawings is best carried through by dealing separately with the less typical subjects, and then grouping together, according to the compositions for which they served, the characteristic examples of the *Fête galante* and theatrical classes. It is in this order that we propose to survey the material and to arrange the selection of plates appended to the volume. This arrangement, it will be observed, is in the main chronological, but makes no attempt to force the question of date where the evidence available is insufficient.

[1] Photo Giraudon 14067. The figures were originally parts of the same drawing, as proved by an offset at Stockholm. [2] K.d.K. pp. 24, 25. [3] Prestel, I, 7. [4] Lippmann-Grote, Pl. 110. [5] Uzanne, Pl. 10.

STUDIES OF MILITARY FIGURES

The first distinct group of drawings in which Watteau reveals himself as an independent artist is that of the studies for his early military pictures. A fair number of such drawings is still in existence, but they are by no means common, and judging from the quantity contained in the Jullienne volumes and from the pictures of this class either extant or engraved, there can be small doubt that an appreciable part of the material has been lost. No fewer than thirty-eight military figures appear among the *Différents Caractères*, many of which are unknown in the original; it is also significant that there are numerous examples, both of drawings and etchings, which do not reappear in the finished compositions. Nearly a dozen of the latter are included in the *Œuvre gravé*, each one peopled with a host of small figures, and clearly compiled to the last from preliminary sketches. The quantity of drawings lost must therefore be considerable, but one point must be allowed for in estimating their original number: it was the artist's practice to make several different studies, often as many as four, on a single sheet. These sketches are as a rule in red chalk alone. They are vigorously drawn in a firm and incisive style and, in spite of their restricted range of subject, show an extraordinary diversity of pose and movement.

Of the round dozen originals hitherto recorded, only one is entirely dependent on stylistic evidence for proof of its authorship, in other words, shows no direct connection either with the engraved compositions or the *Différents Caractères*. It is a sheet of studies in the Quimper Museum,[1] and represents the successive movements of musketry drill. Next come two drawings, in the École des Beaux-Arts[2] and the former Heseltine collection,[3] both of which were omitted from Jullienne's earlier publication, but have at least one figure each occurring in pictures, *Escorte d'Équipages* (D. & V. 125) and *Recrue allant joindre le Régiment* (D. & V. 178). Perhaps the finest individual example of this class is also connected with the latter picture: it is a drawing of three figures, in an anonymous private collection (Plate 6), Jullienne's appreciation of which is shown by the fact that he included each one in his selection of plates. It is uncommon to find a sheet of military studies thus reproduced throughout;[4] that in the Louvre (Plate 7) is in itself somewhat exceptional, being composed of only two figures. Even in the case of so fine a drawing as that at Berlin (Plate 8) not all the figures were etched, while a second sheet, in the École des Beaux-Arts,[5] and one in the Koenigs collection,[6] were entirely passed over, though extensively utilized by the artist. They provided the principal figures for *Alte* (D. & V. 222) and *Les Délassements de la Guerre* (D. & V. 216) respectively, the latter being of special interest to us since we also know of a sketch showing the general setting in which the figures are placed (F.d.d.C. 270). Herr Koenigs's drawing has further claims to notice: like the sheet in Paris already mentioned in connection with it, it provides a case in which a study was used for two different compositions (D. & V. 125 and 216); furthermore, it includes a female figure which, though not used for any of the pictures, is clearly intended as of the class of camp followers. The British Museum has two such drawings connected with though not strictly of the military group; the sketch of a scullion[7] used for *Escorte d'Équipages*, and the charming sheet of studies of a reclining woman (Plate 9), one of which occurs in this same picture.

[1] Delacre-Lavallée, Pl. 36. [2] Lavallée, Pl. 3. [3] Guiraud, Pl. 99. [4] Another example is in the Desfontaines collection in Paris and comprises F.d.d.C. 127, 95 and 241. From an offset at Stockholm it is seen that F.d.d.C. 233-6 were also united on a single sheet. [5] Photo Giraudon. [6] Prestel, Pl. 6. [7] O.M.D., XVII, Pl. 1.

LANDSCAPES

There can be small doubt that Watteau is still imperfectly known as a landscape draughtsman, and that this section of his work has suffered more than any other from neglect. Although landscapes are specially referred to in the title of Jullienne's publication, it contains only thirteen such examples, all etched by Boucher. If we add the extant originals, this total is slightly increased, but even so the landscape group remains a comparatively small one, and the more strikingly so when one considers its frequent mention in eighteenth-century sale catalogues. A quantity of such drawings was contained in the Jullienne collection (lots 819-25), including examples *aux trois crayons* and in pastel chalks; others figured in the sales of Antoine La Roque (1745), Augran de Fonspertius (1747), Mariette (1775), and elsewhere.

A separation has first to be made between the purely imaginary landscapes and the much commoner type drawn straight from nature. An important example of the former class is in the Pierpont Morgan Library;[1] it resembles the backgrounds in such compositions as the *Embarquement* and *Ile enchantée*, and is definitely fanciful in character. The realistic studies again fall into two unequal groups: the majority is rustic in character, while a smaller number, without being imaginary, is yet of a specifically formal conception. To the latter, no doubt, would belong the Luxembourg drawings referred to by Caylus, but curiously enough these have not hitherto come to light. Formal in character, however, is the scene in a park (F.d.d.C. 256, identical perhaps with a drawing in a sale at Paris in November, 1776), and the vista down an alley of trees, which is now in the Hermitage (Plate 25). The former certainly, and possibly the latter as well, represent views from Crozat's property at Montmorency. For certain examples, too, of the rustic type there is reliable evidence as to the exact localities represented. Those in the Mariette sale were specified as *des environs de Paris*, while motives have been recognized with more or less certainty from the banks of the Marne and the property owned by Jullienne at the Gobelins.[2]

The finest specimens known at present are probably the two in the Musée Bonnat (Plates 26, 27), while others of importance are in the Morgan Library,[3] the Wauters collection[4] and the British Museum,[5] the latter a study of cottages among trees recalling *Le Marais* (D. & V. 136) which, according to Mariette, dates from Watteau's period of residence with Crozat. A drawing which passed from the Rodrigues collection into the possession of Herr Koenigs[6] is curious as showing two superimposed landscape motives. A study at Frankfurt,[7] and one, unfortunately mutilated, in the Louvre, are in a rougher and more summary style than the rest; both, like the imaginary landscape at New York, are on the backs of other drawings. Certain landscape copies after Titian and Campagnola will be dealt with at a later stage (below, p. 25), but we must here mention the *desseins de paysage des environs de Rome et de Venise*, of which a whole set was in the Jullienne Sale (lot 825). These, too, must obviously be copies, though it remains doubtful from what models they were actually taken. A sheet inscribed *a Padoue*, with a mutilated letter in Watteau's writing on the back, is in M. Lucien Guiraud's possession; the same collector has a similar sheet without inscription (also a fine realistic study not hitherto mentioned), while another inscribed *a Bassan*[8] belongs to M. Mathey of Paris. There can be little doubt that these formed part of the Jullienne series.

[1] Morgan Publ. III, 90. [2] See *Revue de l'Art*, XL, p. 109, and Herold and Vuaflart, I, p. 234. [3] Fairfax Murray, Pl. 277. [4] Not included in the Amsterdam Sale of 1926. Lees, Fig. 165. [5] Uzanne, Pl. 31. [6] Cat. Bourgarel Sale (1922), Pl. 66. [7] Staedel Publ., II, 5. [8] Cat. Bourgarel Sale (1922), Pl. 72.

ORNAMENTAL DESIGNS

As stated above, the main sources of information on Watteau as a designer of decorative arabesques are the plates, mostly by Huquier, in the *Œuvre gravé*. Over and above these there are two examples among the *Différents Caractères* (100, 163), and a very limited number of originals. The Huquier engravings, valuable as they are to us, need to be used with considerable caution, for they are by no means in the nature of facsimiles, indeed outwardly they present no differences whatever from the renderings of the artist's finished decorative panels. To distinguish these one has to rely entirely on the underlines. In one case (D. & V. 64) it is expressly mentioned that the print was taken from *le dessein original inventé et coloré par A. Watteau;* as a rule there is only the indication *invenit*, as opposed to *pinxit*, to denote that the original was a drawing. The engraver's methods can be exactly studied in the case of four drawings included in the *Œuvre* which are still extant. Two of them, formerly in the Goncourt collection,[1] correspond to *Le Berceau* (D. & V. 25) and the *Temple de Diane* (D. & V. 225). These were drawings complete in themselves, so that Huquier needed only to elaborate the details without making substantial additions or modifications. Two further examples, however, at Leningrad (Plate 15) are designs in which only the main indications are given; to make them uniform in style with the others, the engraver had therefore to work them up extensively (*cf.* D. & V. 141 and 283). A few originals which were not engraved are known: a large oblong panel in the Musée des Arts-Décoratifs, a roundel with *Fête galante* figures in the Fenaille collection, and a sheet in the Koenigs (formerly Heseltine) collection,[2] which is exceptional as including an independent study of a head. While there are thus appreciable differences of outward type, what is common to all these drawings is a swift and summary execution. A highly finished drawing, at Vienna,[3] corresponding to *La Pelerine altérée* (D. & V. 89), is for that reason alone readily recognizable as a copy; it is probably the engraver's working design based on a less elaborate, perhaps indeed only partly finished drawing by the master himself. There are further sheets, at Dijon, marking somewhat different stages in the process of Huquier's work. Two of these correspond to the Hermitage drawings already mentioned.[4]

STUDIES OF POPULAR TYPES

Although Watteau as a rule avoided the cruder aspects of reality, he evinced a distinct liking for various types of *le bas peuple*, such as beggars, Savoyards, artisans, etc. The existence of a considerable group of such drawings makes it probable, indeed, that he had in mind the execution of a series of street-criers somewhat similar to those of Boucher and Bouchardon at a later date. He also painted a few isolated pictures of this type, *La Marmotte* amd *La Fileuse* (D. & V. 122-3), which correspond to the drawings F.d.d.C. 6 and 103 (the former now in the Dutuit collection, Plate 10). One of Watteau's favourite models was an old bearded Savoyard or peepshow man, of whom there are sketches seated, standing, kneeling,[5] with his peepshow on his back or by his side (see Plates 11, 12 and note). A similar female figure also occurs repeatedly: a fine example is in the British Museum,[6] another was formerly in the possession of Mr. Augustine Birrell,[7] corresponding to one of the rejected plates in the Arsenal Library, and a third was included by Jullienne as Plate 35 of

[1] O.M.D., XVII, Pl. 7; the other photo, Braun 65807. [2] Guiraud, Pl. 84. [3] Photo, Braun 71084.
[4] In the Provinzial Museum at Hannover are drawings corresponding (in reverse) to D. & V. 16, 18, 217, 220; but they are doubtless all copies by the engraver. [5] Prestel Portf. Koenigs, P. 1.
[6] Uzanne, Pl. 30. [7] Burl. Mag., XXXVIII, p. 156. Now Strauss coll., New York.

his work. But perhaps the most important of Watteau's drawings of this class is the figure of a knife-grinder, in the Louvre,[1] which at the Mariette Sale of 1775 reached a price considerably greater even than that of the studies of a negro's head shortly to be discussed (see below). Among the finest of the remaining are the young Savoyard of the Bonnat collection,[2] the shepherd of the Musée Condé,[3] the *décrotteurs* (corresponding to F.d.d.C. 38, 170) in the Koenigs collection,[4] and the fruit-seller formerly belonging to Léon Michel-Lévy.[5] It should be noted that the Louvre sheet representing two studies of a seated bag-piper (Plate 29) is definitely not of the class here under consideration, the man represented being the actor, La Tourillière, who served Watteau as a model on several other occasions. Related to the group, however, are such important drawings as the monk and the pilgrim, both here reproduced (Plates 13, 14), and the less elaborate study of the figure of a verger in Mr. Walter Gay's collection (F.d.d.C. 267). Similar in conception are also certain domestic figures, well exemplified by the little girl sewing, in the Iveagh collection (Plate 95), and the study of an old woman spinning, used for *L'Occupation selon l'Âge* (D. & V. 208), the original of which is in the Hermitage (F.d.d.C. 3).

STUDIES OF EXOTIC TYPES

A fairly extensive and clearly defined group of drawings, a number of which is still preserved, shows that Watteau was as interested in Oriental and other racial types as in the picturesque *bas peuple* of the Paris streets. It is, indeed, no exaggeration to say that some of his most brilliant achievements as a draughtsman belong to this class. A drawing justly celebrated for its unrivalled quality is the sheet of three studies of a negro's head in the Weill collection (Plate 51); it is aptly described in the Mariette catalogue as *d'une vérité frappante*, and though not included among the *Différents Caractères*, seems already then to have been considered an outstanding work of its kind. Though much the finest, this is not the only study that Watteau made of his negro model. Similar heads occur, for example, on a sheet in the Louvre;[6] the British Museum has two in pastel chalks,[7] while the original of F.d.d.C. 183 is now in the Koenigs collection.

No less important are the Eastern studies already referred to in connection with the chronology of Watteau's drawings (above, p. 16). These again include works of the highest quality. A splendid example is the Turk in profile, in the Teyler Museum (Plate 99); a similar figure was in the James collection (F.d.d.C. 122), and the same model occurs as a standing figure (together with the same man, probably an actor, occurring on a drawing in the Lugt collection) on a sheet seen in recent years in the Paris market. The Victoria and Albert Museum has, curiously enough, two specimens of this class: a seated Kurd or Persian (Plate 98), whom Watteau also drew in a standing position (F.d.d.C. 4), and a full-length figure of an Eastern Jew, showing a separate study of the head, the latter resembling a sketch belonging to a Paris dealer, which corresponds to No. 16 of Jullienne's work. A somewhat similar full-length figure was recently sold from the Wendland collection (F.d.d.C. 73).[8] Furthermore, one may mention the beautiful study of a striding Eastern slave, in the British Museum[9] (P. 12), whom Watteau also portrayed in a standing attitude; the original of the latter has not been located, but it appears among the rejected plates in the Arsenal Library. In conclusion, a word of warning on the subject of a

[1] Piazza, Pl. 35. [2] Bonnat Publ., 1926, 52. [3] Piazza, Pl. 30. [4] O.M.D., XVII, Fig. 12.
[5] Cat. L. Michel-Lévy, Pl. 110. [6] Uzanne, Pl. 32. [7] Uzanne, Pl. 6.
[8] Int. Studio, May 1931, p. 23. [9] Uzanne, Pl. 38.

large drawing of a Chinaman,[1] in the Albertina, which on Goncourt's authority has constantly been referred to as connected with Watteau's decorations in the Château de la Muette. It is actually the work of Étienne Jeaurat and should definitely be eliminated from the list of Watteau's works.

PORTRAIT DRAWINGS

It has often been stated,[2] by Goncourt, among others, that portrait drawings by Watteau are exceptional. In point of fact just the opposite is the case; almost all his studies of heads are in a general sense portraits, the natural result of drawing constantly from the living model, and of seizing with supreme facility its distinctive characteristics. But even if the term portrait is narrowed down to such works as show the specific intention to depict an individual, the volume of Watteau's output is considerable, and in a number of cases definite identifications can be made.

An original self-portrait, perhaps the most interesting document of this class that one could wish for, is the head, engraved by Filleul, in the Gutekunst collection (see title-page). The drawing etched by Audran (F.d.d.C. 213), showing the artist's features distorted in laughter, was last recorded in the Paignon-Dijonval collection in 1810, while that for the picture engraved as the frontispiece to the *Différents Caractères* figured in the Jullienne Sale (1776), but has not since been traced. A copy, probably by Boucher, is at Chantilly.[3] Watteau's most ambitious achievement as a portrait draughtsman is the highly finished drawing, now in the Weill collection, of the musician, Jean-Ferry Rebel (Plate 75); its inclusion in the *Œuvre gravé* and certain other peculiarities have already been referred to in their appropriate places (pp. 5, 12, 13). Another example definitely identified and, like the preceding, a link with the musical circle that gathered around Pierre Crozat, is the drawing in the Louvre representing the flautist, Antonio Guido, and the singers, Paccini and Mlle. d'Argenon.[4] These have Mariette's authority to establish their identity, but it has proved to be unfounded that they were executed during a concert in Crozat's house in 1720, to which reference is made in the journal of Rosalba Carriera. Unlike certain minor sketches occurring on the Louvre sheet, an authentic portrait of Rosalba is the drawing corresponding to F.d.d.C. 263, which, when exhibited at the École des Beaux-Arts in 1879, was in the possession of M. Dutuit.[5] It gives an unflattering impression of the celebrated Venetian as she sits at her toilet table in front of a mirror. Such close associates of the artist as Jullienne, Gersaint and Caylus do not, strangely enough, figure among his drawings; on the other hand, there is definitely the painter, Nicolas Vleughels (Plate 63), and very probably also Antoine La Roque (Plate 74). As to Abbé Haranger, another of the artist's intimate acquaintances, a curious misunderstanding has recently been pointed out. While Haranger's name is traditionally attached to one of Watteau's most impressive portrait drawings, at Berlin (Plate 76), the underline on certain impressions of the corresponding etchings prove that the sitter was actually the actor, La Tourillière. This brings us to the portraits of theatrical personalities. In the case of Poisson (Plate 32) there is again the definite evidence of a lettered print. More doubtful are the figures grouped together in such compositions as *L'Amour au Théâtre Italien*, the *Comédiens Italiens* and the Louvre *Gilles;* but the identifications suggested by MM. Herold and Vuaflart seem more or less convincing, and on the ground of these certain drawings may be named. Thus

[1]O.M.D., XIX, Pl. 33. [2]Gazette d. B.-A. III/XVI (1896), p. 177; IV/V (1921), p. 257.
[3]Art Ancien et Moderne, XL (1921), p. 75. [4]Art Ancien et Moderne, XLVI (1924), p. 289.
[5]Photo Braun, 65675.

a bust of a woman, in the British Museum[1] (P. 42), is probably the portrait of Helena Balletti, known as Flaminia; another, in the Iveagh collection (F.d.d.C. 82), Giovanna Benozzi, called Silvia; and the head of a pierrot, at Munich,[2] Giovanni Bissoni. It must be admitted, however, that we are not here on really secure ground. A case in which an altogether fanciful name has been adopted is the matchless drawing, in the Greffuhle collection, described as the actress, Mlle. Duclos (Plate 43). Not only is this identification chronologically impossible, but also the face is clearly the same as on a sheet in the British Museum (Plate 44), which connects with a picture (D. & V. 72) on which Mariette provides information. According to him the principal male figure in the *Concert champêtre* represents a certain M. Bougy, and it is probable that the persons around him are members of his family. Similar information is available for *Sous un habit de Mezzetin* (D. & V. 131); here it is Sirois, the picture dealer and father-in-law of Gersaint, with his sons and daughters. One of the male heads occurs on a drawing at Rouen (Plate 49); the two women are on a drawing in the British Museum,[3] the sketch on the right being clearly the same face as that of which the Stockholm Museum has four studies on a single sheet.[4] Such observations, it should be remarked, could readily be multiplied. Those recorded in this paragraph are but a selection of the more interesting, while in fact a number of similar points are equally convincing and notable.

NUDE STUDIES

It is affirmed by Caylus that Watteau rarely made studies of the nude model, but there can be little doubt that this statement was intended in an academic sense, in other words, that the artist was little concerned with the anatomical structure of the undraped figure. If nudes in the wider sense are now comparatively rare, it is probable that the true explanation for this lies in the fact, likewise recorded by Caylus (Champion, p. 110), that shortly before his death Watteau, in undue modesty, destroyed a quantity of drawings which he thought too free. Among the *Différents Caractères* nudes are scarcely represented at all; indeed, it is only No. 105, a drawing now lost, wrongly connected by Goncourt with the naiads in the *Fêtes au Dieu Pan* (D. & V. 226), that comes within the present class. It is not, however, a typical example. Among the finest of a type more characteristic of the artist are two sheets in the British Museum (Plates 82, 83), both remarkable for their intimate, almost domestic interpretation, far removed from the academic convention. Others of a similar type, indeed probably executed on the same occasion, are at Lille, in the Walter Gay collection (Plate 81), and elsewhere. Somewhat in the nature of a connecting link between the foregoing group and that of a more formal interpretation is the beautiful half-length figure in the Louvre (Plate 84). It is in this collection, too, that the finest of the latter type are preserved. A superb example is the male figure, used for the picture of *Jupiter* and *Antiope* (Plate 21), and, almost equally impressive, the study for *Spring*[5] in the set of allegorical compositions painted for Pierre Crozat about 1712. The seated figure of Bacchus, in Mr. Gay's possession (Plate 20), also the figure of a satyr, until some years ago in the Henri Michel-Lévy collection, connect with the panel of *Autumn* in this series.[6] The same model as the last occurs on a drawing in the Louvre,[7] and possibly again on one formerly in the Heseltine collection.[8] The majority of Watteau's nude studies show a combination of red and black chalks, sometimes with the additional use of white.

[1] Piazza, Pl. 36. [2] Schmidt, II, 40a. [3] Uzanne, Pl. 11. [4] Schönbrunner-Meder 1110, as by Lancret. [5] Uzanne, Pl. 43. [6] Cat. H. Michel-Lévy, Pl. 116. [7] Helleu, Pl. 4. [8] Guiraud, Pl. 89.

FIG. 1

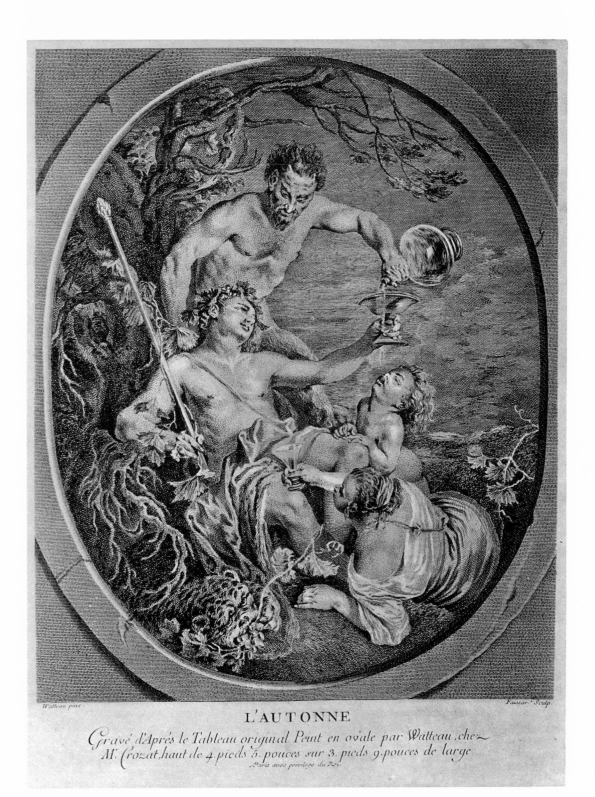

L'AUTONNE

Gravé d'Aprés le Tableau original Peint en ovale par Watteau, chez M.ͬ Crozat, haut de 4. pieds 5. pouces sur 3. pieds 9. pouces de large

Paris avec privilege du Roi.

AUTUMN, FROM THE CROZAT "SEASONS"

Engraving (in reverse) by Étienne Fessard

Cf. Plates 19 and 20

FIG. 2

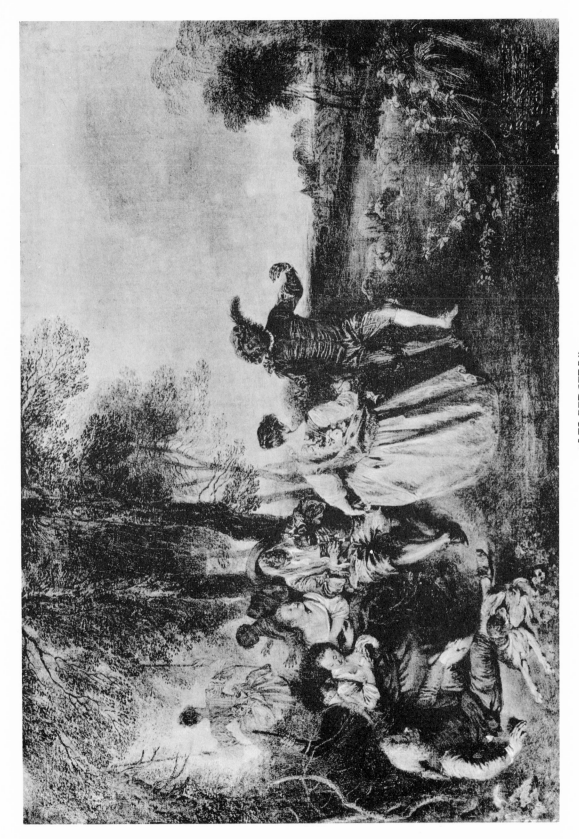

"LES BERGERS"
(Potsdam, Neues Palais)
Cf. Plates 28 and 29

STUDIES OF HANDS

It is important to stress Watteau's studies of hands, since this class of drawing was passed over entirely by Jullienne, who probably looked upon such sketches as too slight and fragmentary to be included in his work. At their best, however, they show a sensitiveness unsurpassed even by the master's most vivid studies of heads and figures. Though not exactly common, their number to-day is still fairly considerable, especially if one takes into account those scattered at random over sheets of miscellaneous sketches. Such examples are met with in many collections, and it would be easy to quote cases in which the other studies were selected for inclusion in Jullienne's work, while the details of hands were omitted by the engravers. Of the sheets hitherto recorded composed entirely of hand studies, that from the H. Michel-Lévy collection is on the whole the most important (Plate 77). It combines the finest quality with an exceptional number of separate sketches. As a rule not more than two or three go together, and these are generally drawn on a small scale. In function and attitude they show great variety, but among the artist's favourite motives are the holding of a fan or mask (Plate 79), and the finger-play over the strings or stops of a musical instrument (Plate 78). There are comparatively few cases of direct correspondence with pictures. One such is a sheet in the British Museum,[1] that was closely followed for the *Comédiens Italiens* (D. & V. 204); the hands of the cello-player in Watteau's self-portrait with Jullienne (D. & V. 3) occur on a sheet, again from the Michel-Lévy collection;[2] and a particularly fine study, formerly in the Heseltine collection,[3] seems to have been used repeatedly, e.g. for the Chantilly *Plaisir Pastoral*, the Dresden *Plaisirs d'Amour* and their respective derivatives (see below, p. 37). A large sheet in the Musée Jacquemart-André[4] is somewhat exceptional in character and includes studies of feet in addition to hands. Chennevières, who formerly owned it, assigned it to a much too early date; the figure on the right is that of La Tourillière, and the drawing must be contemporary with the Berlin portraits.

ANIMAL STUDIES

This class, like the preceding, is lacking among the *Différents Caractères*, but a few originals still in existence show that Watteau was adept in the rendering of animal life. As is the case with studies of hands, there are pages composed entirely of figures of animals, as well as sketches on sheets of miscellaneous studies. Their total, however, remains strikingly small in comparison with the large number of different animals appearing in Watteau's pictures. Only in one or two isolated cases is there direct correspondence between pictures and drawings.

A case of such correspondence is the charming page of sketches of a toy spaniel[5] which passed into the possession of Princesse de Poix at the Helleu Sale in 1928. One of these studies served no less than three times, for *Le Conteur* (D. & V. 4), *L'Amour paisible* (D. & V. 268), and the Berlin *Assemblée dans un Parc* (below, p. 39). The same spaniel occurs on numerous other occasions in Watteau's pictures, and the artist must have drawn it frequently, though at present only this one sheet is known. Another study of dogs, in the Cognacq Museum (Plate 89), connects with the *Rendez-vous de Chasse*, in the Wallace collection (D. & V. 213), but it is interesting to observe that further figures of dogs in this picture derive from a sketch by Pietro Testa, in the British Museum, inscribed in an old hand with the name of

[1] Uzanne, Pl. 13a. [2] Cat. H. Michel-Lévy, Pl. 131. [3] Guiraud, Pl. 83. [4] Delacre-Lavallée, Pl. 37.
[5] Cat. Helleu Sale (1928), Pl. 86.

Rubens. Rubens's dogs, incidentally, were studied by Watteau on more occasions than one. In the *Charmes de la Vie* (D. & V. 183) and several other pictures, a figure may be noticed that is taken over from the Marie de Médicis cycle; and on a drawing, formerly in the Bottollier-Lasquin collection, we have a direct copy, this time from a figure in the Louvre *Kermesse*.[1]

Likewise in the Cognacq Museum is a study of a leopard,[2] probably identical with a drawing mentioned in the Jullienne catalogue (lot 826). The *Singe Peintre* and *Singe Sculpteur*, known as recently as 1846 to be in the Saint collection, have now unfortunately disappeared. They would otherwise represent a more fanciful aspect of Watteau's draughtsmanship of this class, which for the rest is purely realistic in conception. Detached studies of animals are found in the Musée Bonnat,[3] the Louvre,[4] the British Museum,[5] etc., the two former with charming studies of cats, the latter a small head of a hound. A study of owls, also in the British Museum, is a puzzling drawing of doubtful authorship. In handling it is distinctly reminiscent of Watteau, but it is inscribed on the back with an old attribution to Sebastien le Clerc.

COPIES OF OTHER MASTERS

An interesting group of drawings is that of the copies by Watteau after other artists. Isolated specimens of this class occur in both parts of Jullienne's *Recueil*, but it would seem, nevertheless, that his actual intention was to exclude them. The standing figure of a monk after de Troy (D. & V. 117) is in itself exceptional, being placed not among the *Différents Caractères*, but in the *Œuvre gravé*. The former publication contains but one example that is definitely a copy, certain figures extracted from the Louvre picture by Adriaen van de Venne, commemorating the treaty of 1609 between Spain and the Netherlands.[6] The original of this drawing[7] appeared in the Valori Sale of 1907, and Watteau adapted the figure of the guitar-player for the less familiar of his pictures entitled *Amour paisible* (D. & V. 268). What is arresting, however, about its inclusion among the *Différents Caractères* is that it is the only unnumbered plate in the two volumes, being interposed between Nos. 270 and 271. Also exceptional, though in different respects, are Plates 1 and 346. The former, perhaps identical with Jullienne's *Buste de Religieux* (lot 774) and now preserved in the Museum of Rouen,[8] is probably, but not certainly, the copy of an older master. The same applies to the St. Antony (F.d.d.C. 346), from the Léon Michel-Lévy collection.[9] It is certainly connected with an engraving by Raphael Sadeler after Martin de Vos, but it is perhaps more accurately described as an independent adaptation in the style of David Teniers than as a copy in the stricter sense.

More important sources of information for Watteau's activities as a copyist than the Jullienne *Recueil* are such facsimiles as those of Gonord (above, p. 6), the statements of Caylus (above, p. 8), and references contained in early sale catalogues. His favourite model was Rubens. To begin with there are the copies from the Luxembourg cycle of the history of Marie de Médicis, a group well exemplified by a drawing of classical deities in the British Museum,[10] and another, formerly in the Heseltine collection, showing various figures from the *Landing of the Queen at Marseilles*.[11] No less attentively was the *Great Kermesse*, then in the Royal collection, studied by our artist. The Louvre has a sheet showing three different motives taken from this picture,[12] while in the Musée des Arts-Décoratifs is a copy of the man and woman

[1] L'Art XXXV (1883), p. 82. [2] Cat. H. Michel-Lévy, Pl. 121. [3] O.M.D., XVII, Fig. 6. [4] Helleu, Pl. 38.
[5] Piazza, Pl. 36. [6] Burl. Mag. LI (1927), p. 37. [7] Cat. Valori Sale, Pl. 247. [8] Photo Bulloz.
[9] Cat. L. Michel-Lévy, Pl. 119. [10] Burl. Mag., XII, p. 164. [11] Guiraud, Pl. 90. [12] Helleu, Pl. 31.

embracing, which Watteau introduced into *La Surprise*, in Buckingham Palace (D. & V. 31). A copy of Rubens's *Mars and Venus*, at Dulwich, which was recorded in a sale of 16 germinal an IX, is now in the Châteauroux Museum. Similar studies after Van Dyck are not so frequent, but among others may be mentioned a copy of the portrait of Adam de Coster, in the Ricketts and Shannon collection, for which the original drawing, now at Frankfurt, was in the Crozat collection; and a figure of Queen Henrietta Maria from a portrait group, then in the Orleans collection.

Next there are the Italian masters to be considered, among whom Bassano, Titian, Campagnola, Veronese and della Bella are specially named by contemporary authorities. Here we have chiefly the fruits of Watteau's studies in the Crozat collection. A typical example of his copies of Renaissance drawings is the landscape with two kneeling figures, the original of which, by Titian, is in the Albertina, while Watteau's copy (in red chalk instead of pen) is in the Louvre.[1] A particularly fine landscape of Titianesque character is that in the Lugt collection (Plate 23); others of the same class are at Besançon, in private ownership in Paris, etc. For Veronese one can instance a figure study, formerly in the Bottollier-Lasquin collection,[2] which connects with the picture of the *Finding of Moses*, then in the Cabinet du Roi; and two sheets of studies of heads, obviously companions, in the Louvre[3] and Morgan Library,[4] derived mainly from a composition of *Christ and the Centurion*, recently in the possession of the late Mr. George Sulley. The Louvre drawing, however, contains certain extraneous figures, among others of the Virgin and Child, which have given rise to the statement that the original by Veronese represented an *Adoration of the Shepherds*. Probably after della Bella is the attractive page of sketches of ships that figured in the Helleu Sale.[5] Further examples of this type hardly need mention, but we may conclude by a reference to certain isolated copies of sculpture. Two drawings, in the British Museum,[6] and the former Henri Michel-Lévy collection,[7] represent, from different angles, a group of children with a goat, which also occurs in one of the Berlin pictures (Figure 14) and in D. & V. 28, 86, 126. The original of this group, now in the Louvre, is by Jacques Sarazin, and Watteau's copies must have been made either direct from the statue, then in the garden of Marly, or from the model for it, which formed part of the Mariette collection (lot 57).

Isolated examples are preserved or recorded of various other distinct classes of subject, but their importance is not sufficient to claim our attention for long. Most interesting, perhaps, is a solitary biblical subject, the *Finding of Moses*, in the École des Beaux-Arts (Plate 24). Here is a definite example of a *disegno storiato* (see above, p. 9), but, as Mariette states, it is quite exceptional to find anything of this type. It should be remarked that at Berlin a drawing is preserved corresponding (with modifications) to Watteau's picture of *Louis XIV mettant le Cordon bleu à Monsieur de Bourgogne* (D. & V. 227). Almost certainly an original design, it seems, however, impossible to attribute it to Watteau's hand, and it may be connected conjecturally with Antoine Dieu. Allegory is represented (apart from the sketches for the Crozat *Seasons*) by the two Gillotesque compositions of *Summer* and *Autumn* (see above, p. 15); allegorical, too, is the Oxford drawing which has reference to the failure of Law's system and the assistance given to the artist by Jullienne during this crisis (D. & V. 182). More or less pictorial, like the preceding, but not highly finished, are certain drawings of mountebank subjects, at Oxford, Besançon, etc., recalling Gersaint's statement about the artist's earliest beginnings (above, p. 7). Definitely

[1] Helleu, Pl. 35. [2] L'Art, XXXV (1883), p. 82. [3] Helleu, Pl. 36. [4] Fairfax Murray Publ., Pl. 276. [5] Cat. Helleu (1928), Pl. 87. [6] Uzanne, Pl. 26. [7] Cat. H. Michel-Lévy, Pl. 123.

satirical is the figure of **Dr.** Misaubin engraved by Pond (above, p. 6), and essentially so, but less obviously, the various studies for *Qu'ai-je fait, assassins maudits?* the most important of which is in the British Museum. An example of caricature is provided by a group of grotesque musicians on the back of a design for an interior decoration at Florence (Plate 16). A motive of still-life occurs on a drawing in the Koenigs collection (Plate 88); of flower studies we hear in the Jullienne catalogue (above, p. 12), and studies of plants occur on the reverse of two sheets in the British Museum[1] and the Staedel Institute. An example, to all appearance genuine, of the study of an inanimate object is the sketch of a shell in the Berlin Print Room. The above, however, are all of secondary importance as compared with the two great classes yet to be dealt with: the studies connected with the master's most typical pictures, the *Fêtes galantes* and kindred subjects on the one hand, and the theatrical subjects on the other. To gain a survey of this astonishing wealth of material, we may proceed to analyse certain of the more important of these pictures.

Le Plaisir Pastoral (D. & V. 209). Chantilly, Musée Condé.

This important early composition must be studied in relation to a later, somewhat modified version of the same subject, which is preserved at Potsdam under the title *Les Bergers*, but is not included in Jullienne's *Recueil* (Figure 2). To all appearance there is a considerable interval between the two works, but a number of the same drawings was used for both, and even those corresponding to the new figures in the later picture are in all probability of about the same date as the others. We have thus an interesting example of the artist's practice of reverting to his earlier studies, and a striking proof that, as already stated, a picture and its preparatory materials need by no means be contemporary.

A prominent feature in both versions of the composition is the group on the left representing a man embracing a woman. These figures have already been discussed at some length as illustrating Watteau's tendency as a draughtsman to separate even such closely connected elements of one and the same group (above, p. 11); the drawing of the man, in the Cognacq Museum,[2] was made independently of that of the female figure, formerly in the Varennes collection,[3] the two studies being subsequently combined on the canvas. Another sketch that served on both occasions corresponds to the charming figure of a girl on a swing; formerly in the James collection, the original is now the property of the Earl of Iveagh (Plate 28). The pair of dancers, too, occurs both at Chantilly and Potsdam, but while the female figure is included in the *Différents Caractères* (322), neither of the drawings is at present accessible. This group, however, claims careful attention by reason of its occurrence in yet another picture, to wit *L'Accordée de Village*, in the Soane Museum, a composition which is further connected with *Les Bergers* through the splendid figure of a rustic musician playing the bagpipes. This connection, it is true, is merely indirect: a drawing, in the Louvre (Plate 29), shows the figure in two different poses, the side view being that adopted for the *Accordée*, while the front view occurs in *Les Bergers* and *Fêtes Vénitiennes* (below, p. 28). This latter work, now in the Edinburgh Gallery, must, for diverse reasons, be relatively early; we thus have proof that the drawing is actually closer in point of date to the Chantilly picture than to the Potsdam version for which it was used. New to *Les Bergers* is also the head of a young man wearing a tall cap: the drawing for this passed from the Heseltine into the Tuffier collection,[4] and seems to have been executed at the same time, and from

[1] O.M.D., XVII, Fig. 5. [2] Cat. H. Michel-Lévy, Pl. 118. [3] Cat. Varennes Sale, Pl. 144. [4] Guiraud, Pl. 92.

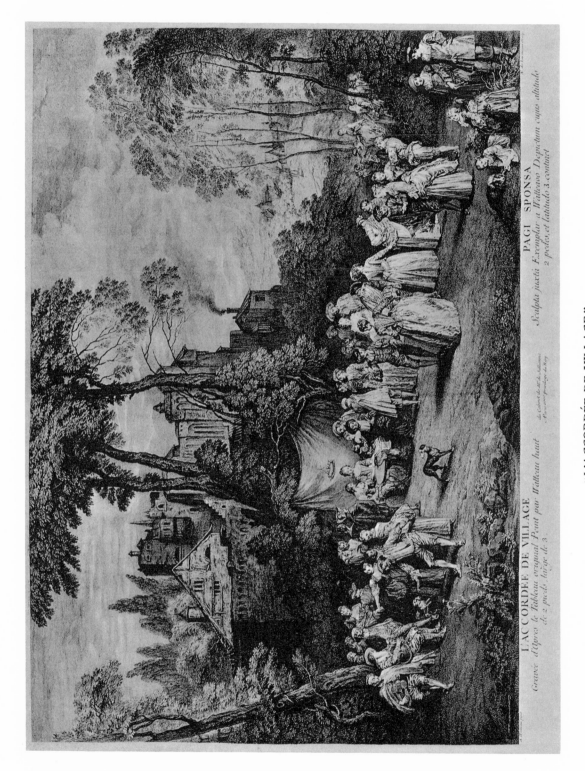

FIG. 3

"L'ACCORDÉE DE VILLAGE"

From Larmessin's engraving (in reverse) after
the picture in the Soane Museum

Cf. Plates 29, 30 and 46

FIG. 4

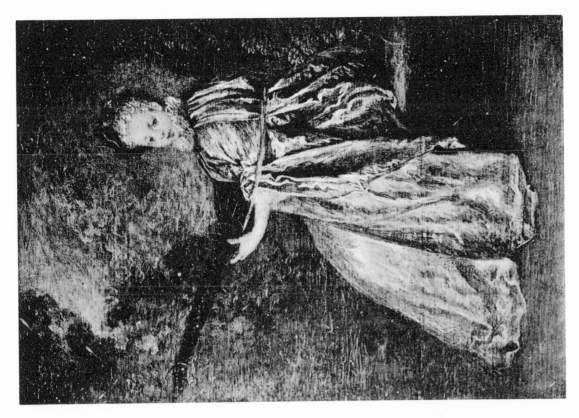

"L'INDIFFÉRENT" AND "LA FINETTE"

(*Louvre*)

Cf. Plates 30 and 31

the same model, as the man who (again in the Potsdam picture) is swinging the girl corresponding to the Iveagh drawing. The original of this second male figure is not accessible, and the point referred to is not visible in the picture itself. There exists, however, an etching by Caylus which shows that the drawing was not only a full-length figure, but included the same tall cap, subsequently omitted, as in the Tuffier drawing. Finally, the two versions of the composition differ in the recumbent figures in the foreground to the left. That in the Chantilly picture is the more interesting of the two, for apart from its recurrence in *Les Agréments de l'Été* (D. & V. 132), it corresponds to certain drawings that are worth recording, although the original itself is still lacking. What appeared to be an exact copy of the missing sheet, showing the figure in question along with five other studies, was recently seen in a London sale-room;[1] a further copy, at Munich, is probably by Pater, but to all appearance it was drawn from the picture, not from the preliminary study for it.

L'Accordée de Village (D. & V. 116). London, Soane Museum (Figure 3).

This is one of the most elaborate and detailed of Watteau's earlier masterpieces, with which (unlike its pendant, *La Mariée de Village*) a quantity of drawings can be connected. Over the latter composition we need hardly pause, as only two studies for it come into account at all. One, showing a number of youthful male figures, is in the Louvre;[2] to the other, a page of small dimensions, at Dublin, reference will be made in connection with *La Conversation* (below, p. 28).

As previously mentioned, *L'Accordée de Village* is directly connected with *Le Plaisir Pastoral* and *Les Bergers* by the group of two dancers, indirectly also with *Les Bergers and Fêtes Vénitiennes* by the figure of a seated man playing the bagpipes (Plate 29). Its closest relation, however, is with a somewhat reduced and modified version of the same subject, at Madrid (K.d.K. 33), a picture which, though traditionally ascribed to Watteau, has recently been claimed as the work of his imitator, Pierre-Antoine Quillard. Were it merely an adaptation of the composition in the Soane Museum, the picture at Madrid could here be ignored; it has, however, this point of interest that it includes two figures not occurring in *L'Accordée de Village*, but yet definitely based on sketches by Watteau. These are the musician on the extreme right, corresponding to F.d.d.C. 9, but not occurring elsewhere; and the old man with long hair to left of the notary. The drawing for this figure is on an important sheet of studies, in the British Museum,[3] from which Watteau himself took two youthful male dancers included in the *Accordée* in the group around the piper already familiar to us.

Another figure in the Soane Museum picture which deserves special attention is that of a man seen from behind, partly covered by the female dancer repeated from *Le Plaisir Pastoral*. The corresponding sketch occurs on a large and important sheet in the Menier collection (Plate 30). Apart from its connection with the Louvre *Indifférent* (Figure 4), which becomes apparent from one of the further sketches on the drawing, the figure is remarkable as being the only detail occurring in the *Embarquement* which had previously appeared in a picture other than its immediate antecedents (see below, p. 33). Interesting in other respects is the figure of the notary seated at the table in the centre of the picture: though included among the *Différents Caractères* (No. 135), the drawing is still classified in the Louvre under the name of Lancret.[4] The back view of a man conversing with the notary is also worth noticing: it occurs on two different drawings of about equal merit, in the Teyler and Cognacq

[1] Sotheby, 13th May, 1931, lot 86. [2] Chennevières, 11a. [3] Uzanne, Pl. 27. [4] Guiffrey-Marcel, VII, Pl. 94.

E

Museums.[1] On the same sheets are studies of a seated man playing the hurdy-gurdy, resembling the figure occurring in the picture next to the piper. We here reproduce a sheet of studies of heads in the Louvre, including the male profile, seen half from behind, in the group of dancers (Plate 46); for the rest, however, a bare enumeration must suffice. Two drawings formerly in the Bureau[2] and Knaus[3] collections are connected respectively with the female figure next but one to the left of the male figure repeated in the *Embarquement*, and the young man in a cloak standing near the bridal pair. Further connections are revealed by six plates among the *Différents Caractères* (Nos. 11, 139, 157, 159, 314, 317), and with the help of these the picture can be more or less completely reconstructed.

LA CONVERSATION (D. & V. 151). Paris, Heugel collection.

This composition is easier to analyse than either of the preceding, being comprised of a relatively small number of figures and showing no direct correspondence with other pictures. Even a more distant connection is shown by but a single document: a small sheet of studies, at Dublin, contains the figure of an elderly man leaning on a stick, used for *La Mariée de Village* (above, p. 27), while two others on the same sheet connect with the lady and gentleman on the extreme left of the Heugel picture. As is commonly the case with such sheets of studies, although in the finished picture the two latter figures appear next to each other, they are isolated in the drawing and show no spacial relationship. Just the contrary applies to the figures of a kneeling man and a negro page-boy on the opposite side of the picture. The corresponding drawing has not itself been recorded, but it is reproduced among the *Différents Caractères* (No. 300), and illustrates the unusual feature of figures combined to a group (above, p. 11). The studies for two further male figures occur on a drawing in the École des Beaux-Arts,[4] i.e. for the standing man in the centre, and another, wearing a large periwig, seated more to the left. While the latter has been thought, without any particular justification, to represent either Jullienne or Crozat, the standing figure has been identified with at least some semblance of reason as the artist himself. It should be noticed, however, that in the drawing both figures are clearly from the same model, and that while in the picture the seated figure has different features, the other shows no change as compared with the drawing. But since the attitudes are hardly compatible with self-portraits, one would expect, assuming that the model served only for studying the general posture, to find different features in the standing figure as well. The accuracy of the identification, therefore, is not beyond question. No drawing is known for the face of the seated man, but in the case of the negro on the right, a detail study of the head occurs on one of the celebrated sheets from the Ymecourt collection, now in the Louvre.[5] Of the remaining figures only one can at present be accounted for, this being the seated lady holding a fan, which corresponds to No. 130 of the *Différents Caractères*.

FÊTES VÉNITIENNES (D. & V. 6). Edinburgh, National Gallery of Scotland (Fig. 5).

One of the most notable of Watteau's works prior to the *Embarquement*, this picture comprises a considerable number of figures and shows manifold connections with other compositions. Hitherto only the piper has claimed our attention; it is the figure we have met with in *Les Bergers* at Potsdam, the drawing for which, along with the side view used for *L'Accordée de Village*, occurs in the well-known drawing in the Louvre (Plate 29). Two dancing figures, a man and a woman, share

[1]Cat. H. Michel-Lévy, Pl. 120. [2]Cat. Bureau Sale, 1927, Pl. 16. [3]Cat. Knaus Sale, 1917, Pl. 45.
The drawing was engraved by J.-C. François. [4]Lavallée, Pl. 1. [5]Uzanne, Pl. 32.

FIG. 5

"FÈTES VÉNITIENNES"
(National Gallery of Scotland)
Cf. Plates 29 and 47

FIG. 6

"L'AMOUR AU THÉÂTRE FRANÇAIS"

From Cochin's engraving after the picture
in the Kaiser-Friedrich-Museum

Cf. Plates 2, 61 and 62

with the piper the most prominent positions in the picture; they connect, the latter directly, the former indirectly, with a drawing preserved in the Goethe Museum at Weimar.[1] The female sketch differs from the picture only in quite subordinate accessories of costume; it resembles, moreover, though in reverse, one of the dancers occurring in the next picture to be discussed. The male figure of the Weimar drawing, on the other hand, does not appear as such in the finished work, though the general motive is essentially the same. Distinct *pentimenti*, however, occur in the picture at this point, and it is probable that the drawing shows the artist's first idea, the subsequent change being perhaps due to his intention to introduce at this point a portrait of the painter Vleughels. His are the features with the aquiline nose appearing in the finished work. The study for this head, along with that of the girl nearest him in the picture, occurs on a drawing reproduced as Plate 285 of the *Différents Caractères;* it is one of the few cases in which Jullienne's engravers refrained from separating the various detached items of a sheet of studies.

The most striking, perhaps, of the subordinate figures are those of a pair of lovers seen between the two dancers in the middle distance. The attitude of the man resembles that of the Berlin sketch,[2] attributed to Lancret, which has already been mentioned (above, p. 16): the girl is notable for appearing not only among the *Différents Caractères* (201), but in three other pictures in addition to the present one: the Dulwich *Plaisirs du Bal*, the Louvre *Assemblée dans un Parc*, and finally *L'Amant repoussé*, this last also including the seated man on the extreme right of the Edinburgh picture. To complete the analysis of the left half of the composition, it need only be added that the remaining female head corresponds to another drawing at Weimar;[3] unlike the other, it is in the collection of the Schloss-Museum (F.d.d.C. 344). In the right half of the picture we again notice figures elsewhere repeated: the statue recurs in *La Récréation Italienne* (D. & V. 198); both the seated women are included in the Louvre *Assemblée*, one corresponding to F.d.d.C. 259 and the other to a drawing in the Koenigs collection; the reclining man, seen from behind, is more prominent in the Dulwich picture. Finally, the standing male figure and the profile head of a child deserve attention. The study for the latter appears on a sheet from the Louvre included among our illustrations (Plate 47); the other, also at Paris, is on a drawing which is a companion to the sheet in the Menier collection, and clearly represents the same model. From these manifold indications it becomes evident that among Watteau's earlier compositions the *Fêtes Vénitiennes* holds a central position. Its component elements are not perhaps all among the master's happiest inventions, but they are nevertheless of great individual importance and are combined in the picture with consummate skill.

L'Amour au Théâtre Français (D. & V. 270). Berlin, Kaiser Friedrich Museum (Figure 6).

Unlike its pendant entitled *L'Amour au Théâtre Italien*, this is another of Watteau's relatively early pictures of special importance in relation to the study of his drawings. Not that the material available is in this case at all abundant, let alone complete, but it opens up vistas of interest, and in that respect differs markedly from the small group of sketches which are connected with its companion. An analysis of the latter affords few positive results. The pierrot, it is true, appears among the *Différents Caractères* (187), but otherwise the only studies for the picture are those of the heads of Mezzetin and the doctor, and of the hands of Pantalon. The two former

[1] Photo by Dr. E. Schilling. [2] Lippmann-Grote, Pl. 110. [3] Prestel I, 14. Uzanne, Pl. 39.

occur on a sheet at Lyons;[1] the latter is one of the motives of a drawing, in the Louvre, which has yet to be discussed in connection with other pictures (Plate 93).

Whether the centre figure of *L'Amour au Théâtre français*, the female dancer resembling the protagonist of *Fêtes Vénitiennes*, was indirectly derived from the same drawing at Weimar is a point which can only be answered conjecturally. The figure is reversed and the costume differs appreciably; it would seem, however, that for the picture under consideration Watteau's methods of work were somewhat different from his usual practice, and that he adapted his preparatory studies more freely than he usually did. Thus a sheet of sketches in an American collection includes the seated musician on the extreme left, and the reclining figure of Bacchus; both, however, agree in their essential motives only—the latter, indeed, is comparatively so remote from the picture that it is by no means readily recognizable. Somewhat similar is a drawing in the possession of Mr. Louis Clarke[2] which shows the male dancer and the standing figure with a sword on the extreme right. Here again, though to a less degree, the accessories are modified: unusual, too, is the way in which a different study was used for the head of the latter figure (see p. 28). In Mr. Clarke's drawing the face is that of a young and rather undistinguished model, while in the picture the much more individual features of Poisson, the actor, are taken over from a drawing in the British Museum (Plate 62). Even more remarkable, but in a different way, is the correspondence between the actor in the part of Cupid (he is seen on the right, facing towards Bacchus) and a figure occurring on a sheet of studies, at New York, which dates back to Watteau's Gillotesque period (Plate 2). Though an appreciable time often separates a picture and the drawings preparatory to it, this use of a sketch dating from the artist's earliest phase is not a little surprising. Something of a curiosity, too, is the resemblance of the vine leaves at the side of Bacchus's throne and the similar motive on a drawing of the Dutuit collection (Plate 61). There can be small doubt that this study was actually used, a fact that is the more remarkable in view of the rare occurrence of sketches of this class.

L'ASSEMBLÉE DANS UN PARC (K.d.K. 45). Paris, Louvre (Figure 7).

As was pointed out in connection with *Fêtes Vénitiennes*, the present work, though of a different type, agrees in several of its principal figures with the Edinburgh picture. Apart from this, its closest relationship is with *L'Ile enchantée* (D. & V. 264), of which the general composition approximates to that of the *Assemblée*, but in reverse. In each picture the landscape background is a sheet of water surrounded by trees, and it is interesting to observe that one of the few purely imaginary landscape sketches by Watteau, that in the Pierpont Morgan Library,[3] shows a similar motive (see above, p. 18). There are points of analogy, too, with the landscape of the *Embarquement*. With this greatest of Watteau's masterpieces the Louvre *Assemblée* has a further link: the upright female figure on the left derives from the same sheet of studies, in the Schiff collection (Plate 53), which includes the seated pilgrim first used in *Bon Voyage* and later incorporated in the *Embarquement* (see below, p. 32). The male figure attendant on the lady in the *Assemblée* is readily recognizable as the first use of a study that was later to serve for the Potsdam *Amour paisible*, and again for the two similar versions of the *Assemblée galante* (below, pp. 34, 38). The drawing, in the Louvre, here reproduced (Plate 93), also includes a kneeling male figure which, though lacking in the *Assemblée*, holds a prominent place in the *Ile enchantée*. Only in a single figure, that of a reclining man seen from the back, is there direct

[1] Cantinelli, Pl. 17. [2] Vasari Soc., II-XII (1931). [3] Morgan Publ., III, 90.

FIG. 7

"ASSEMBLÉE DANS UN PARC"

(*Louvre*)

Cf. Plates 53 and 93

FIG. 8

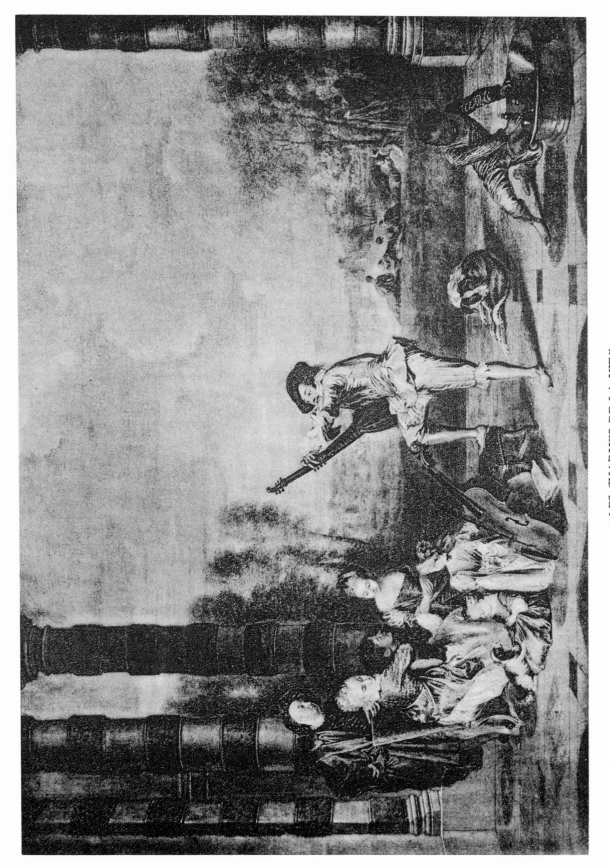

"LES CHARMES DE LA VIE"

(*Wallace Collection*)

Cf. Plates 33, 34, 35, 47 and 51

resemblance between these two pictures. The corresponding drawing, like the picture of the *Ile enchantée* itself, was formerly in the Léon Michel-Lévy collection;[1] on the same sheet is the flute-player on the extreme right of the *Assemblée*. For the rest, the two pictures are merely analogous in general composition, the *Ile enchantée*, on the whole, being the more varied of the two. It includes, besides a second upright couple, the figure of a man stretched on the ground, which was taken from the same drawing, in the Dutuit collection, already mentioned in connection with the studies for *L'Amour au Théâtre français* (Plate 61). The figures in the *Assemblée* recurring in *Fêtes Vénitiennes* are in each case of women, and correspond, one to a drawing in the Koenigs collection, the others to F.d.d.C. 201 and 259. Two figures of children are also included in Jullienne's publication, viz. Nos. 21 and 177.

LES CHARMES DE LA VIE (D. & V. 183). London, Wallace Collection (Figure 8).

This admirable composition, for which an almost complete set of preparatory drawings can be produced, has to be studied in relation to two derivatives, the Potsdam *Concert* (K.d.K. 55), which retains the essential features of its prototype, and the so-called *Music Lesson* (D. & V. 96), likewise in the Wallace Collection, a canvas much smaller and simpler in design. In each case the principal figure is of a musician tuning a stringed instrument; the same study served on each occasion, and only in the last-named composition are the lower extremities omitted. The figure is one of the finest of Watteau's inventions, and it is unfortunate that the sketch has not come to light. It is lacking, too, among the *Différents Caractères;* in the Arsenal copy, however, is the impression of a rejected plate by Audran, which, though of inferior execution, has at least preserved the general aspect of the drawing. Next in prominence is the figure of a woman playing the guitar, corresponding to one of three studies on a single sheet in the Louvre (Plate 35). Around her five other figures are grouped, the studies for three of which are included in our selection of plates: for the standing man with the features of Vleughels, at Frankfurt (Plate 33); for the seated girl, in the British Museum (Plate 34); and for the seated child, in the Louvre (Plate 47). This last is already familiar as a recurrent motive, in one case, it will be remembered, in the reverse direction to the drawing (see above, p. 13). Of the two remaining components of the group, the study for the male head is again in the British Museum (P. 14), while the standing child resembles No. 56 of the *Différents Caractères,* more closely followed in *L'Occupation selon l'Âge* (D. & V. 208).

In the Potsdam picture the group is considerably modified, indeed only the two children remain unaltered. For the guitar player is substituted the figure of a girl with a book of music; this motive also occurs in the smallest of the three versions, in the Wallace Collection, while the drawing is again among the interpolations of the Arsenal *Recueil*. With this figure are grouped two violinists tuning their instruments, one of which corresponds, though with different features, to a drawing last recorded in the Drouot Sale of April, 1909; the other to the matchless sheet of studies which passed from the Doucet to the Donaldson collection, and is now again in Paris (Plate 38). Another drawing of superlative quality connects with the charming head of a child introduced into the *Music Lesson:* it is the sheet of two studies, formerly in the James collection, now one of the treasures of the Morgan Library (Plate 41). Returning for the moment to the *Charmes de la Vie*, we must refer again to one of the most justly celebrated of Watteau's drawings, the studies of negro heads in the Weill collection (Plate 51). One of these probably served as a detail for the kneeling page-

[1] Soc. de Repr. d. Dessins de Maîtres I (1909), Pl. 25.

31

boy, while the entire figure corresponds to No. 24 of the *Différents Caractères*. Finally, it is worth mentioning that the dog is one of the comparatively few cases in Watteau's pictures of a direct adaptation from Rubens (see above, p. 24).

L'EMBARQUEMENT POUR CYTHÈRE (D. & V. 110). Berlin, Schloss-Museum (Fig. 9).

For an adequate understanding of Watteau's greatest masterpiece we must first of all deal with three preliminary versions of the subject before coming to the final work, now at Berlin, the picture reproduced in Tardieu's masterly engraving. The earliest and most rudimentary of these antecedents is a picture entitled *L'Ile de Cythère* (D. & V. 155); it was followed by *Bon Voyage* (D. & V. 35), and the Louvre picture submitted to the Academy in 1717. The Berlin canvas which completes the set is a more elaborate and highly finished derivative of that in Paris. All these works are variations of the same theme: the embarkation of pilgrim lovers for a distant Elysium of ideal happiness—a theme which, as first observed by the eminent French critic, Louis de Fourcaud, derived ultimately from the closing scene of Dancourt's comedy, *Les Trois Cousines*. Certain as is the connection of these pictures, with each other and with Dancourt's play, it is only on approaching them as a sum of individual motives that their derivation and interrelation becomes truly manifest.

That Watteau was acquainted with the plot and characters of Dancourt's play is conclusively shown by certain of his *Figures françaises et comiques* (above, p. 5), the underlines of which name several of the actors and actresses included in the cast. It is probable that he saw the play, first produced in 1700, on the occasion of its revival in 1709; it must have been shortly after that *L'Ile de Cythère* was painted as a direct reminiscence of the stage scene. Two sheets of studies at Frankfurt and Dresden, and the facsimile by Bonnet of a third now lost, enable one to reconstruct the essential features of this obviously still immature composition. The Frankfurt drawing[1] is notable for containing the male pilgrim near the centre, pointing with his left hand, and another, leaning forwards, on the extreme right. The companion of the former appears on the Bonnet[2] print; but what is more important, this figure corresponds to *Mlle. Desmares jouant le Rôle de Pelerine* in the *Figures françaises et comiques*, for which the working drawing is in the Groult collection. If thus early there is a definite link between the play and the earliest version of the *Embarquement* theme, the Dresden drawing carries us even further forward (Plate 3). It shows not only the standing pilgrim occupying the centre of *L'Ile de Cythère*, but also a kneeling figure absent in this picture, but included in *Bon Voyage* and later in both versions of the *Embarquement* proper.

Bon Voyage, if maturer than *L'Ile de Cythère*, is yet less ambitious as a composition. Apart from subordinate figures in the middle distance, it consists of a single group of a kneeling male and seated female pilgrim. The former, we have seen, derives from the Dresden drawing; the latter occurs on a sheet of studies in the Mortimer Schiff collection (Plate 53), along with the standing figure used for the Louvre *Assemblée dans un Parc* (above, p. 30). As the whole group of *Bon Voyage* is incorporated in the *Embarquement*, there is obviously no need to stress their connection; the only problem remaining is whether definitely the smaller picture preceded the larger. The contrary opinion has, in point of fact, found support. It seems, however, almost unthinkable that the meagre composition of *Bon Voyage* should interrupt the crescendo from the Paris to the Berlin picture; but apart from this, the Dresden drawing provides further evidence. While in the *Embarquement* a detail such as the

1 *Stift und Feder*, 1926, Pl. 4. 2 Herold and Vuaflart, I, p. 199.

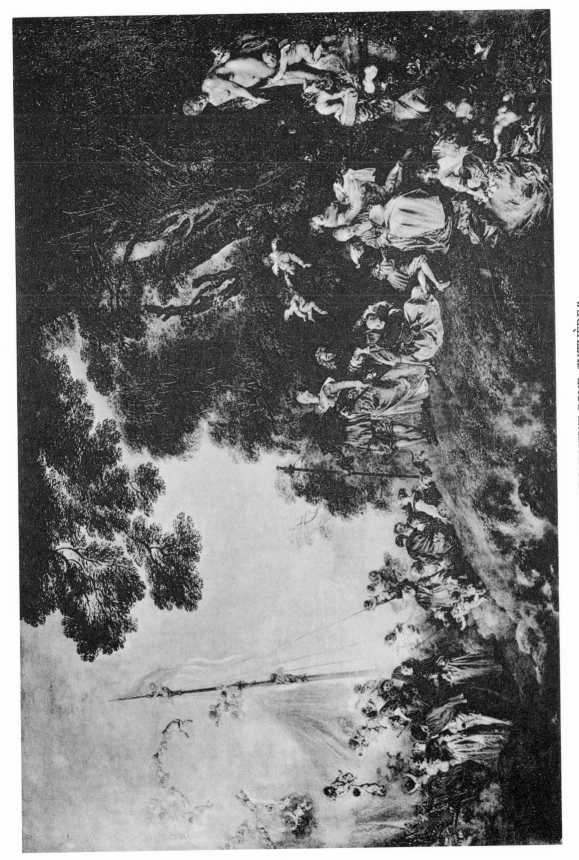

FIG. 9

"L'EMBARQUEMENT POUR CYTHÈRE"

(Berlin, Schlossmuseum)

Cf. Plates 3, 30, 53, 54, 55 and 56

FIG. 10

"LES PLAISIRS DU BAL"

From an unique impression of an undescribed state before letter of
Scotin's engraving (in reverse) after the picture in the Dulwich Gallery.

Hon. Mrs. Pleydell-Bouverie)

Cf. Plates 31, 65 and 66

position of the pilgrim's staff on the ground is freely modified, it is closely followed in *Bon Voyage*. This seems definitely to indicate the priority of the smaller picture.

Proceeding to the Louvre canvas, painted by Watteau for admission to the Academy, we may start by recalling its one extraneous element: the figure of a man seen from behind, in the middle distance, which had previously appeared in *L'Accordée de Village* (see above, p. 27). The sketch for it, it will be remembered, occurs in the Menier drawing (Plate 30). One other drawing connected with *L'Embarquement* has already been discussed at an earlier stage: it corresponds to the group of a cavalier assisting his lady to rise (Plate 55), and has been cited as one of the rare examples of the correlation of figures (above, p. 11). For the adjacent group nearer the centre of the picture there are no drawings known, either single studies or combined; the male figure, however, is repeatedly met with in prints: it was etched by Caylus, by Audran (F.d.d.C. 150), again, but with the indication *Watteau pinxit*, by Desplaces among the *Figures françaises et comiques*, finally in crayon manner by Bonnet with two other figures on the same sheet. We have next to consider a male pilgrim in the middle distance, seen from in front, the drawing for which is in the British Museum (Plate 54). Separate studies of the heads of this man and of the man immediately to the right of the figure repeated from the *Accordée* occur on a drawing preserved in the Louvre;[1] but this to all appearance was used only for the corresponding passages in the Berlin picture, and is therefore probably somewhat later in date. Only one other reference need be added to the preceding: to the group occupying the left of the middle distance in the Louvre picture corresponds one of the offsets in oily pigment mentioned in connection with the subject of counterproofs (above, p. 14). It is preserved at Edinburgh,[2] and is perhaps the most important specimen of its kind.

There are certain omissions from the corresponding group in the later version; for the rest the differences between the Paris and Berlin pictures are almost entirely in the nature of additions to the latter. Thus while the above-mentioned drawings in each case served again, a number of others were either in the interval added to the artist's stock of motives or brought into use for the first time. The most important of these, in the British Museum (Plate 56), corresponds in the picture to the girl holding out her apron, behind the pilgrims of *Bon Voyage*. Apart from its beauty—Watteau was rarely more felicitous in the representation of feminine grace—the figure is notable as a link with other compositions; it recurs exactly in *Amusements champêtres* (D. & V. 126), while two other drawings closely allied to it (Plates 57, 58) served for the *Leçon d'Amour* (D. & V. 263) and *Réunion champêtre* respectively (below, p. 37). But this is not the only conspicuous addition to the right-hand portion of the Berlin *Embarquement*. Thus there is the statue representing a figure of Venus, the drawing for which, were it preserved, would be one of particular interest to the student. Copied, as it was, from an engraving by Marcantonio,[3] it would be comparable to only one other among the studies which Watteau utilized for this picture—that corresponding to the figure of a nude amoretto occurring near the base of the statue. Neither is this of Watteau's invention; it derives from one of the pictures of the Médicis cycle in the Luxembourg, and from an offset, in the Louvre,[4] we may judge in some measure of the quality of the drawing. Another prominent addition is the reclining couple in the foreground to the right, but only the sketch for the girl's head, formerly in the James and Lehmann collections,[5] can definitely be cited as connected with this group. The man's head, like others in the middle distance, shows

[1] Piazza, Pl. 38. [2] Vasari Soc., VII, 30. [3] Kunstchronik, 1923, p. 251. [4] Helleu, Pl. 37.
[5] Cat. Lehmann Sale, 1925, Pl. 174.

analogies to a drawing in the Lugt collection (Plate 52), but the resemblance is probably accidental. One female head, appearing near the mast of the ship around which the pilgrims are assembling, is certainly taken from a drawing in the Louvre.[1] There remains for the rest only the study of two male heads, which has already been spoken of in our description of the Paris picture.

L'Amour Paisible (D. & V. 74). Potsdam, Neues Palais.

We need not pause long over this composition, the essential features of which can be summed up in a few words. The main point of interest in it is the group of seated figures, near the centre, comprising a young man with a guitar and a girl holding a fan. A sketch corresponding to the latter belongs to Herr Koenigs at Haarlem;[2] but what is more interesting and unusual is that among the *Différents Caractères* (178) the group already appears in its entirety. The drawing itself is unfortunately not recorded, but there is no reason to doubt that it existed, and that the artist here combined two separate studies. Another notable group is that of a standing couple on the extreme left, the male figure in particular being important to us. The corresponding study occurs on a sheet in the Louvre already familiar to us (Plate 93); differently paired, the figure recurs in the *Assemblée dans un Parc* (above, p. 30) and the two similar versions of the *Assemblée galante* (p. 38). It is interesting to observe how the artist varied the female figure in each case; on two occasions he used the drawings of the Schiff collection and Musée des Arts-Décoratifs (Plates 53, 90), but for the picture here under consideration he preferred a sketch formerly in the library of Charkow University.[3] Of the finished group the British Museum has an offset[4] similar to that, at Edinburgh, corresponding to a portion of the Louvre *Embarquement*. Yet another example of this type, in the Ricketts and Shannon collection,[5] shows the reclining female seen from behind. The original drawing is included in the *Différents Caractères* (33); a version at Berlin is certainly a copy.

Les Plaisirs du Bal (D. & V. 114). Dulwich Gallery (Figure 10).

In spite of its small size, this is one of the most elaborate of all Watteau's compositions, and contains over fifty figures, each rendered with meticulous precision. A certain number of repetitions occur, for example, a female figure (F.d.d.C. 201) and a reclining man with a guitar, both taken over from *Fêtes Vénitiennes*. The general scheme of composition, however, is different from any other, and the picture is not one that shows clearly the artist's practice of re-grouping his figures, though none is more striking as an example of his compilatory methods. Even quite subordinate details correspond with specific drawings, these being in several instances full-length figures, while in the picture only a head or bust, much reduced in scale, becomes visible. A case in point is that of the female in profile to left below the two caryatids in the right half of the composition. Here the artist made use of the sketch of an entire figure which, until some years ago, was in the Wauters collection.[6] The effect achieved by this extraordinary minuteness is certainly in its way vivid and brilliant, but as in the *Accordée* and notably the *Mariée de Village*, the dangers of excessive elaboration are not entirely overcome.

The most prominent individual figure in the Dulwich picture is that of a female dancer; it corresponds to a sketch in the Teyler Museum (F.d.d.C. 87) and recurs with slight modifications in two other compositions, both of which go under the

[1]Uzanne, Pl. 32. [2]Prestel Soc., Pl. 5. [3]O.M.D., XX, Pl. 51 [4]Vasari Soc., III, 34.
[5]Vasari Soc., III, 33. [6]Lees, Fig. 162.

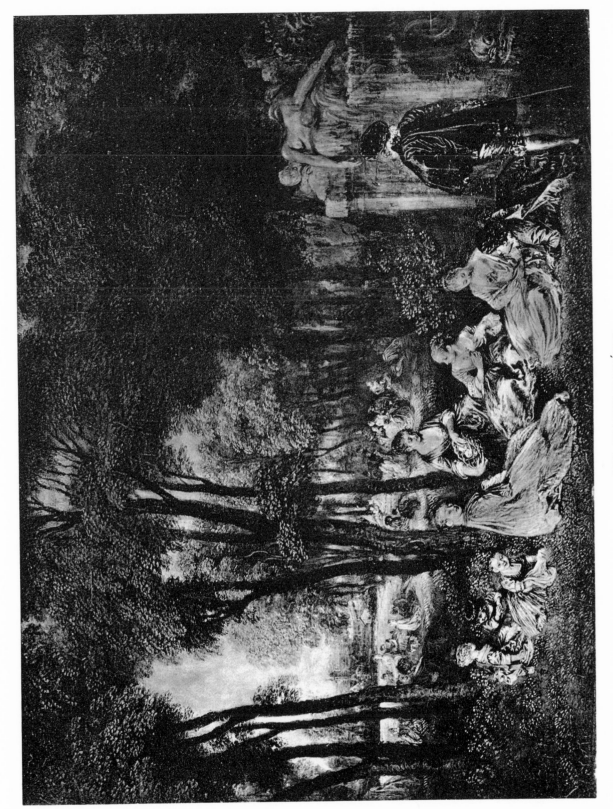

"LES CHAMPS-ELYSÉES"
(*Wallace Collection*)
Cf. Plates 64 and 70

FIG. 12

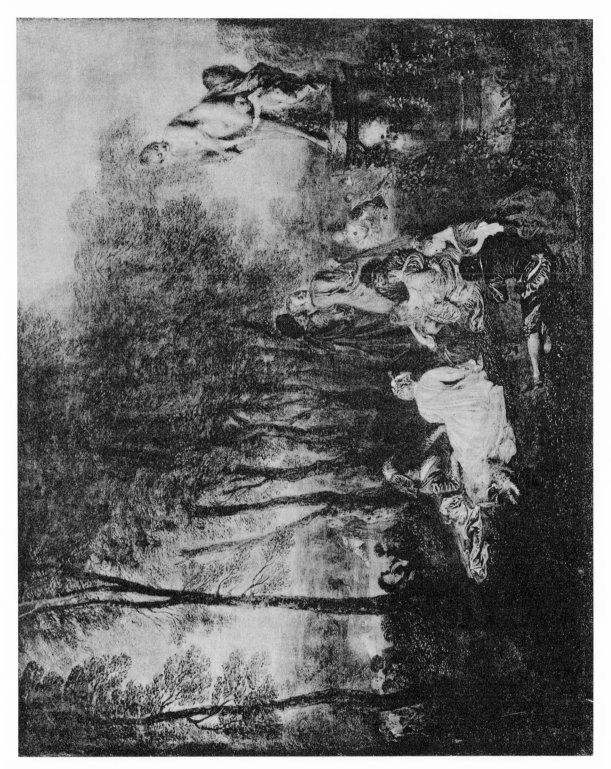

"PLAISIRS D'AMOUR"
(Dresden Gallery)
Cf. Plates 68 and 69

name of *Le Bal Champêtre* (D. & V. 293, 311). To all appearance the drawing was executed at the same time as the sketch for the analogous figure in the Edinburgh *Fêtes Vénitiennes*. The male dancer recalls the Louvre *Indifférent*, and the sketch in the Menier collection which served for it (Plate 30). This latter, however, cannot actually have been used, and there are differences also as compared with the *Bal Champêtre* (D. & V. 311) and the *Danse aux Castagnettes* (D. & V. 307). More important is the man leaning on the back of a lady's chair near the double columns; a masterly sketch for this figure is in the Gay collection (Plate 66). Likewise included in the present selection of plates is the drawing, now M. Weill's, for a woman raising her veil, further towards the right (Plate 65). A detail of particular interest is the small page-boy almost exactly in the centre; this is the figure (see above, p. 13) copied in reverse from Veronese's composition of *Christ and the Centurion*.[1] While at this point we may mention that the seated woman and the child appearing on either side of the page-boy correspond to Nos. 101 and 85 of the *Différents Caractères* respectively, while elsewhere Nos. 7 and 295, both female figures, are readily recognizable. The originals of these have yet to be located. Among the studies used that are still definitely extant is the woman standing in the extreme left corner (private collection, Paris); the two corresponding figures on the other side (Messrs. Agnew and Louvre); the seated woman to left immediately behind the male dancer (Louvre), and the well-known figure of Harlequin (École des Beaux-Arts) (Plate 31). For a number of further details information is at present lacking, but the foregoing references should amply suffice to illustrate the salient features of the composition.

COMÉDIENS ITALIENS (D. & V. 204). Schloss Rohoncz, Coll. of Baron Thyssen.

We have already touched on this composition in connection with the identity of certain of the personages portrayed (above, p. 21). We need not here deal with this topic again, but may content ourselves with examining the figures as such. A number of drawings can be connected with the picture, but the material is at present far from complete.

There are two rough sketches showing groups of comedy figures which, though not exact, are at least distantly connected with the picture under consideration. One of these, in the Musée Jacquemart-André, is here reproduced (Plate 59), the other, formerly in the Marius Paulme collection, has recently passed into the possession of Mr. Irwin Laughlin at Madrid.[2] That the celebrated *Gilles* (K.d.K. 96) is also in the nature of a variation of the principal motive is almost too obvious to need pointing out. A detail less evident than the resemblance of the two pierrots is that one of the female figures of the *Comédiens Italiens* recurs exactly in the Louvre picture. It is the head of a woman, identified as Silvia, the drawing for which, from the James collection, now belongs to Lord Iveagh (F.d.d.C. 82). The two adjacent figures of a Harlequin and a guitar-player are likewise repeated in other pictures; the former (Plate 31) belongs to Watteau's regular stock-in-trade, while the latter reappears in the composition known as *Le Rendez-vous* (D. & V. 174), where it is combined with a figure from one of the Ymecourt drawings (Plate 46). It may be worth mentioning that a drawing of the heads of the Pierrot and guitar-player in the Schiff collection is certainly a copy, drawn, moreover, not from the picture itself, but from Baron's engraving. Two interesting details of the picture are here repro-duced: the slight, but wonderfully vivid study of the man raising a curtain (Plate 60)

[1] Helleu, Pl. 36. [2] Cat. Paulme Sale, 1929, Pl. 176 (No. 260).

and the right arm of Mezzetin extended towards Pierrot (Plate 91). Both are in the British Museum, which also contains further studies for the picture. On the reverse side of Plate 60 are sketches for the hands of Pierrot and Harlequin, while a small drawing of a female head (P. 42) corresponds, though without the hat, to the figure identified as Flaminia. A curious feature about this whole group of sketches is that, with the one exception of the head of Silvia, it was not included in Jullienne's volumes. Even No. 164, a sketch now in the Bayonne Museum,[1] resembling in several ways the figure of Mezzetin, cannot be claimed as directly connected. The drawing actually used is at present lost, but it can still be studied in a good, indeed deceptive, counterproof.[2] The only remaining original that has yet to be mentioned is in the Koenigs collection, and corresponds with the head of the child crouching at the jester's feet. Thus another comparatively subordinate detail of the picture has survived, while many of its more prominent components are no longer accessible.

LES CHAMPS-ELYSÉES (D. & V. 133). London, Wallace Collection (Figure 11).

There is a close connection between this charming composition and a later, much larger canvas, also in the Wallace Collection, though not included in Jullienne's *Recueil* (K.d.K. 98). The correspondence extends to nearly all the principal figures; their relation to the landscape, moreover, is analogous in the two works. A similar prominence, too, is given to nude sculptured figures in both cases, though these sculptures are not identical in detail. That in *Divertissements champêtres*, the larger of the two pictures, repeats a motive from the *Leçon d'Amour* (D. & V. 263), while curiously enough the figure in the *Champs-Elysées* is identical with the Louvre *Antiope* (K.d.K. 43), one of Watteau's masterpieces of nude painting. There are further repetitions, but only two are in themselves of particular note: the crawling child and the standing male figure, both derive from the *Accordée de Village* (above, p. 27), a picture dating back to the artist's early maturity. Of the four singularly beautiful female figures in the *Champs-Elysées*, three recur in the *Divertissements*. To the one seated in the centre a drawing in the British Museum corresponds (P. 30), but this is in itself comparatively slight and uninteresting. Of greater merit is the Chantilly drawing for the figure omitted from the larger composition (Plate 70); it is interesting, too, to recognize in it the same model, similarly dressed, as in the Dresden picture, which we shall shortly proceed to examine (Plate 69). The next point to be noticed, though it is one of detail, claims particular interest. Directly above the head of the woman corresponding to the Chantilly sketch, minute figures of a man and woman, seated on the ground, can be seen: that of the man shows analogies to one in *Le Plaisir pastoral*, but what is more important is that for the female figure the artist made exact use of a sketch (F.d.d.C. 209), occurring on a sheet of studies, otherwise not utilized, in the Schiff collection (Plate 64). Turning now to the *Divertissements champêtres* we find not only these same minute figures, but several others that can also be identified. The first to be noticed is a man playing a flute; he corresponds exactly with a figure in *Les Plaisirs du Bal*, for which the sketch is in the British Museum.[3] Next, the seated woman with her hands crossed in her lap is no other than the figure in *Les Charmes de la Vie* (Plate 34). For the woman seated on the ground, at the feet of the figure just referred to, the artist selected one of the finest of his drawings, a sheet which, curiously enough, served only for this one somewhat insignificant purpose. The sketch in question is that on the left of the wonderful sheet of studies in the Bayonne Museum (Plate 73); typical, as it is of the

[1] Bonnat Publ., 1925, Pl. 50. [2] Vasari Soc., 2nd Series, X. 13. [3] Uzanne, Pl. 5.

36

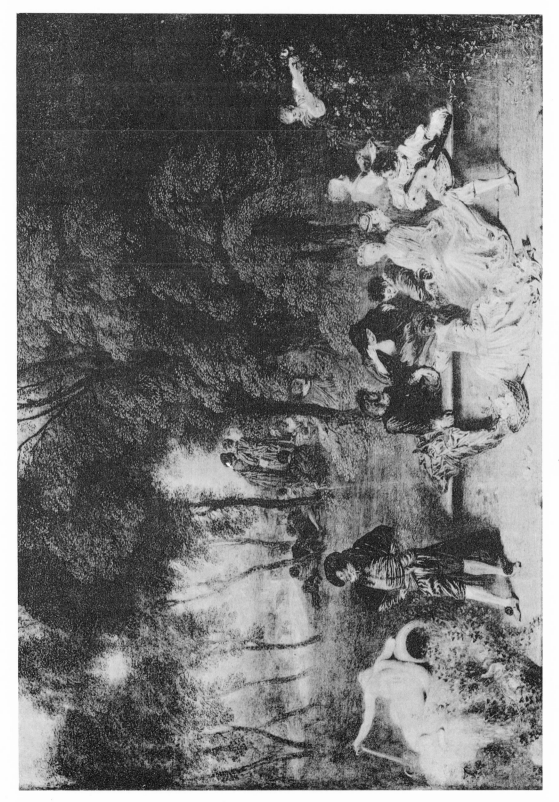

FIG. 13

"RÉUNION CHAMPÊTRE"
(*Dresden Gallery*)
Cf. Plates 57, 58, 59 and 63

Fête galante spirit, it is the more remarkable that Watteau made no further use of it. To pursue the subject of these altogether subordinate points of correspondence between drawings and pictures is clearly unnecessary; but until due attention has been paid to minutiae of this kind, the artist's extraordinary painstaking methods cannot be fully appreciated.

PLAISIRS D'AMOUR (K.d.K. 89). Dresden, Gemälde-Galerie (Figure 12).

The main interest of this picture in relation to our present study is due to the existence of a complete compositional sketch which, though slightly different in certain details, is yet clearly the direct antecedent of the finished work. The drawing in question, which passed from the Doucet to the Fenaille collection (Plate 68), has already been discussed as one of the few definite exceptions to the master's methods of work as described by Caylus (see above, p. 11). Apart from this *esquisse d'ensemble*, however, the picture and its preparatory drawings are in no way anomalous; a number of the figures are readily identifiable, and certain repetitions meet the eye at the first glance. Thus the statue of Venus, which closes the composition on the right-hand side, is immediately recognizable as the figure, derived from Marcantonio, which appears in the Berlin version of the *Embarquement* (above, p. 33). Less familiar is the half-length of a reclining man which, in point of fact, recurs in *La Boudeuse* of the Stroganoff collection (D. & V. 303); but another well-known group is that appearing near the centre of the Dresden picture and representing a seated woman resisting the embrace of a man. With slight changes of detail, the same figures form the independent theme of a small picture known as *Le Faux Pas* (K.d.K. 83), while in a more subordinate position they reappear in *La Danse paysanne* (D. & V. 27). There are no drawings known either for the group as such or for its components, but a detail of the man's hand appears as a masterly sketch on a sheet formerly in the Heseltine collection[1] (see above, p. 23). Only two other extant drawings of high quality are connected with the picture. One of these, in the British Museum (Plate 69), is for the reclining woman, seen from behind; the other, for the head of the woman walking away from the seated figures, appears on a capital sheet, in private ownership, formerly one of the treasures of the de Ganay collection.[2]

RÉUNION CHAMPÊTRE (K.d.K. 87). Dresden, Gemälde-Galerie (Figure 13).

The second of the celebrated pictures of the Dresden Gallery is perhaps the most notable of Watteau's compositions not to appear in Jullienne's *Recueil*. Painted with a singular brilliance of finish, it is both masterly in detail and in its complete effect. Only one figure recurs as a direct repetition, viz. the splendid guitar-player which (singly) had been used for a picture at Chantilly (K.d.K. 28), and (combined with a group adapted from Rubens's *Kermesse*) in a composition known as *La Surprise*, in Buckingham Palace (D. & V. 31). Both these pictures being certainly of an earlier date, the drawing, formerly in the Denon collection (F.d.d.C. 71), (known also in a counterproof, once the property of Miss James),[3] must likewise belong to an earlier stage than that at which the Dresden composition was actually executed. The date of this latter may safely be assumed to be more or less contemporary with the final version of the *Embarquement*. The two figures of girls gathering flowers on the right were obviously conceived at the same time as that added to the Berlin picture after 1717 (Plate 56). For both these figures in the Dresden composition the preliminary drawings are still in existence. One is preserved in the museum of the artist's native town (Plate 57); the other, in the Dormeuil collection, shows a further

[1] Guiraud, Pl. 83. [2] Cat. de Ganay Sale, 1922, Pl. 27. [3] Bethnal Green Publ., Pl. 8.

study from the same model which was not used (Plate 58). For the singularly beautiful figure of a girl seated on the ground, near the centre of the composition, only Audran's etching (F.d.d.C. 188) is at present available; but another important original, at Chantilly, corresponds to the figure directly above the last-mentioned, and represents a girl raising a veil from her face (Plate 63). If drawn, as it appears to be, at the same sitting as the similar motive in M. Weill's collection (Plate 65), its date would be fixed by the Dulwich picture (above, p. 34). Before leaving this part of the Dresden *Réunion*, it should be mentioned that the male figure to right of that corresponding to the Chantilly drawing derives from a sheet of studies in the British Museum.[1] The child's figure near by has been connected by certain writers with No. 83 of the *Différents Caractères* (the original of which was formerly in the Doucet collection), but actually it must be based on another similar sketch, which was neither engraved nor has been as yet located. A drawing in the Cognacq Museum,[2] in reverse to the Doucet figure, is certainly a copy made after the etching. In the left-hand section of the picture the principal figure is a standing man, the counterpart to one in the *Champs-Elysées* (above, p. 36). His gaze is directed on another of those sculptured figures to which reference has been made in connection with the *Champs-Elysées* and its companion in the Wallace Collection. The present figure occurs, somewhat unexpectedly, on the sheet representing a group of comedians, in the Musée Jacquemart (Plate 59), which resembles the motive of the picture in Schloss Rohoncz (p. 35). Whether it was drawn from memory or from sight is hard to decide; in the latter case the indication of a dolphin alongside the figure proves clearly enough that it must have been from an actual sculpture, not from an undraped model as in the case of the *Antiope* and her derivative. It will be remembered that in at least one case a known piece of sculpture can be identified among Watteau's sketches (see above, p. 25).

ASSEMBLÉE DANS UN PARC (K.d.K. 105). Berlin, Kaiser Friedrich Museum.
(Figure 14.)

This is another example of a composition existing in two versions; the Berlin picture stands in a similar relation to one now lost, but engraved by Le Bas under the title *Assemblée galante* (D. & V. 139), as does the Chantilly *Plaisir Pastoral* to *Les Bergers* at Potsdam. For convenience we may start by recording these points of resemblance. Common to both is firstly the central male figure, a guitar player somewhat similar to that in the last picture dealt with. The drawing, in the British Museum (Plate 91), is one of the finest of that collection. Next the three male figures appearing in the right-hand section of the composition. These belong together not only by reason of their occurrence in both versions of the *Assemblée*, but also because they were clearly drawn from the same model, and are found united on a single sheet of studies in the Louvre (Plate 93). The kneeling figure, it will be remembered, and that on the extreme right of the drawing, have already been mentioned in connection with the Louvre *Assemblée dans un Parc* and the Potsdam *Amour paisible* (above, pp. 30, 34). The third is remarkable for its inclusion among the *Différents Caractères* (118), not, however, as a single figure, but paired with its companion as in the finished pictures. This latter figure is the only remaining detail of direct correspondence, for, although similar, neither of the two other females which go together with the other male figures of the Louvre drawing are actually the same in the two

[1]O.M.D., XVII, Pl. 3. [2]Guiraud, Pl. 95.

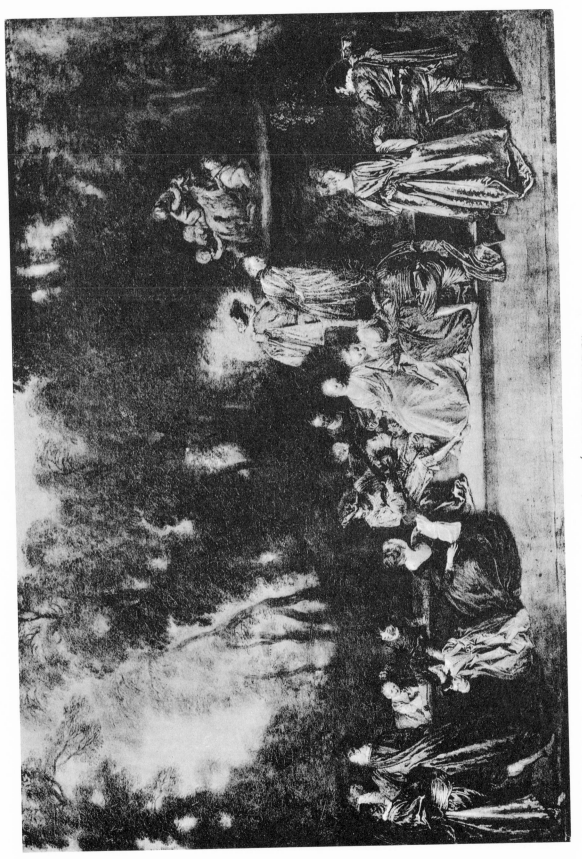

FIG. 14

"ASSEMBLÉE DANS UN PARC"

(*Kaiser-Friedrich-Museum*)

Cf. Plates 90, 91 and 93

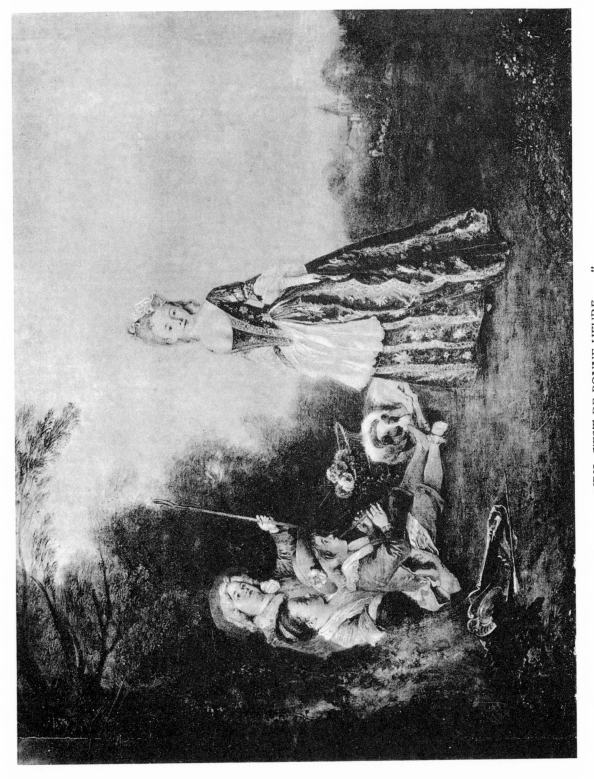

FIG. 15

"IRIS, C'EST DE BONNE HEURE . . ."

(Potsdam, Neues Palais)

Cf. Plates 85 and 86

cases. While for the standing woman in the Berlin version the artist used a drawing in the Musée des Arts-Décoratifs (Plate 90), the corresponding figure in the engraved version resembles a rough and somewhat indifferent sketch at Stockholm. As to the seated figures, the only drawing known is a detail for the hand holding a fan, again in the Berlin picture. This occurs on the same sheet, formerly in the Léon Michel-Lévy collection,[1] to which reference has been made in relation to *L'Ile enchantée* (above, p. 31). Another such detail that calls for notice is the dog held by the little girl on the left. This derives from the charming sheet of sketches in the Helleu Sale,[2] (above, p. 23), and recurs exactly in *Le Conteur* (D. & V. 4) and *L'Amour paisible* (D. & V. 268). Two further components of the Berlin composition are elsewhere repeated: the corner figure on the left (F.d.d.C. 271) recurs in *Le Bosquet de Bacchus* (D. & V. 265), and the seated woman at the feet of the guitar player in *La Gamme d'Amour* (D. & V. 199), in the National Gallery. The drawing for this last passed from the possession of Miss James into the Groult collection;[3] a deceptive offset is in the British Museum.[4] A word finally on the sculptured group in the background to the right. For this the artist made use of a drawing, now in the British Museum,[5] which also shows the same sculpture from the angle at which it is seen in *La Cascade* (D. & V. 28), and furthermore a seated female figure which is of interest in connection with the *Assemblée galante*.

Truly this sketch shows no direct correspondence to the composition engraved by Le Bas, but in reverse it presents remarkable analogies to the figure, which actually was taken from No. 51 of the *Différents Caractères*. The original of the latter was one of the treasures of the Doucet collection, while the male figure next to it appears on the lovely sheet of studies of the Blumenthal collection (Plate 92). It should be noted that the whole of this group recurs (with minor alterations) in the picture engraved as *La Famille* (D. & V. 86). The one remaining original that is accessible (Plate 47) need not again be discussed in detail: it is the figure of a child in the group on the right of the engraving, to which repeated allusions have been made elsewhere (above, pp. 13, etc.). Its three companions can also readily be identified: two date back to the *Accordée* of the Soane Museum, where they are prominently placed as foreground figures; the older seated girl, finally, corresponds to the charming study No. 37 of the *Différents Caractères*. It is significant that it was etched by Boucher, for there are several others by him connected with this composition,[6] and it would definitely appear that Jullienne entrusted Boucher with what he considered the finest of the examples he selected. The inference thus suggested is amply justified; we here see Watteau in one of his happiest moments, and the individual merit of the figures is no less notable than that of the composition as a whole.

<div align="center">* * *</div>

Akin to the studies that have been dealt with in the preceding pages, and yet definitely in a category of their own, are the drawings which, though outwardly of the *Fête galante* class, show no actual connections with known pictures. Their number is by no means inconsiderable, and from the examples included among the plates of this volume, it is clear enough that they cannot have been rejected by the artist as being of inferior quality. The reason why in fact they were not used must remain a matter of speculation, but two obvious explanations suggest themselves, namely,

[1] Soc. de Repr. d. Dessins de Maîtres, I (1909) Pl. 25. [2] Cat. Helleu Sale, 1928, Pl. 86.
[3] O.M.D., XVII, Pl. 6. [4] Uzanne, Pl. 24. [5] Uzanne, Pl. 26. [6] Besides the above, there is F.d.d.C. 22).

that Watteau's premature end prevented his using them, or that the drawings in question may have passed out of his possession so that he was unable to employ them further. It is obviously unnecessary to emphasize the fact that, quite especially as a painter, Watteau's career was anything but completed. As to the second point, certain casual remarks in Caylus's discourse shed interesting light on its relevancy. Without giving specific details, Caylus speaks of the importunities of a class of *soi-disants curieux* who force their way into artists' studios and appropriate what loose drawings or sketches they can. It is clearly implied that Watteau was often thus molested, and although in no one case can we go beyond conjecture, it is safe to assume that the point has definite significance. That after the master's death his drawings were divided among his friends has already been mentioned in the testimony of Gersaint (above, p. 7). The bulk, to all appearance, passed either directly or through intermediate channels into Jullienne's possession. Few, unfortunately, are individually described in the catalogue of the Jullienne Sale, in fact the summary indications in the majority of eighteenth-century listings are a constant hindrance to the researches of the student concerned with these minor points of historical association.

Many writers have been at pains to express the beauties of Watteau's draughtsmanship, but few have attained even a remote suggestion of its transcendent delicacy and bloom. Only in the pages of the brothers Goncourt has the vehicle of language proved equal to the task. *Quel dessinateur, en effet, a mis en des dessins rapides et de premier coup le je ne sais quoi indicible, qu'y met Watteau? Qui a sa grâce de crayonnage piquante? qui a la science spirituelle d'un profil perdu, d'un bout de nez, d'une main? . . . Voyez, sur toutes ces têtes d'hommes et de femmes, l'espèce de piétinement qu'y fait ce crayon revenant sur l'estompage, avec des sabrures, des petits traits géminés, des accentuations épointées, des tailles rondissantes dans le sens d'un muscle, des riens et des bonheurs d'art qui sont tout—un tas enfin de petits travaux de verve et d'inspiration trouvés devant le modèle, animant le dessin de mille détails de nature, vivifiant presque la teinte plate du plat papier, du relief et de l'épaisseur d'une touche: . . . C'est de la sanguine qui contient de la pourpre, c'est du crayon noir qui a un velouté a nul autre pareil, et cela mélangé de craie, avec la pratique savante et spirituelle de l'artiste devient, sur du papier chamois, de la chair blonde et rose.*

*

* *

FIG. 16

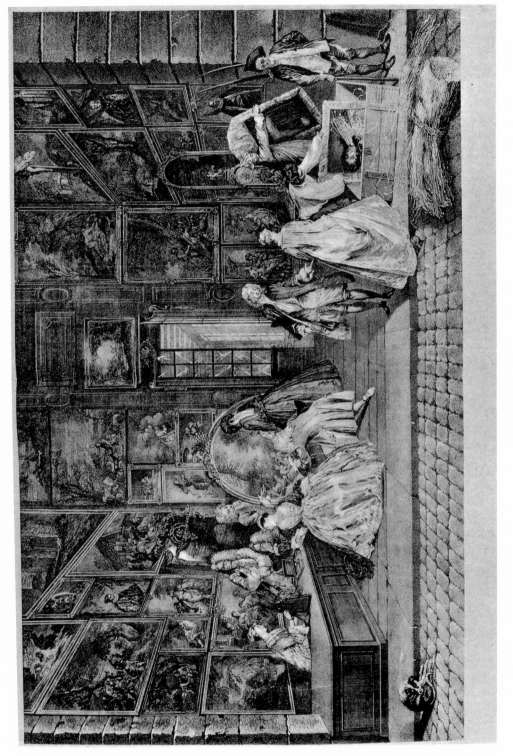

"L'ENSEIGNE"

From an unrecorded impression of the state before letter of Aveline's
engraving (in reverse) after the picture in the Schlossmuseum, Berlin.

(Hon. Mrs. Pleydell-Bouverie)

Cf. Plate 100

CATALOGUE OF PLATES

FRONTISPIECE: FOUR STUDIES OF THE HEAD OF A YOUNG WOMAN. London, British Museum (P. 17). Collections: Utterson; Robinson; Malcolm. Sanguine of two shades, black and white chalks; 331:238.

None of these studies was used for pictures or included among the *Différents Caractères*. For peculiarities of medium and handling, see above pp. 12-13. A somewhat similar sheet is at Stockholm, another in the Groult collection, and the copy of a third in the British Museum (P. 16).

TITLE-PAGE: SELF-PORTRAIT. London, Mrs. Otto Gutekunst. Black and red chalks; 117: 94. Etched by Filleul in *Livre de différents Caractères de Têtes*, Pl. 4. See *Apollo*, XII (1930), No. 72, p. 400.

1. LE MEUNIER GALANT. Paris, Musée Jacquemart-André. Collection: Chennevières (Lugt 2072). Red chalk; 210: 290.

 F.d.d.C. 249 (Boucher sc.). An early work in Gillotesque style. The drawing shows notable differences of detail as compared with Boucher's etching. A closer rendering is the rejected plate by Jullienne himself in the Arsenal copy of the *Différents Caractères* (G. 626; between Plates 90 and 91).

2. VARIOUS FIGURE STUDIES. New York, Pierpont Morgan Library. Collection: Fairfax Murray. Red chalk; 165: 205.

 The two reclining figures appear in the Madrid picture *Les Jardins de Saint Cloud* (K.d.K. 9), which has recently been attributed by J. Guiffrey to Watteau's imitator, P.-A. Quillard (*Gazette des B.-A.*, VI-I, 1929, p. 72). The theatrical figures above are probably characters in a comedy by Dancourt. The man on L. closely resembles a figure on the counterproof of a drawing by Gillot, in the Louvre, illustrating Dancourt's *Les Vendanges*. It is also similar to *Dumirail en Habit de Paysan* (D. & V. 57) and *Le Vendangeur* (D. & V. 79). The third figure from L. connects with *L'Amour au Théâtre français* (D. & V. 270), for the interpretation of which see Herold and Vuaflart, I, p. 64.

3. THREE STUDIES OF PILGRIMS. Dresden, Kupferstichkabinet (Woermann, X, 1). Collection: Woodburn. Red chalk; 155: 210.

 The standing figure occurs in *L'Ile de Cythère* (D. & V. 155); a copy was in the Drouot Sale, 28 Nov., 1927, lot 13. The kneeling figure, but without the angel, occurs in *Bon Voyage* (D. & V. 35) and both versions of *L'Embarquement pour Cythère* (K.d.K. 59 and D. & V. 110). A companion drawing is at Frankfurt (*Stift und Feder*, 1926, Plate 4); see above, p. 32.

4. A LADY SEATED. Stockholm, National Museum (Lugt 1638). Collection: Tessin. Red chalk; 113 :74.

5. A LADY STANDING. Cambridge, Mr. L. C. G. Clarke. Collections: Maria Cosway; College of *Dame Inglesi* at Lodi; Fairfax Murray. Red chalk; 113: 74.

 The seated figure, engraved by Thomassin fils, was placed by Jullienne among the plates of the *Figures de Modes* (D. & V. 45), but probably belonged originally to the *Figures françaises et comiques*. See Herold and Vuaflart, I, p. 74. The standing figure was etched with minor differences by Watteau himself (G. 7), the plate being afterwards re-worked by Thomassin fils and included in the *Figures de Modes* (D. & V. 51). See above, pp. 5, 16. Both figures occur without accessories among the *Différents Caractères* (Nos. 307, 308).

6. THREE STUDIES OF SOLDIERS. Anonymous private ownership. Red chalk; 155: 202. Inscribed *A Watteau* below to L. in an eighteenth-century hand (*cf.* below, No. 47).

 F.d.d.C. 175; 243; 174 (J. Audran sc.). The centre figure occurs in *Recrue allant joindre le Régiment* (D. & V. 178). See above, p. 17.

7. TWO STUDIES OF SOLDIERS. Paris, Louvre (Guiffrey-Marcel 5638, as Lancret). Red chalk; 141:138. F.d.d.C. 126 (E. Jeaurat sc.) and 289 (J. Audran sc.). Further studies from the same model are F.d.d.C. 14, 242, 287. Likewise classified in the Louvre as Lancret are the originals of F.d.d.C. 135 and 269.

8. THREE STUDIES OF SOLDIERS. Berlin Print Room (Lippmann-Grote 105). Red chalk; 174: 200.

 The first and second figures correspond to F.d.d.C. 257 and 189 (J. Audran sc.), and were perhaps, but not certainly, used for *Départ de Garnison* (D. & V. 276) and *Escorte d'Équipages* (D. & V. 125) respectively.

9. STUDIES OF THE BACK VIEW OF A SEATED WOMAN. London, British Museum (J.C.R. 492; P. 3). Collections: Huquier (Lugt 1285); Dimsdale; Woodburn; Utterson; Robinson (Lugt 1433); Malcolm. Red chalk; 183: 251.

The figure in the L. lower corner occurs in *Escorte d'Équipages* (D. & V. 125). See above, p. 17.

10. A YOUNG SAVOYARD. Paris, Palais des Beaux-Arts (Dutuit collection). Collections: Robinson (Lugt 1433); Doucet. Red and black chalks; 323:200.
 F.d.d.C. 6 (Boucher sc.). The figure occurs in reverse in a picture at Leningrad (K.d.K. 1) engraved by B. Audran as *La Marmotte* (D. & V. 122). See above, p. 13.

11. AN OLD SAVOYARD, STANDING. Bayonne, Musée Bonnat. Collections: ? Jullienne; Bonnat (Lugt 1714). Black and red chalks; 325:180.
 F.d.d.C. 253 (anonymous). F.d.d.C. 20 shows the same figure rather more from in front; it may be to this drawing that No. 769 of the Jullienne catalogue refers. The same model is represented seated in D. & V. 42, a plate belonging originally to the *Figures françaises et comiques*, but placed by Jullienne among the *Figures de Modes*. The preliminary drawing is reproduced below, Plate 12. A drawing in the Koenigs collection shows the Savoyard displaying his peep-show; the same motive, but with the man kneeling, was used for the title-page of the second volume of the *Différents Caractères*.

12. AN OLD SAVOYARD, SEATED. Florence, Uffizi. Collection: Santarelli (VI, 8368). Black and red chalks; 224:151.
 See note to preceding drawing. Besides the small engraving by Jeaurat belonging to the *Figures françaises et comiques*, the drawing was etched by Caylus (G. 368) and, in the same sense as the original, by Boucher (G. 369), these plates being rejected by Jullienne, but preserved in the Arsenal *Recueil*. A counterproof of the drawing is at Stockholm. On the back is the mutilated draft of a letter connected with inscriptions on P. 7 in the British Museum, and a drawing formerly in the possession of Mr. A. Birrell, now in the Strauss collection, New York.

13. A FRIAR, STANDING. Anonymous private ownership. Collections: Jullienne (769); Brisart; James; Heseltine. Red, black and white chalks; 340:235.
 F.d.d.C. 34 (Boucher sc.). The suggestion of M. Schéfer that the figure is that of Gillot in a friar's dress is purely fanciful.

14. A PILGRIM, STANDING. Paris, Palais des Beaux-Arts (Dutuit collection). Collections: Warwick (Lugt 2600); Doucet. Red and black chalks; 372:251.
 A peculiarity both of this and the preceding drawing is the high position of the eye-point.

15. ORNAMENTAL DESIGN. Leningrad, Hermitage. Collections: Stieglitz; Beurdeley (Lugt 421). Red chalk; 280:185.
 D. & V. 141 (Huquier sc.). A companion to this drawing, corresponding to D. & V. 283 and coming from the same collections, was offered for sale at Leipzig in 1931 (Boerner Cat., CLXXI, Pl. 21), but bought in.

16. DESIGN FOR AN INTERIOR DECORATION. Florence, Uffizi. Collection: Santarelli (VI, 8369). Red chalk; 210:320.
 See below, Plate 88. On the back of the drawing is a group of grotesque heads, one of the few examples of caricature in Watteau's work. See above, p. 26. (This and Plate 12 were kindly brought to the author's notice by Mr. J. Byam Shaw.)

17. TWO STUDIES OF HEADS AFTER RUBENS. London, Mr. Henry Oppenheimer. Collection: Cunard. Red and black chalks; 150:200.
 The female head is that of Marie de Médicis in the penultimate subject of the Luxembourg cycle (*The Interview of the Queen and her Son*). The sketch on the R. is that of the huntsman blowing his horn in the Vienna picture of the *Hunting of the Calydonian Boar* (K.d.K. 216).

18. HEAD OF A YOUNG LADY, AFTER ? RUBENS. Haarlem, Herr Franz Koenigs. Collections: Mariette (No. 1393; Lugt 2097); Czeczowiczka. Black and red chalks; 310:228.
 The drawing is still on Mariette's mount and has the inscription *E. Rubenio/desumptum/opus/ Ant. Watteau*. Possibly, however, the original was by Van Dyck. There is a general resemblance to the portrait of Geronima Spinola in the Kaiser Friedrich Museum.

19. A WOMAN RECLINING, RAISING A GLASS. Paris, Musée Cognacq-Jay (No. 186). Collections: Spengler (Lugt 1434); Doucet. Red, black and white chalks; 170:194. Inscribed *Wateau* below to L. in an eighteenth-century hand.
 For the composition of *Autumn* in the Crozat *Seasons*. See Fig. 1 and below, No. 20.

20. THE YOUTHFUL BACCHUS. Paris, Mr. Walter Gay. Collection: Goncourt. Black, red, white chalks; 280:200.

42

For the composition of *Autumn* in the Crozat *Seasons*. See above, No. 19. Facsimile by *Société de Reproduction des Dessins de Maîtres*, III (1911), Pl. 31.

21. NUDE MALE FIGURE. Paris, Louvre (33360). Collection: Huquier (Lugt 1285). Black, red and white chalks; 245: 298.
 Study for the figure of Jupiter in the Louvre picture of *Jupiter and Antiope* (K.d.K. 43). The attitude is clearly inspired by a figure in Van Dyck's *Carrying of the Cross*, in St. Paul's at Antwerp, for which the study is in the Witt collection, London.

22. HEAD OF A MAN. Paris, M. Georges Dormeuil. Collections: Mailand; Henri Michel-Lévy. Red, black and white chalks; 200: 170.
 Drawn from the same model as the preceding figure.

23. LANDSCAPE WITH ANIMALS. Maartensdijk, Mr. Frits Lugt. Collections: Bibliothèque Doucet; Bourgarel; Rodrigues. Red chalk; 210: 300.
 This is almost certainly one of the copies which Watteau made of sixteenth-century Italian drawings in Crozat's collection. See above, p. 25. The original, strongly Giorgionesque in character, was probably an early work of Titian.

24. THE FINDING OF MOSES. Paris, École des Beaux-Arts. Collections: Saint; Boilly; Armand-Valton. Red chalk; 214:303.
 Pierre Lavallée is right in emphasizing the Venetian influence in this drawing, and in suggesting a date about 1715-17, when Watteau was studying in Crozat's collection. On his copying the *Finding of Moses* by Veronese in the Cabinet du Roi, see above, p. 25. Compare also Mariette's remark to Gaburri on the lack of *dessins historiés* (above, p. 9).

25. VISTA DOWN AN ALLEY OF TREES. Leningrad, Hermitage. Collection: Grassi. Red chalk; 210: 170.
 F.d.d.C. 40 (Boucher sc.). Probably a view of Crozat's park at Montmorency; *cf*. F.d.d.C. 256 and D. & V. 172; also an etching by Caylus with a similar alley of trees (repr. *L'Amateur d'Estampes*, VI, 1927, p. 53).

26. A FARMSTEAD. Bayonne, Musée Bonnat. Collection: Bonnat (Lugt 1714). Red chalk; 145: 207.
 Facsimile in *Dessins de la Collection L.B.*, I (1925), No. 55. See above, p. 18.

27. LANDSCAPE WITH BUILDINGS. Bayonne, Musée Bonnat. Collections: Crozat (Lugt 2951); Bonnat (Lugt 1714). Red chalk; 179: 271.
 Facsimile in *Dessins de la Collection L.B.*, I (1925), No. 56. See above, p. 18.

28. A GIRL ON A SWING. Elveden Hall, Rt. Hon. the Earl of Iveagh. Collections: Spencer (Lugt 1530); James. Red and black chalks; 165: 133.
 F.d.d.C. 260 (Boucher sc.). The figure occurs in *Le Plaisir Pastoral*, at Chantilly (D. & V. 209), and in *Les Bergers*, at Potsdam (K.d.K. 85). See above, p. 26.

29. TWO STUDIES OF A PIPER. Paris, Louvre (33382). Collection: Devéria. Red chalk touched with black and white; 271: 222.
 The figures connect with *Les Bergers* (K.d.K. 85), *Fêtes Vénitiennes* (D. & V. 6) and *L'Accordée de Village* (D. & V. 116); see above, pp. 26-8. The model is clearly the same man (La Tourillière) appearing on the Berlin drawing, below, plate 76. See above, p. 20.

30. FOUR STUDIES OF A MALE FIGURE DANCING. Paris, M. Gaston Menier. Collections: Ymecourt; Goncourt. Red, black and white chalks; 250: 370.
 The first figure corresponds to F.d.d.C. 18 (Cochin sc.). The second, for the Louvre, *Indifférent* (D. & V. 129), resembles F.d.d.C. 102 (Boucher sc.), but a closer rendering of it is the rejected plate by Cochin in the Arsenal *Recueil* (G. 467). Cochin likewise etched the third and fourth figures, but both were rejected by Jullienne (G. 439 and 445). The attitude of the first figure resembles that of the dancer in *La Danse Paysanne* (D. & V. 27), but the correspondence is not exact. The fourth figure was used for *L'Accordée de Village* (D. & V. 116) and for both versions of *L'Embarquement pour Cythère* (K.d.K. 59 and D. & V. 110).

31. VARIOUS STUDIES OF FIGURES AND HEADS. Paris, École des Beaux-Arts. Collections: Guichardot; Armand-Valton. Red, black and white chalks; 230: 354.
 The figure to L. is a preliminary study of *La Finette*, in the Louvre (D. & V. 128), with which, however, F.d.d.C. 54 is more closely connected. The figure in centre appears in *La Contredanse* (D. & V. 177) and in the Angers picture (K.d.K. 154), where the head resembles the study above in centre. The Harlequin appears in D. & V. 95, 114, 309 and 311; in D. & V. 309 one also finds the head below to R., belonging to a figure to which a drawing at Stockholm, there classified as Lancret, corresponds.

32. POISSON EN HABIT DE PAYSAN. London. British Museum (P. 11). Collection: G. Raphael Ward. Red and black chalks; 338: 187.

Corresponds in the same direction but on a much larger scale to F.d.d.C. 202 (Audran sc.). The same figure occurs, engraved by Desplaces, among the *Figures françaises et comiques* (D. & V. 55); the working drawing for the print is at Stockholm. The person represented is Philippe Poisson, the actor, in the part of Blaise in Dancourt's *Les Trois Cousines*. See *Old Master Drawings*, XVII, p. 19, No. 11.

33. A MAN, STANDING. Frankfurt a. M., Staedelsches Institut. Red chalk and pencil; 291: 180.

Facsimile in the Frankfurt Drawings Publ. II, 4. As recorded in an old, very faint inscription below to R., the man portrayed is Nicolas Vleughels, the painter. See Plate 63 and above, p. 21. The figure occurs in *Les Charmes de la Vie*, in the Wallace Collection (D. & V. 183). On the back of the drawing is a landscape sketch, also reproduced in the publication of Staedel drawings.

34. A LADY, SEATED. London, British Museum (P. 21). Collections: Utterson; Robinson (Lugt 1433); Malcolm. Red chalk and pencil; 155: 94.

F.d.d.C. 266 (Boucher sc.). Like the preceding and one of the figures in the next plate, connected with *Les Charmes de la Vie* (D. & V. 183). See also above, p. 36.

35. THREE STUDIES OF A SEATED WOMAN. Paris, Louvre (774). Collection: His de la Salle (Lugt 1333). Black and red chalks; 230: 290.

F.d.d.C. 117 (the figure on L.; B. Audran sc.); F.d.d.C. 284 (the other two figures together; J. Audran sc.). The figure on L. occurs in *Les Charmes de la Vie* (D. & V. 183); the one in centre in the Leningrad picture *La Proposition Embarrassante* (D. & V. 274).

36. A LADY, SEATED. London, British Museum (P. 20). Collections: Utterson; Robinson (Lugt 1433); Malcolm. Black chalk and pencil; 154: 93.

F.d.d.C. 152 (J. Audran sc.). The attitude recalls the preceding. On the technical peculiarity of the drawing, see above, p. 12.

37. A LADY, SEATED. New York, Mr. George Blumenthal. Collection: James. Red, black and white chalks; 210: 133.

F.d.d.C. 19 (Tremolière sc.). The figure occurs in *La Perspective* (D. & V. 172).

38. TWO STUDIES OF A MAN TUNING A VIOLIN. Paris, Private Collection. Collections: Doucet; Donaldson. Black and red chalks; 295: 210.

Facsimile in *Société de Reproduction des Dessins de Maîtres*, II, 5. The lower study was used for the Potsdam *Le Concert* (K.d.K. 55). See above, p. 31.

39. A LADY SEATED, TUNING A LUTE. Chantilly, Musée Condé. Collection: Aumale (Lugt 2779). Pencil and red chalk; 175: 135.

F.d.d.C. 184 (J. Audran sc.). The prominence of pencil-work is exceptional.

40. STUDY FOR LE CONTEUR. Cleveland, U.S.A., Museum. Collection: James. Red, black and white chalks; 350 : 272.

With the exception of the head repeated as a separate study, the drawing corresponds to the picture *Le Conteur* in the Rothschild collection (D. & V. 4). See above, p. 11. Two separate studies of the female figure alone were in the Flameng Sale, 26th May, 1919 (Lot 161).

41. STUDIES OF TWO LITTLE GIRLS. New York, Pierpont Morgan Library. Collection: James. Red, black and white chalks; 187 : 245.

The figure to R., clearly from the same model as the following drawing, occurs in *Pour nous prouver que cette belle*, in the Wallace Collection (D. & V. 96). See above, p. 31.

42. HEAD AND SHOULDERS OF A LITTLE GIRL. Orleans, Museum. Collection: Belot. Red and white chalks; 165 : 115.

Compare the preceding drawing, used for *L'Amour paisible* (D. & V. 268), where the child is holding the little dog, appearing on the sheet from the Helleu collection (above, p. 23) and grouped with P. 46, in the British Museum. For the lute player of this picture, see above, p. 24.

43. THREE STUDIES OF A WOMAN'S HEAD. Paris, Comte Greffuhle. Collections: Dimsdale; James; Josse. Red, black and white chalks; 230 : 310.

A similar head to that on L. occurs in *La Troupe Italienne* (D. & V. 85) and Watteau's etching, G. 1. The woman portrayed has been traditionally identified with the actress, Marie-Anne de Châteauneuf, known as Mlle. Duclos, but as she was born in 1665 or earlier, the conjecture is plainly untenable. Compare the following drawing, and see above, p. 22.

44. TWO STUDIES OF A WOMAN'S HEAD. London, British Museum (P. 28). Red and black chalks; 173 : 156.

44

The profile head corresponds to F.d.d.C. 261 (Caylus sc.). The other was used for *Le Concert Champêtre* (D. & V. 72).

45. SHEET OF STUDIES WITH NINE HEADS. Paris, Palais des Beaux-Arts de la Ville. Collections: ? Jullienne; Rutter; Dutuit (cp. Lugt 709). Red, black and white chalks; 270 : 420.

The two male heads, clearly drawn from the same model, were used for the pictures *L'Enchanteur* and *L'Aventurière* (D. & V. 11, 12); that on L. also for *Leçon d'Amour* (D. & V. 263). *Cf.* also F.d.d.C. 131 and 46. The reclining woman, below in centre, occurs in the Angers *Concert Champêtre* (K.d.K. 154, wrongly rejected).

46. SIX STUDIES OF FIGURES AND HEADS. Paris, Louvre (33385). Collections: Jullienne (771 b); Ymecourt. Red, black and white chalks; 270 : 380.

The female figures facing to L. and below in centre were used for *La Lorgneuse* and *Le Rendez-vous* respectively (D. & V. 13, 174). The male head, third from L., occurs in *L'Accordée de Village* (D. & V. 116). The model for this head and that next it on R. occurs also in *Fêtes Vénitiennes* (D. & V. 6) and F.d.d.C. 66; the man in R. lower corner is the same as F.d.d.C. 115, a head occurring on a sheet in the Musée Bonnat.

47. VARIOUS STUDIES. Paris, Louvre (33366). Red and white chalks; 271 : 400. Inscribed below to L. *Ant. Watteau* in an eighteenth-century hand (cp. above, No. 6).

For the pictures with which the study of a child below in centre is connected, see above, p. 13. The study in R. lower corner was used for *Fêtes Vénitiennes* (D. & V. 6). For the Pierrot's head, cp. D. & V. 114, F.d.d.C. 323, etc., and for the female head, above in centre, D. & V. 26; but in no case is there direct correspondence. The same little girl as in R. upper corner occurs on a drawing belonging to the Earl of Harewood.

48. NINE STUDIES OF HEADS. Paris, Louvre (33384). Collections: Jullienne (771); Ymecourt. Red, black and white chalks; 250: 381.

The profile head to L. (above, second from L.) corresponds fairly closely, in reverse, to F.d.d.C. 224 (Lépicié sc.), but the etching was possibly from another, similar, drawing of the same model. The man's head resembles Plate 45, above.

49. SHEET OF STUDIES MOSTLY OF HEADS. Rouen, Musée-Bibliothèque. Red, black and white chalks; *c.* 205 : 265.

The head in R. upper corner occurs, with the hands, in *L'Indiscret* (D. & V. 121), and, without the hands, in *Sous un habit de Mezzetin* (D. & V. 131). See above, p. 22. The studies of heads to L. and R. of the hands both occur in *Voulez-vous triompher des Belles?* (D. & V. 84), in the Wallace Collection. The male head, above, second from L., is again from the same model as in Plates 45 and 48.

50. A WOMAN SEATED AND THREE STUDIES OF HEADS. Rouen, Musée-Bibliothèque. Red, black and white chalks; *c.* 160 : 200.

None of these studies was used for pictures or reproduced by Jullienne. Clearly of the same group of drawings as the preceding. Two further drawings by Watteau at Rouen correspond to F.d.d.C. 1 and G. 447.

51. THREE STUDIES OF A NEGRO'S HEAD. Paris, M. David Weill. Collections: Mariette (Lugt 2097); James; Bonn. Black and red chalks; 243 : 271.

Facsimile in colours in the Vasari Society, VIII, 32. See above, p. 20. A counterproof is at Stockholm; see above, p. 13. The head above to R. was used for *Le Concert Champêtre* (D. & V. 72) and probably also for *Les Charmes de la Vie* (D. & V. 183).

52. SEVEN STUDIES OF HEADS. Maartensdijk, Mr. Frits Lugt. Collections: Goncourt; Hodgkins. Red, black and white chalks; 220 : 280.

There are resemblances to, but no direct correspondence with, various heads in *L'Embarquement* (D. & V. 110). The female head in upper L. corner was used for *Les Entretiens Badins* (D. & V. 95). The third head from L. in the upper row corresponds exactly with that of the figure etched on a reduced scale, F.d.d.C. 211 (Dr. N. Beets), and closely resembles the portrait of the wife of Philippe Mercier in the family group etched by the latter.

53. THREE STUDIES OF A FEMALE FIGURE. New York, Mr. Mortimer L. Schiff (deceased). Collections: Auguste; Schwiter; Josse; Doucet; Donaldson; Burn. Red, black and white chalks; 264 : 320.

The centre figure appears in *Bon Voyage* (D. & V. 35) and both versions of the *Embarquement* (D. & V. 110 and K.d.K. 59); see above p. 32. The standing figure on the R. occurs in the Louvre *Assemblée dans un Parc* (K.d.K. 45). A figure in *Les Plaisirs du Bal* (D. & V. 114), the drawing for which is in a Paris collection, is also similar, but not identical, nor has F.d.d.C. 205 any direct relation.

54. STANDING MALE FIGURE. London, British Museum (P. 24). Collection: Salting. Red chalk; 206 : 105.

Study used for the Louvre *Embarquement* (K.d.K. 59) and repeated with slight modifications in the Berlin version (D. & V. 110). A separate study of the head occurs on a sheet in the Louvre (33381).

55. A CAVALIER HELPING A LADY TO RISE. London, British Museum (P. 26). Collections: ? Jullienne; James; Salting. Red, black and white chalks; 336 : 226.

Facsimile in Vasari Society, 2nd series, XI, 12. Study for the Louvre *Embarquement* (K.d.K. 59) and repeated with slight modifications in the Berlin version (D. & V. 110). See above, pp. 11, 33.

56. TWO STUDIES OF A FEMALE FIGURE TURNED TO R. London, British Museum (P. 25). Red and black chalks; 209: 148.

The lower figure occurs in the Berlin *Embarquement* (D. & V. 110), also in *Amusements champêtres* (D. & V. 126). From the same model as the two following sketches.

57. A KNEELING WOMAN HOLDING OUT HER APRON. Valenciennes, Museum. Black and red chalks; 170 : 125.

Occurs, like the following drawing, in the Dresden *Réunion champêtre* (K.d.K. 87). It is clearly related to the lower figure of the London drawing (above No. 56), and should also be compared with a slight sketch of a kneeling figure on the Louvre sheet, No. 33381.

58. TWO STUDIES OF A FEMALE FIGURE. Paris, M. Georges Dormeuil. Collections: Alliance des Arts (Lugt 61); Watson; James; Josse; Cronier. Black, red and white chalks; 258 : 208. Inscribed *Vateau* below to R. in an eighteenth-century hand.

Facsimile in the *Société de Reproduction des Dessins de Maîtres* III, 29. The standing figure occurs in *Leçon d'Amour* (D.&V. 263) and in the Dresden *Réunion champêtre* (K.d.K. 87). See above, p. 37.

59. A GROUP OF COMEDIANS AND THE STATUE OF A FEMALE FIGURE. Paris, Musée Jacquemart-André. Collections: Crozat (Lugt 2952); Roqueplan; Chennevières. Red chalk; 140 : 178.

The sculptured figure occurs almost unchanged in the Dresden *Réunion champêtre* (K.d.K. 87). The group of actors recalls *Comédiens Italiens* (D. & V. 204).

60. A MAN RAISING A CURTAIN. London, British Museum (P. 43 rev.). Collection: Deffett-Francis (Lugt 1447). Red chalk; 148 : 225.

Study used for *Comédiens Italiens* (D. & V. 204), as were also the sketches of hands on the *recto*. This is one of the rare cases of important drawings occurring back-to-back on the same sheet; see above, p. 14.

61. STUDIES OF FIGURES, ETC. Paris, Palais des Beaux-Arts de la Ville. Collections: Doucet; Dutuit. Red, black and white chalks; 225 : 364.

The two male figures correspond to F.d.d.C. 153 and 282 respectively (Boucher sc.). The former occurs in *L'Ile enchantée* (D. & V. 264), the latter in the Angers *Concert champêtre* (K.d.K. 154). A similar branch of vine is found in *L'Amour au Théâtre français* (D. & V. 270); see above, pp. 30, 31.

62. STUDIES OF HEADS. London, British Museum (P. 15). Collections: Spencer (Lugt 1530); Vaughan. Black, red and white chalks; 234 : 300.

The male head occurs in *L'Amour au Théâtre français* (D. & V. 270), and is clearly the same face as that of Crispin in *Comédiens français* (D. & V. 205), identified by Herold and Vuaflart as the actor, Paul Poisson (I, p. 64). See above, p. 30. For the second head from L. *cf.* the three following drawings.

63. STUDIES OF A SEATED WOMAN AND OF THE HEAD OF A MAN. Chantilly, Musée Condé. Collection: Aumale (Lugt 2779). Black and red chalks and pencil; 155 : 215.

The female figure (F.d.d.C. 176; Boucher sc.) occurs in the Dresden *Réunion champêtre* (K.d.K. 87). The male head is a portrait of the painter, Vleughels; see above, p. 21, and *cf.* Plate 33. F.d.d.C. 128 is after a similar but more finished sketch; F.d.d.C. 285 shows the head in profile.

64. THREE STUDIES OF A FEMALE FIGURE. New York, Mr. Mortimer L. Schiff (deceased). Collection: Doucet. Red and black chalks and pencil; 226 : 176.

The two upper figures correspond to F.d.d.C. 294 and 209 (J. Audran sc.). The figure above to R. appears on a small scale in the middle distance of *Les Champs-Elysées* (D. & V. 133) and the *Divertissements champêtres*, also in the Wallace Collection (K.d.K. 98).

65. HEAD AND SHOULDERS OF A WOMAN. Paris, M. David Weill. Collections: Huquier (Lugt 1885); Mayor (Lugt 2799); Gower; Heseltine. Black and red chalks; 180 : 120.

46

F.d.d.C. 286 (Boucher sc.). The figure occurs (with minor changes in the position of the hand) in *Les Plaisirs du Bal*, at Dulwich (D. & V. 114). For other drawings of the same model, *cf.* the preceding and F.d.d.C. 72, 208 and 252.

66. THREE STUDIES OF A MALE FIGURE. Paris, Mr. Walter Gay. Collections: Ymecourt; Schwiter; Josse. Red and white chalks; 265 : 382.

 Facsimile in *Société de Reproduction des Dessins de Maîtres* III (1911), 32. The figure on R. occurs in *Les Plaisirs du Bal* (D. & V. 114), but has only a general resemblance to two others somewhat similarly posed in *La Recréation Italienne* (D. & V. 198) and *La Perspective* (D. & V. 172). The drawing for the latter was in the Henri Michel-Lévy collection. Observe the inscription *doublure*, below in centre; see above, p. 14.

67. STUDIES OF TWO MUSICIANS, ETC. Oxford, Ashmolean Museum (Lugt 2003). Collection: Chambers Hall (Lugt 551). Red and white chalks; 260 : 365.

 The two figures of musicians occur in the same grouping in *La Contredanse* (D. & V. 177); see above, p. 11. In handling the drawing is similar to the preceding.

68. FÊTE GALANTE. Paris, M. Maurice Fenaille. Collections: Chennevières; Doucet. Red chalk and pencil; 194 : 264.

 Similar in type to drawings in the Louvre (H. de la S. 773) and the Ricketts and Shannon collection, but unique in that it connects with a known picture. The composition is essentially the same as the Dresden *Plaisirs d'Amour* (K.d.K. 89); see above, pp. 11, 37.

69. WOMAN SEATED ON THE GROUND, SEEN FROM THE BACK. London, British Museum (P. 31). Collections: Utterson; Robinson (Lugt 1433); Malcolm. Red and black chalks and pencil; 146 : 181. Inscribed *AW* in minute letters in upper L. corner.

 F.d.d.C. 161 (Boucher sc.). The figure occurs in the Dresden *Plaisirs d'Amour* (K.d.K. 89); see above, p. 37.

70. TWO RECLINING FEMALE FIGURES. Chantilly, Musée Condé. Collection: Aumale (Lugt 2779). Red and black chalks and pencil; 155 : 235.

 The figure on L. occurs in *Les Champs-Elysées* in the Wallace collection (D. & V. 133); see above, p. 36. In the Musée Condé is another similar sheet of studies of the same woman; *cf.* also the preceding drawing.

71. A WOMAN, SEATED ON THE GROUND. Paris, Musée Cognacq-Jay (191). Collection: H. Michel-Lévy. Black and red chalks; 158 : 209.

 The figure was not reproduced by Jullienne or used in a picture. One of the finest examples in which the use of black chalk dominates the sanguine; see above, p. 12.

72. A WOMAN, SEATED ON THE GROUND. Chantilly, Musée Condé. Collection: Aumale (Lugt 2779). Red chalk; *c.* 200 : 195.

 The figure was not reproduced by Jullienne or used in a picture. Clearly the same model as in the following drawing.

73. TWO STUDIES OF A WOMAN, SEATED ON THE GROUND. Bayonne, Musée Bonnat. Collections: Schwiter; Bonnat (Lugt 1714). Red, black and white chalks; 190 : 262.

 The study on the left seems to have been used for one of the small figures in the middle distance of the Wallace Collection *Divertissements champêtres* (K.d.K. 98); see above, No. 64.

74. PORTRAIT OF A MAN ON CRUTCHES. London, Messrs. Ricketts & Shannon. Red chalk; *c.* 210 : 160.

 It may reasonably be conjectured that the man represented was the artist's friend, Antoine de La Roque, who was wounded in the left leg at the battle of Malplaquet. There is a distinct resemblance to the portrait engraved by Lépicié (D. & V. 269). Another portrait-drawing that should be compared was in the Bourgarel sale (Hôtel Drouot, 13 Nov. 1922, Lot 156).

75. PORTRAIT OF THE MUSICIAN, J.-F. REBEL. Paris, M. David Weill. Collections: Chiquet de Champ Renard; Morel de Vindé; Rohan. Red, black and white chalks with touches of pastel; 460 : 350.

 Engraved by Moyreau in the *Œuvre gravé* (D. & V. 104). Facsimile in the *Société de Reproduction des Dessins de Maîtres*, V (1913), 3. See above, pp. 12, 13, 21.

76. TWO STUDIES OF THE ACTOR, LA TOURILLIÈRE. Berlin, Kupferstichkabinet (Lippmann-Grote 103). Collections: Jullienne; Suermondt. Black, red and white chalks; 258 : 370.

 The figure on L. corresponds to F.d.d.C. 69 (Boucher sc.); a copy of the head appeared on a drawing in the Hodgkins Sale (1914, Lot 45). The figure R. corresponds to F.d.d.C. 198 (Boucher sc.), but the hat is omitted. See above, p. 4. The Arsenal impression of the latter etching has an annotation wrongly identifying the sitter as Abbé Haranger, whereas there are lettered impressions inscribed *La Tourillière*. See Herold and Vuaflart, I, p. 117; above, p. 21, and *cf.* Plate 29.

77. VARIOUS STUDIES OF MALE HANDS. Anonymous, private ownership. Collection: Bardac. Red chalk; 170 : 250.
 The studies were probably made from the hands of La Tourillière, the actor. None seem to have been used for pictures; see above, p. 23.

78. STUDY OF THE HANDS OF A MAN PLAYING THE BASS VIOL. Berlin, Kupferstichkabinet. Collections: Tassaert (Lugt 2388); Knaus. Red and black chalks; 248 : 157.
 The study was not used, but should be compared with *Assis auprès de toi* (D. & V. 3) and *Le Concert Champêtre* (D. & V. 72); see above, p. 23. A drawing of a double-bass player is in the Koenigs collection.

79. STUDIES OF FEMALE HANDS. Berlin, Kupferstichkabinet. Collection: Matthes (Lugt 2871). Red chalk; 89 : 161.
 A similar sketch of a hand holding a mask occurs on a sheet with studies of heads in the Louvre (No. 33383); there are also similar motives in *Coquettes qui pour voir . . .* (D. & V. 36) and *La Sultane* (D. & V. 214).

80. A WOMAN RECLINING ON A CHAISE LONGUE. Maartensdijk, Mr. Frits Lugt. Collections: Bull; Heseltine. Black and red chalks; 210 : 310.
 A drawing (? copy) in the Koenigs (ex Rodrigues) collection, though similar to the present one, differs in the position of the head and arm, the cast of the draperies, etc. *Cf.* also F.d.d.C. 212.

81. A WOMAN, SEMI-NUDE, RECLINING ON A CHAISE LONGUE. Paris, Mr. Walter Gay. Red, black and white chalks; *c.* 175 : 206. Inscribed below to L. *Watteau oui*.
 Facsimile in *L'Illustration*, Christmas 1927. Closely related to the preceding and following drawings.

82. NUDE FIGURE OF A WOMAN, SEATED ON A CHAISE LONGUE. London, British Museum (P. 50). Collections: James; Salting. Black and red chalks; 225 : 254. Inscribed below to R. *Watteau oui*.
 The figure occurs in *La Toilette* in the Wallace Collection (K.d.K. 50). See above, p. 22. The inscription is the same as on the preceding drawing.

83. A WOMAN, SEMI-NUDE, SEATED ON A CHAISE LONGUE. London, British Museum (P. 49). Collections: ? Jullienne; Ottley (Lugt 2664); Lawrence (Lugt 2445); Woodburn. Red and black chalks; 341 : 221. Inscribed *Watteau* in ? Jullienne's hand below to L.
 See above, p. 14. Should be compared with Plates 58, 80-82.

84. NUDE FEMALE TORSO. Paris, Louvre (33361). Collection: Huquier (Lugt 1285). Red and black chalks; 283 : 233.
 The suggestion that this drawing was made in connection with the Crozat *Seasons* is plainly in defiance of chronology.

85. A CHILD'S HEAD IN PROFILE TO R. Paris, Musée Cognacq-Jay (187). Collections: Lawrence (Lugt 2445); Woodburn; Addington; Heseltine. Red and black chalks; 190 : 140.
 The head occurs in the Potsdam picture *Iris, c'est de bonne heure. . . .* (D. & V. 76). In the picture the child is blowing a flute.

86. SIX STUDIES OF HEADS. Cambridge, Mass.; Mr. Paul J. Sachs. Collection: Spencer Churchill. Red, black and white chalks; 224 : 220.
 Facsimile in the Vasari Society, IX, 27. The boy's head in upper L. corner occurs in *Iris, c'est de bonne heure* (D. & V. 76); *cf.* the preceding drawing. The girl's head in centre recurs almost exactly on a sheet of studies in the Louvre; see below, Plate 87.

87. FIVE STUDIES OF A WOMAN'S HEAD. Paris, Louvre (33368). Red, black and white chalks; 217:229.
 The head above in centre corresponds to F.d.d.C. 349 (Caylus sc.), that in L. lower corner should be compared with the preceding drawing.

88. HOUNDS AND DEAD GAME. Haarlem, Herr Franz Koenigs. Collection: Spencer (Lugt 1530). Red chalk; 217 : 158.
 The shape suggests a decorative panel, probably designed for a hunting-box. Similar still-life motives occur in *Retour de Chasse* (D. & V. 19) and *Rendez-vous de Chasse* (D. & V. 213), but this is the only example of its kind among Watteau's drawings. See above, p. 26.

89. THREE STUDIES OF A HOUND. Paris, Musée Cognacq-Jay (196). Collections: Jullienne; James; H. Michel-Lévy. Stamped in R. lower corner with the mounter's mark, Lugt 1042.
 The uppermost study was used for *Rendez-vous de Chasse*, in the Wallace collection (D. & V. 213); see above, p. 23.

90. A WOMAN SEEN FROM BEHIND. Paris, Musée des Arts-Décoratifs. Collection: Perrin. Black and red chalks; *c.* 225 : 120.

F.d.d.C. 334 (Boucher sc.). The figure occurs in the *Assemblée dans un Parc* in the Kaiser Friedrich Museum (K.d.K. 105). A similar drawing, but larger and certainly a copy, is in the Louvre (33376). See above, p. 39.

91. TWO STUDIES OF A GUITAR PLAYER. London, British Museum (P. 44). Collections: Spencer (Lugt 1530); White. Red, black and white chalks; 244 : 379.

The figure on L. occurs in *Assemblée Galante* (D. & V. 139) and the Berlin version of the same composition (K.d.K. 105), also in *La Game d'Amour*, in the National Gallery (D. & V. 199); see above, p. 38. The figure on R. corresponds to a picture formerly in the Murray-Scott collection. The study of an arm was used for *Comédiens Italiens* (D. & V. 204); see above, p. 36.

92. STUDIES OF A MALE AND FEMALE FIGURE. Paris, Mr. George Blumenthal. Collections: Lallemand; Léon Michel-Lévy. Black, red and white chalks; 235 : 350. Inscribed *Watteau* and *Vataux fec* in the lower corners.

The male figure occurs in *La Famille* (D. & V. 86) and *L'Assemblée Galante* (D. & V. 139); see above, p. 39. The female figure was not used or reproduced by Jullienne.

93. THREE STUDIES OF A MALE FIGURE, ETC. Paris, Louvre (33365). Red and white chalks; 270: 312.

The three figures all occur in *Assemblée Galante* (D. & V. 139) and the Berlin version of the same composition (K.d.K. 105). The figure on R. also appears in the Louvre *Assemblée dans un Parc* (K.d.K. 45; connected with the drawing in the Schiff collection, above Plate 53) and the Potsdam *Amour paisible* (D. & V. 268; connected with the drawing formerly in the Charkoff Library). The study of hands leaning on a stick was used for *Amour au Théâtre Italien* (D. & V. 271).

94. A CHILD, SEATED IN A CHAIR. Paris, M. David Weill. Collections: James; Heseltine. Black, red and white chalks; 170 : 120.

The figure does not occur among the *Différents Caractères* or in any known picture. It belongs, like the following drawing, to the group of Watteau's domestic figures.

95. A LITTLE GIRL SEWING. Elveden Hall, Rt. Hon. the Earl of Iveagh. Collection: James. Red and black chalks; 230 : 165.

F.d.d.C. 36 (B. Audran sc.). Recalls the picture *Occupation selon l'Âge* (D. & V. 208), a late work in which Watteau anticipates the domestic genre of Chardin.

96. AN ENGRAVER AT WORK. London, British Museum (P. 51). Collections: Howard; Wicklow. Red chalk; 235 : 304.

The traditional identification of the man represented as Bernard Baron was refuted by Herold and Vuaflart (I, pp. 92-3), who suggest that he was perhaps Nicolas Dorigny. Possibly, but not certainly, of Watteau's period of residence in England.

97. TWO HALF-LENGTH STUDIES OF A WOMAN. London, British Museum (P. 52). Collections: Robinson; Malcolm. Black and red chalks; 291 : 171.

The watermark in the paper being English (coat of arms of the City of London), the drawing was almost certainly made during Watteau's residence in England, 1719-20. An old inscription on the back, *Singulari disegni di Vatò*, makes it probable that this was the drawing of *due teste belle a maraviglia*, sent by Mariette on behalf of Jullienne to the Florentine collector, Gaburri; see above, p. 9.

98. AN ORIENTAL, SEATED, FACING TO R. London, Victoria and Albert Museum. Collection: Dyce. Red and black chalks; 290 : 195.

F.d.d.C. 215 (Boucher sc.). Attributed until recently to Lancret; see *Old Master Drawings*, XIV, p. 27. Probably of earlier date than the following.

99. A TURK, IN PROFILE TO L. Haarlem, Teyler Museum. Black and red chalks; 248 : 211.

F.d.d.C. 156 (Boucher sc.). See *Old Master Drawings*, XVI, p. 68, and above, pp. 16, 20.

100. TWO STUDIES FOR L'ENSEIGNE. Paris, Musée Cognacq-Jay (195). Collections: Clément de Ris; H. Michel-Lévy. Red, black and white chalks; 170 : 228.

One of the latest of Watteau's drawings, made for *L'Enseigne*, painted in 1720. See above, pp. 15-16. The only other known drawing connected with this picture, a female figure seen from behind, was likewise in the Michel-Lévy collection (F.d.d.C. 121). Its date is possibly earlier. The man on L. is engaged in packing up a portrait of Louis XIV, the explanation for this being that Gersaint's shop was named *Au grand Monarque*, and that the old *enseigne*, substituted by Watteau's, bore the effigy of the King.

INDEX OF PLATES

PLATE 1

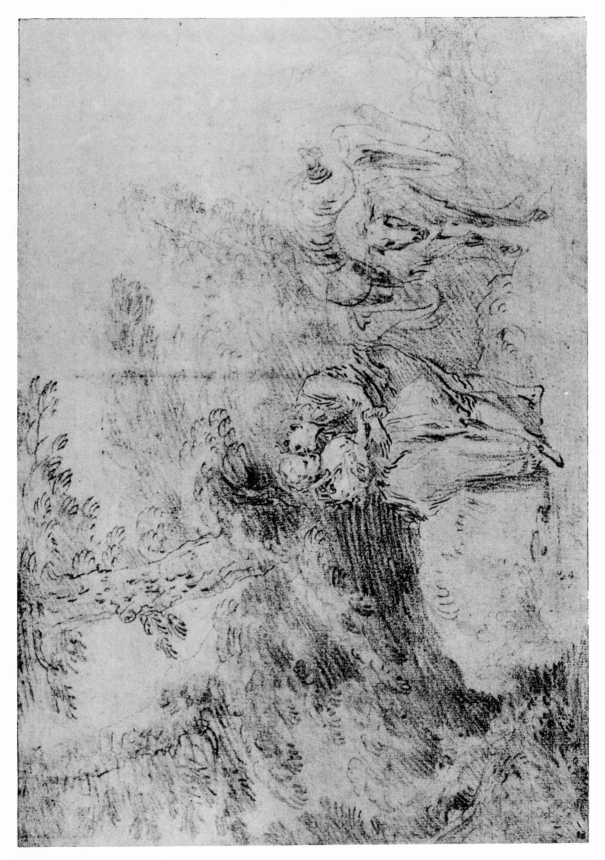

"LE MEUNIER GALANT"
(Musée Jacquemart-André)

PLATE 2

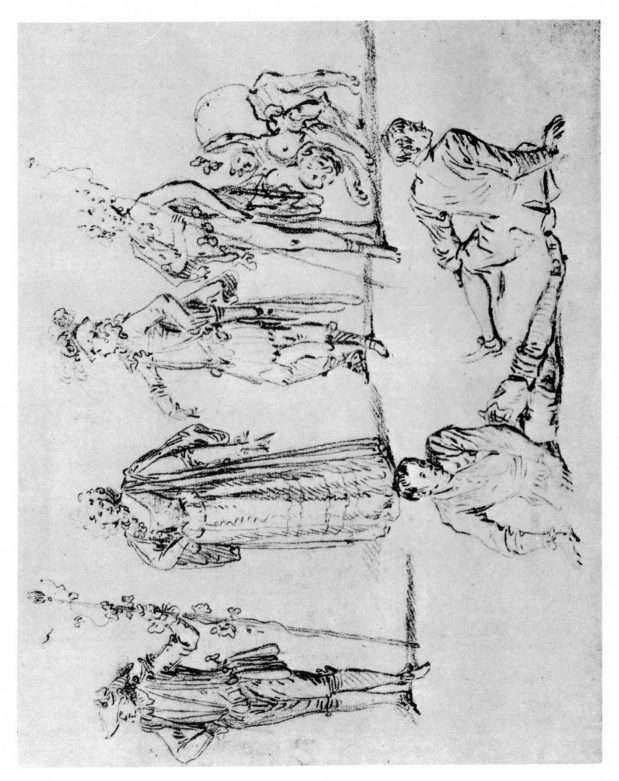

FIGURE STUDIES
(Pierpont-Morgan Library)

Cf. Fig. 6

PLATE 3

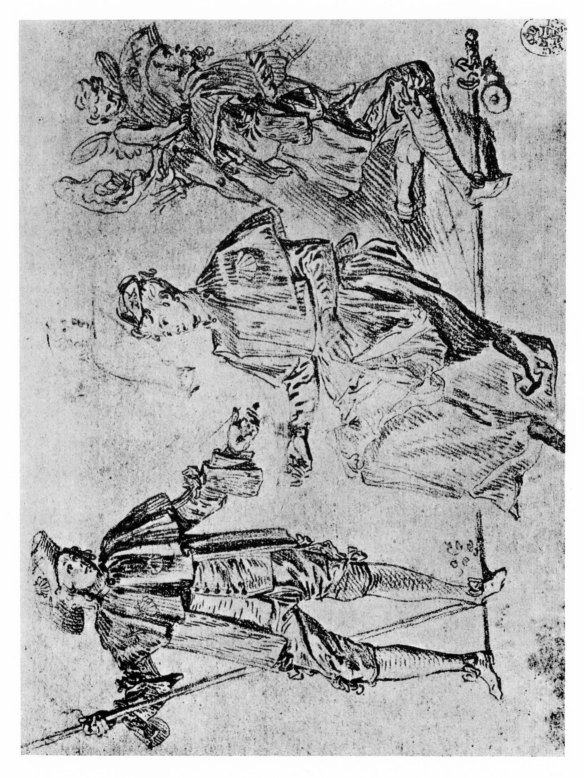

FIGURE STUDIES
Dresden Print Room
Cf. Fig. 9

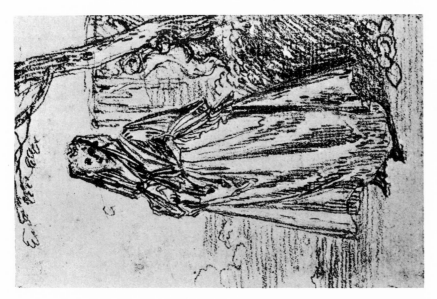

A LADY STANDING
(Collection Mr. L. C. G. Clarke)

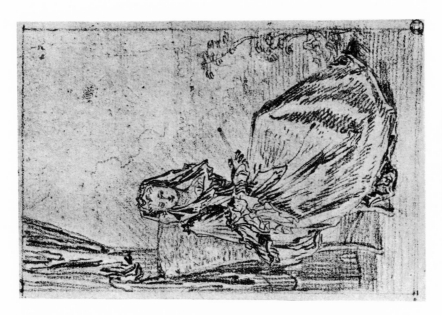

A LADY SEATED
(National Museum, Stockholm)

PLATE 6

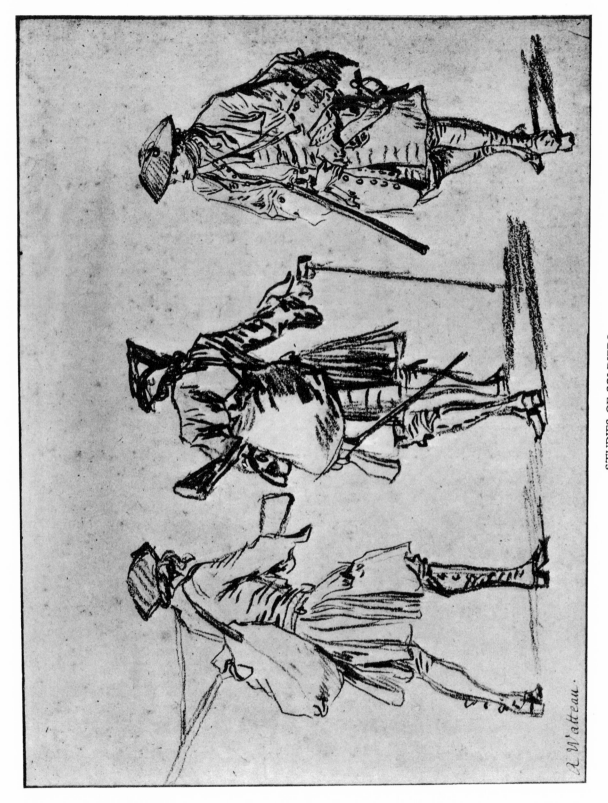

STUDIES OF SOLDIERS
(Anonymous Private Collection)

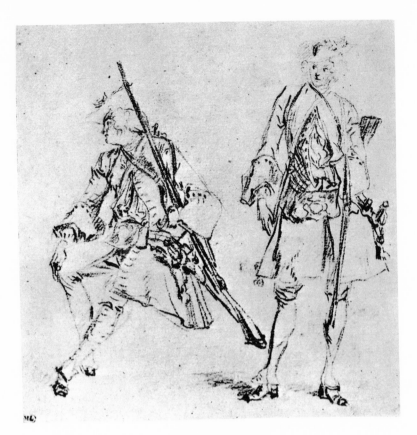

TWO SOLDIERS
(Louvre)

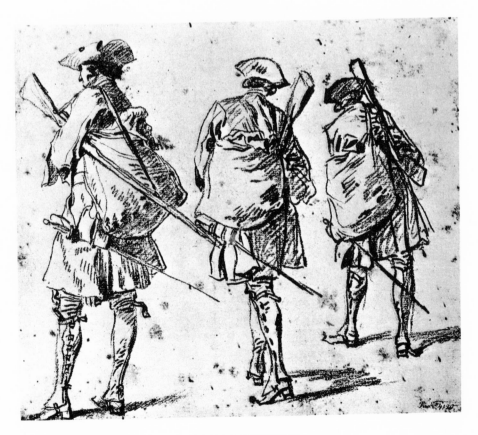

THREE SOLDIERS
(Berlin Print Room)

PLATE 9

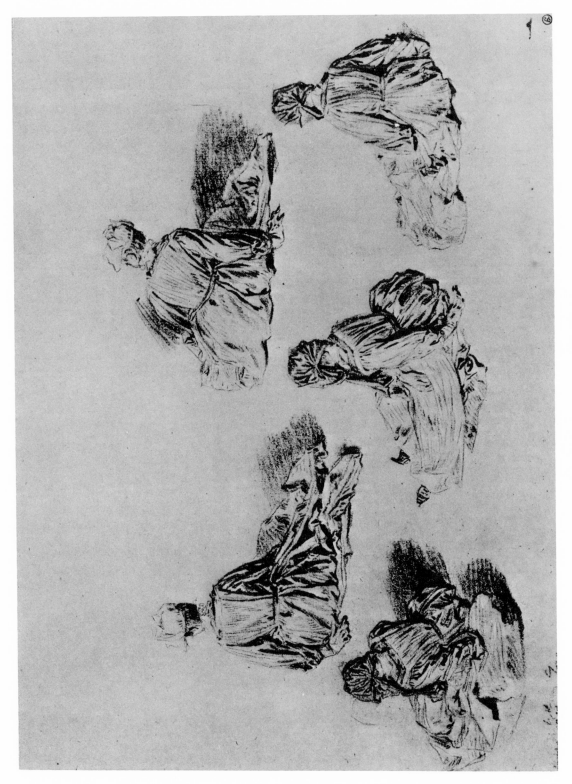

STUDIES OF A SEATED WOMAN
(British Museum)

PLATE 10

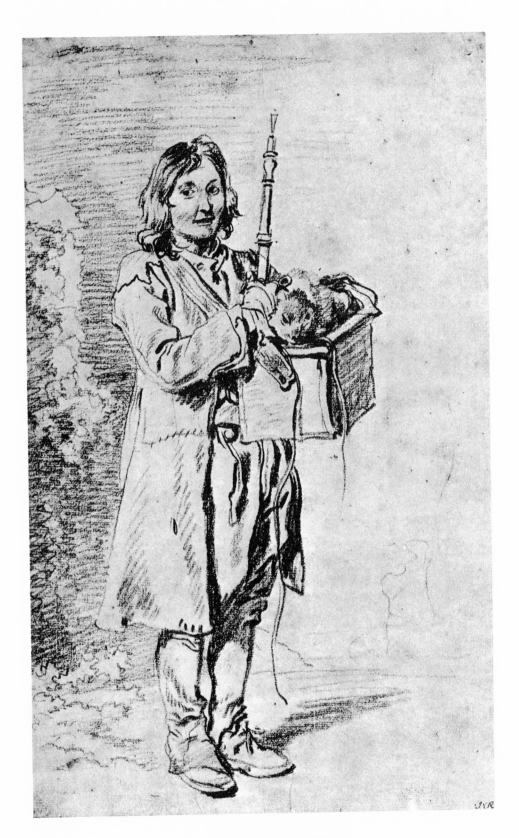

A YOUNG SAVOYARD

(Palais des Beaux-Arts, Paris)

PLATE 11

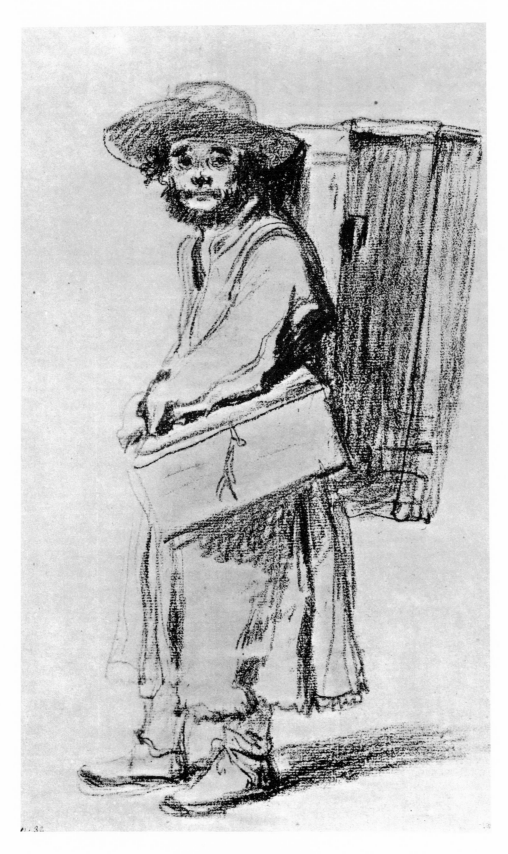

AN OLD SAVOYARD
(*Musée Bonnat*)

PLATE 12

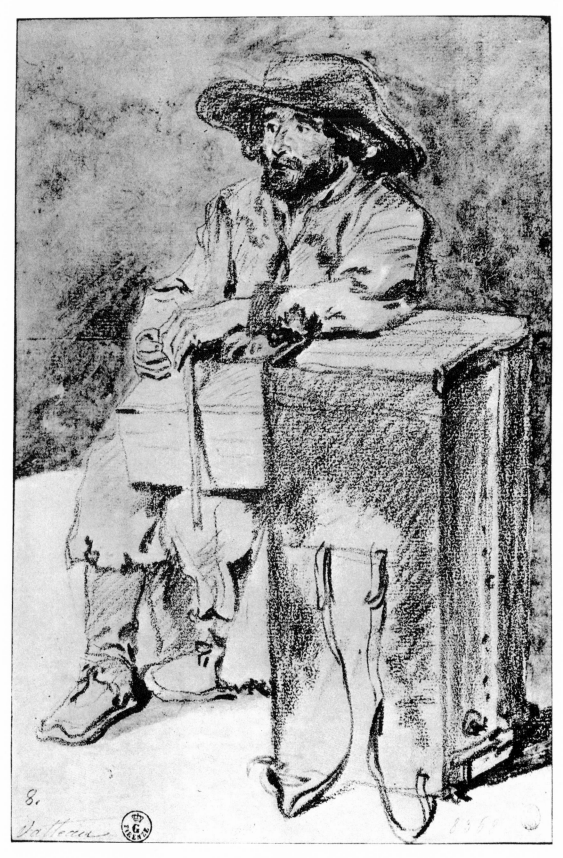

AN OLD SAVOYARD, SEATED
(*Uffizi*)

PLATE 13

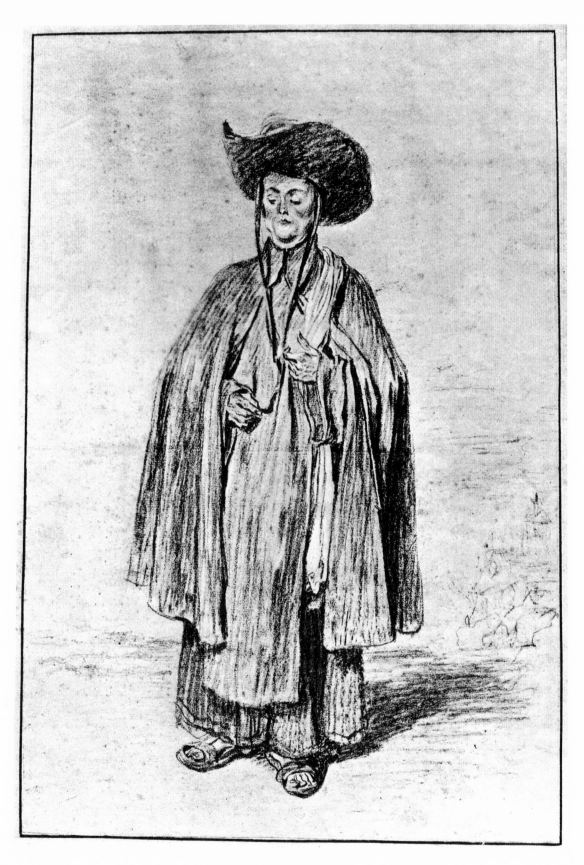

A FRIAR
(Anonymous Private Collection)

PLATE 14

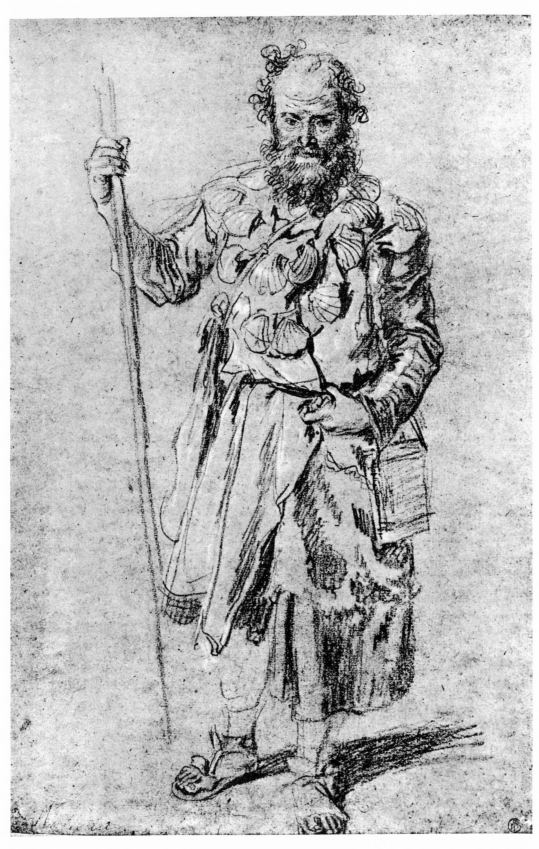

A PILGRIM
(Palais des Beaux-Arts, Paris)

PLATE 15

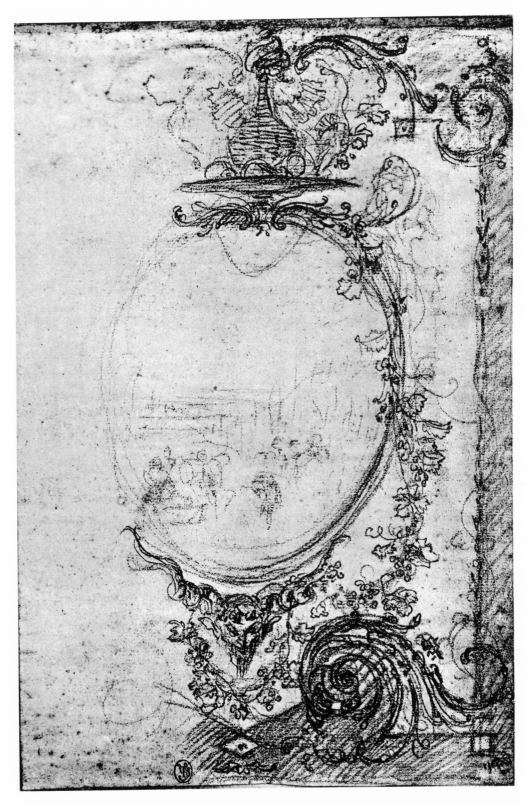

ORNAMENT
(*Hermitage*)

PLATE 16

INTERIOR DECORATION

(*Uffizi*)

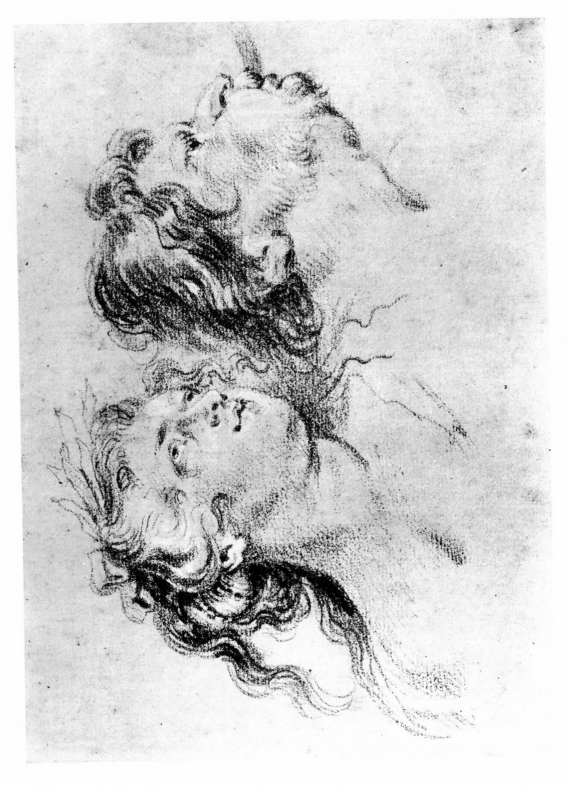

HEADS, AFTER RUBENS
(Collection Mr. H. Oppenheimer)

PLATE 18

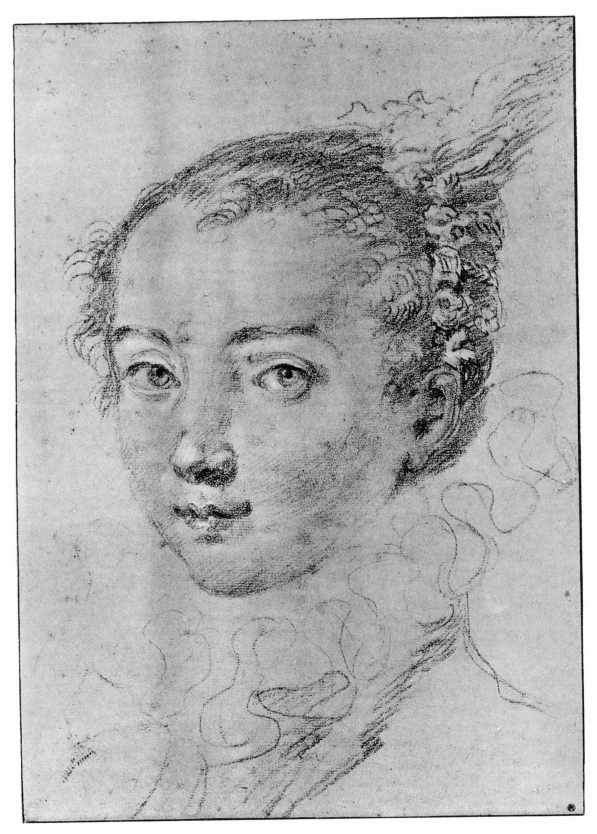

HEAD, AFTER ? RUBENS
(Colléction Herr Franz Koenigs)

PLATE 19

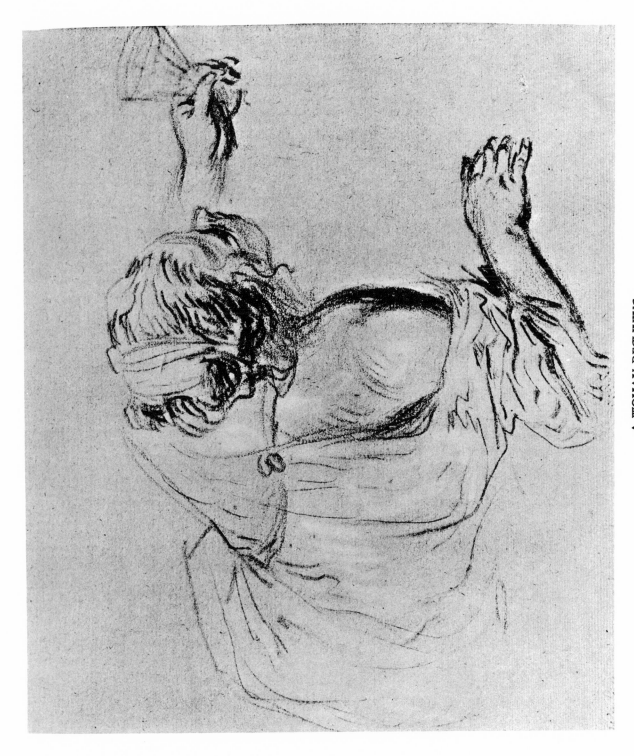

A WOMAN RECLINING
(Musée Cognacq-Jay)
Cf. Fig. 1

PLATE 20

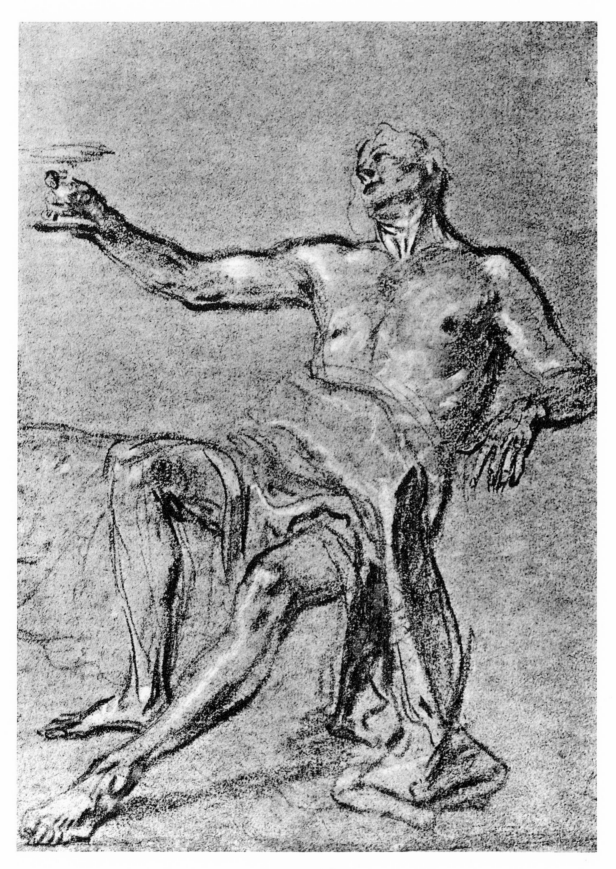

BACCHUS
(Collection Mr. Walter Gay)
Cf. Fig. 1

PLATE 21

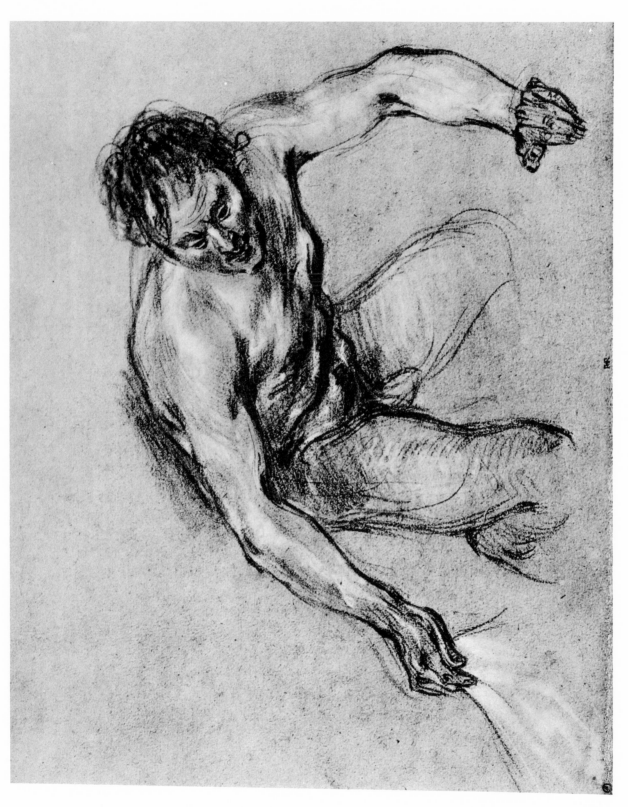

NUDE MALE FIGURE
(*Louvre*)

PLATE 22

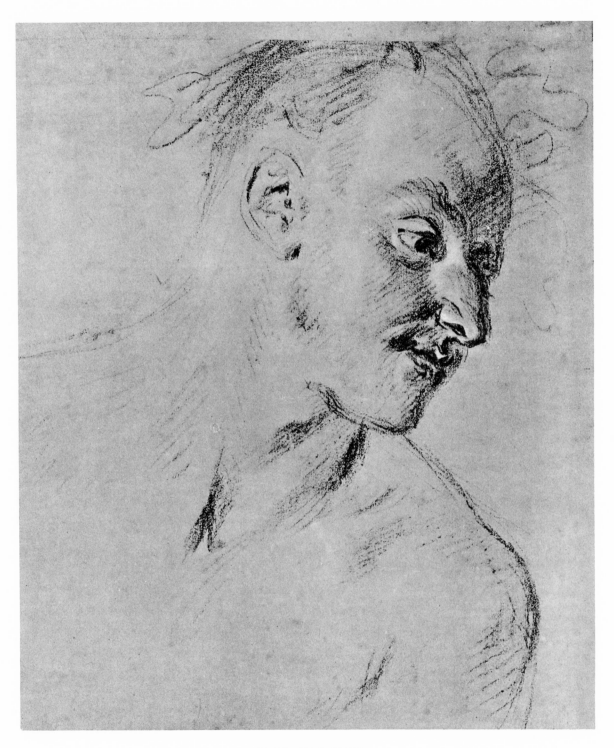

HEAD OF A MAN
(Collection M. Georges Dormeuil)

PLATE 23

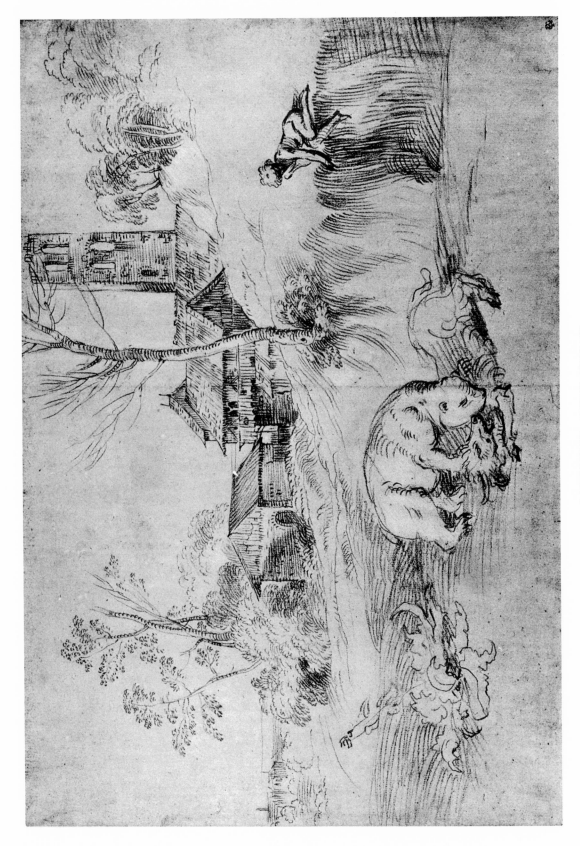

LANDSCAPE, AFTER TITIAN
(Collection Mr. Frits Lugt)

PLATE 24

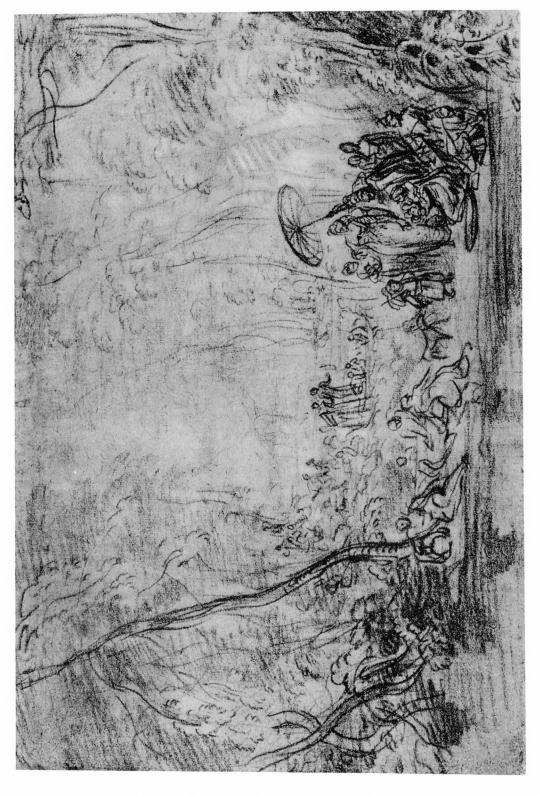

THE FINDING OF MOSES
(École des Beaux-Arts, Paris)

PLATE 25

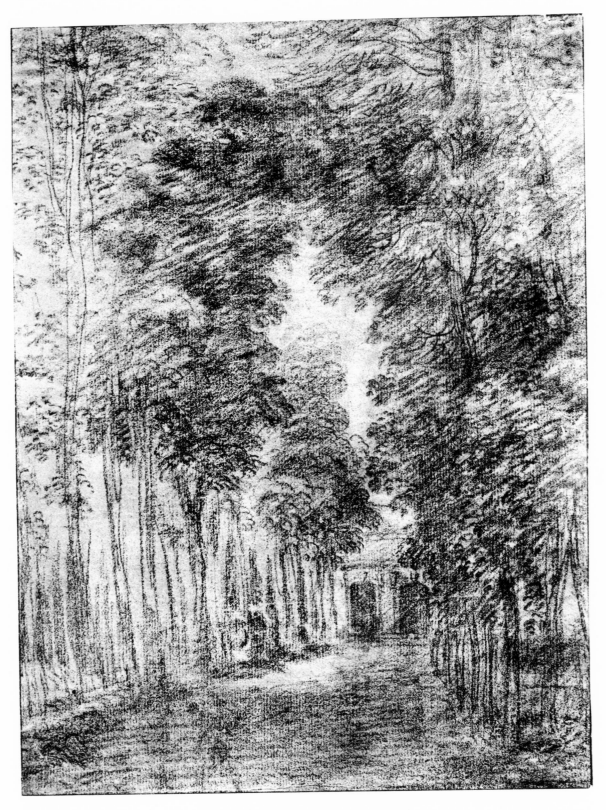

VISTA DOWN AN ALLEY OF TREES
(*Hermitage*)

PLATE 26

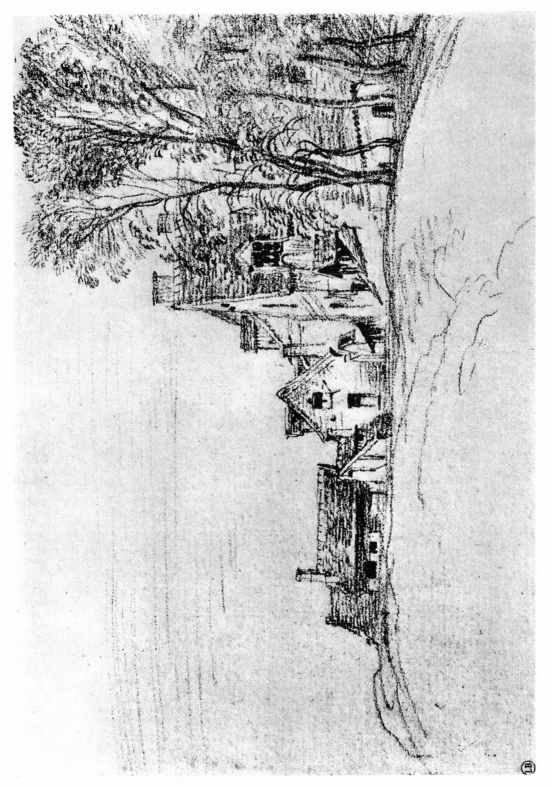

A FARMSTEAD
(Musée Bonnat)

PLATE 27

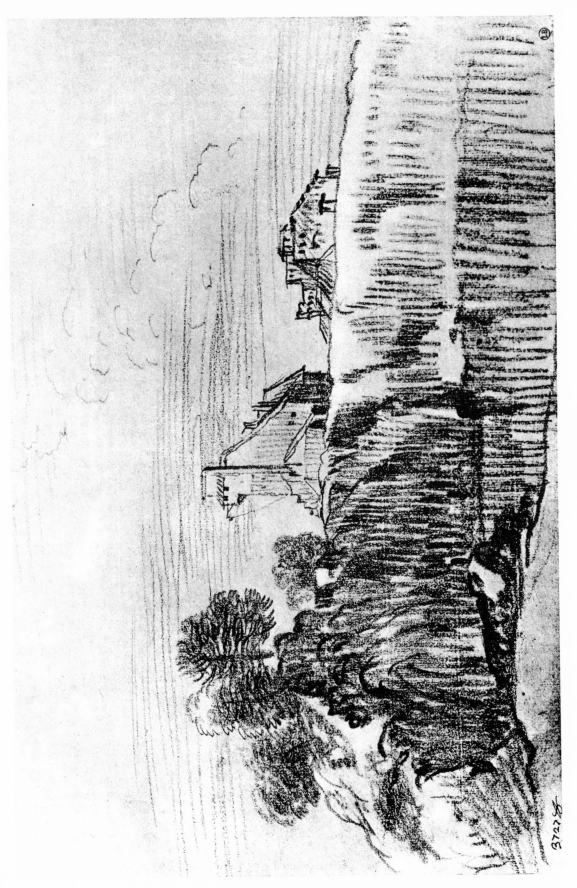

LANDSCAPE
(Musée Bonnat)

PLATE 28

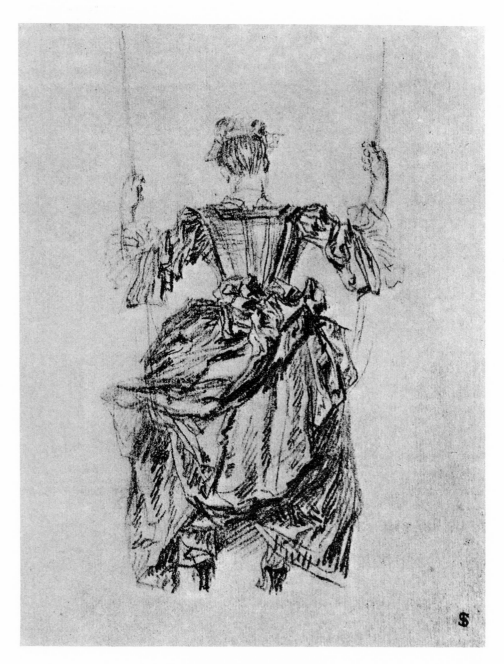

A GIRL ON A SWING
(Collection Rt. Hon. the Earl of Iveagh)
Cf. Fig. 2

PLATE 29

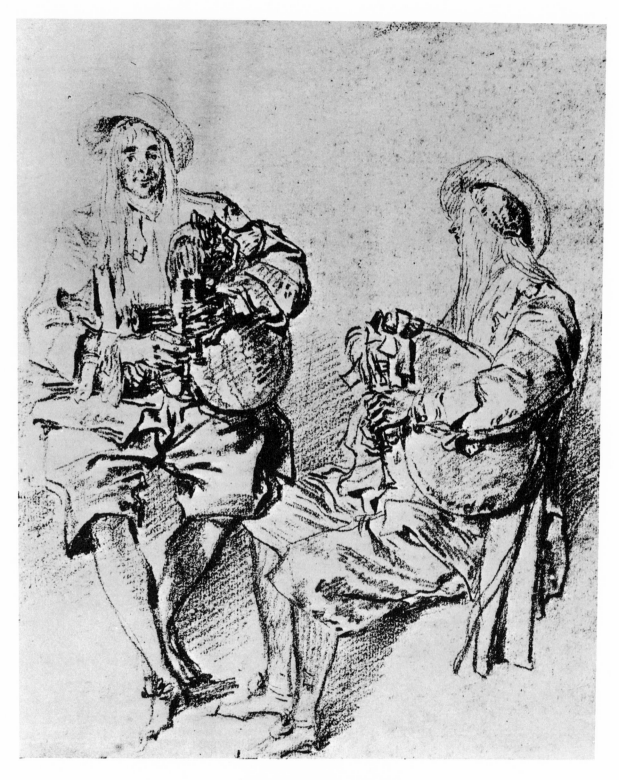

TWO STUDIES OF A PIPER
(*Louvre*)
Cf. Figs 2, 3 and 5

PLATE 30

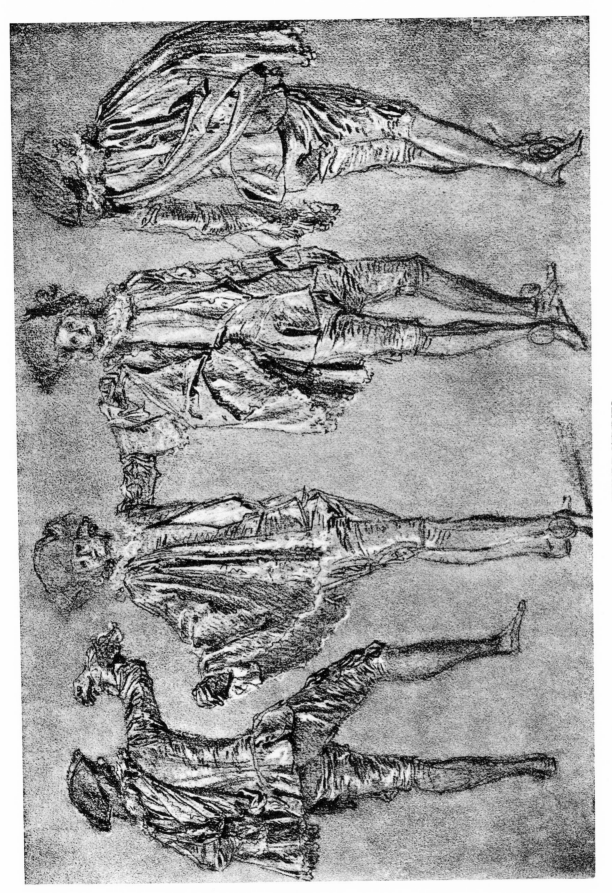

FIGURE STUDIES
(Collection M. Gaston Menier)
Cf. Figs. 3, 4 and 9

PLATE 31

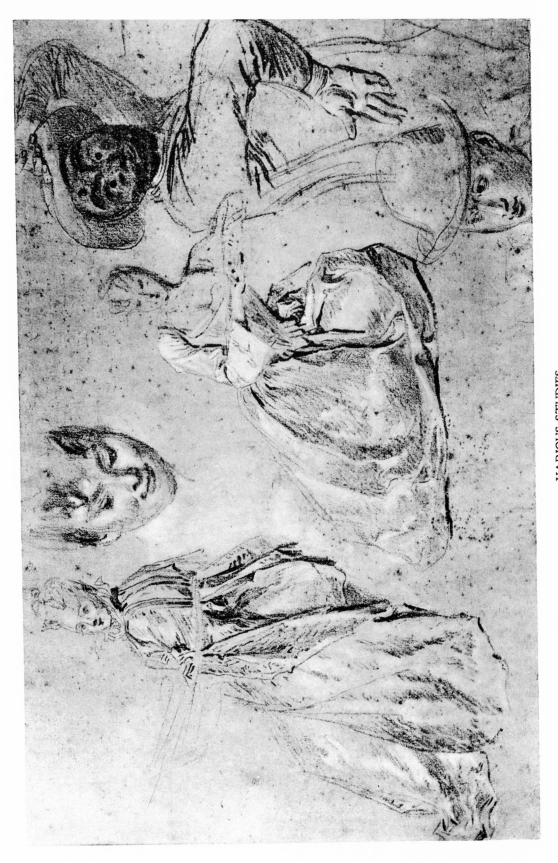

VARIOUS STUDIES
(*École des Beaux-Arts, Paris*)
Cf. Plates 4 and 10

PLATE 32

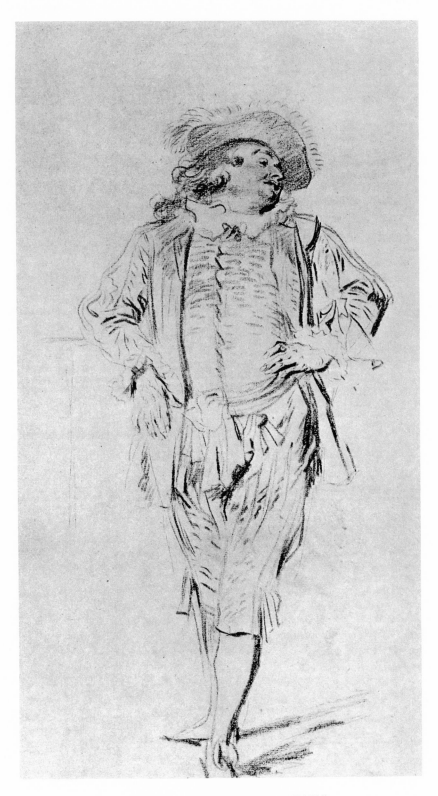

"POISSON EN HABIT DE PAYSAN"
(British Museum)

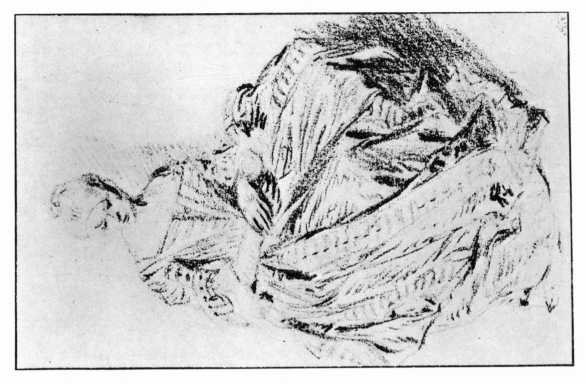

A WOMAN SEATED
(*British Museum*)
Cf. Fig. 8

A MAN STANDING
(*Staedel'sches Institut*)
Cf. Fig. 8

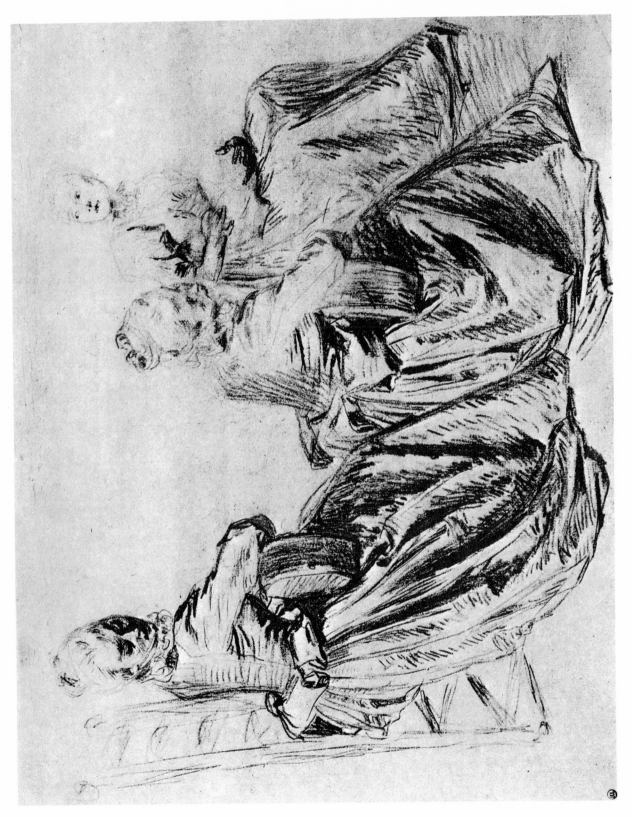

PLATE 35

STUDIES OF A FEMALE FIGURE
(*Louvre*)
Cf. Fig. 8

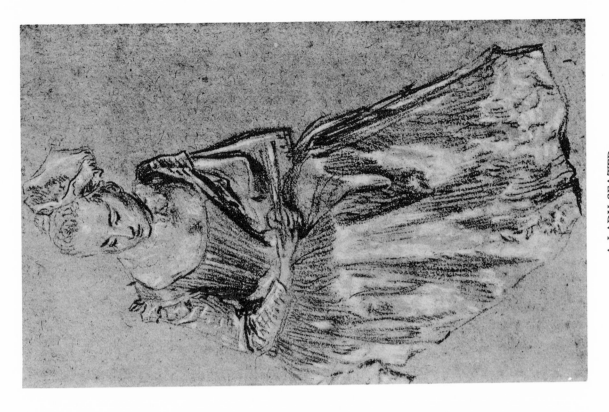

A LADY SEATED
(*Collection Mr. George Blumenthal*)

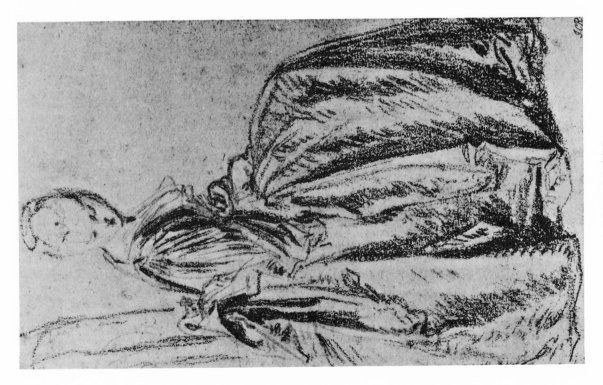

A LADY SEATED
(*British Museum*)

PLATE 38

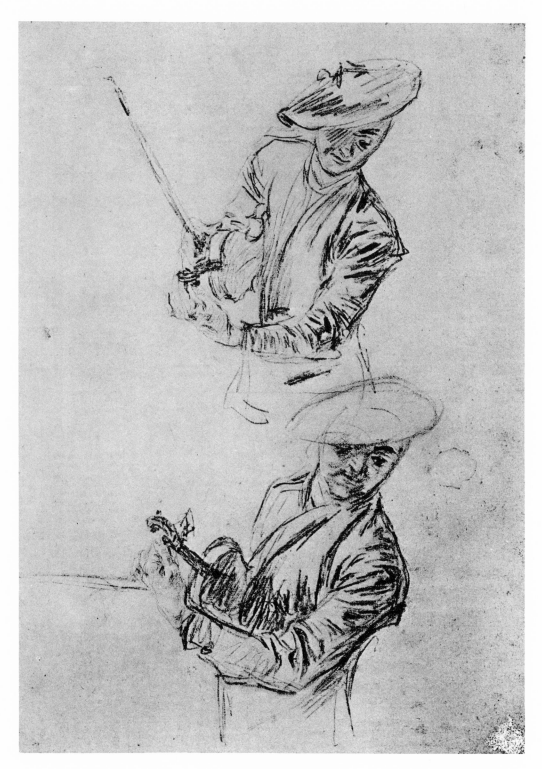

FIGURE STUDIES
(Anonymous Private Collection)

PLATE 39

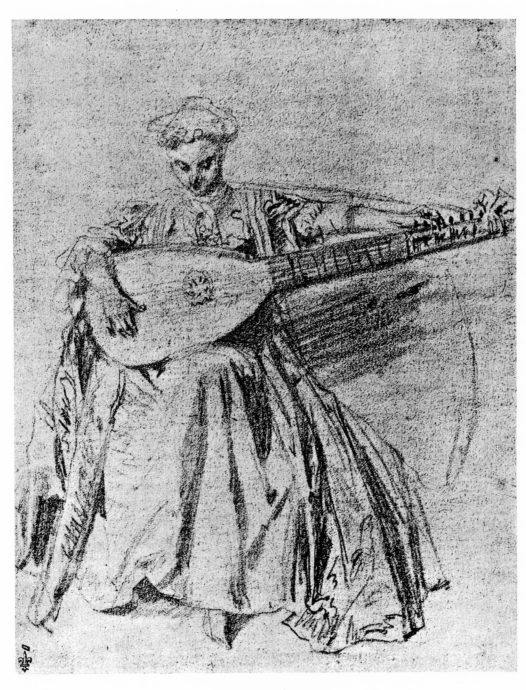

A LUTE PLAYER
(Musée Condé)

PLATE 40

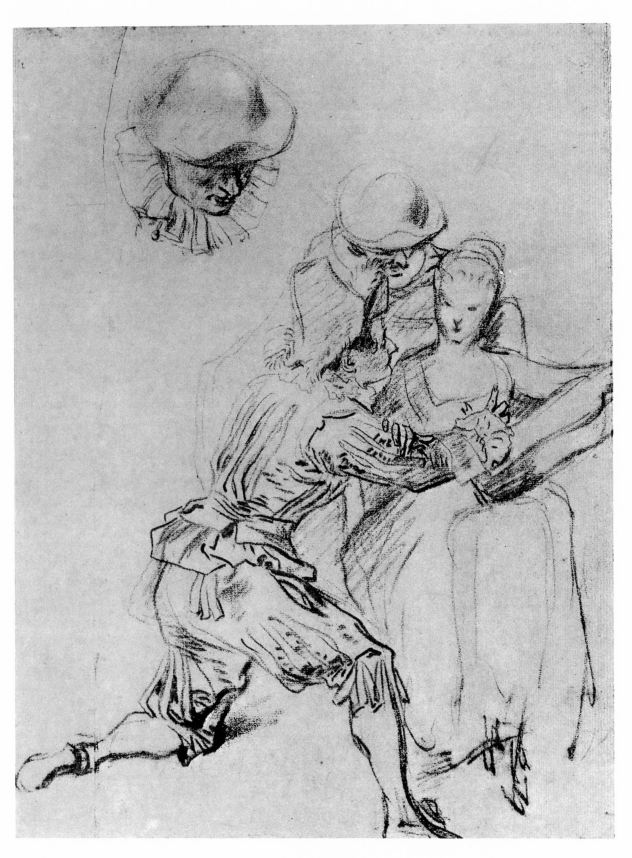

" LE CONTEUR "
Cleveland Museum

PLATE 41

PLATE 42

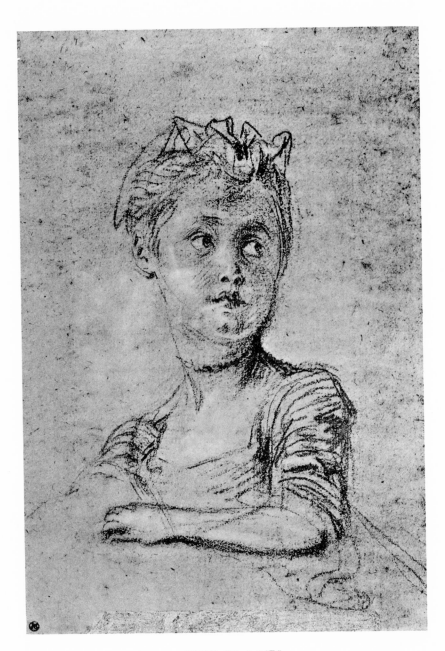

HEAD OF A GIRL
(*Orleans Museum*)

PLATE 43

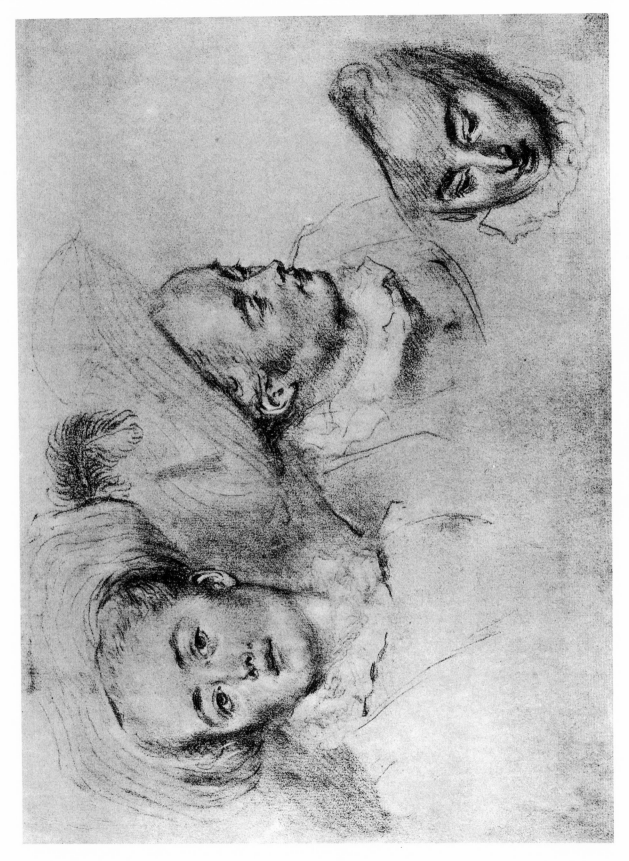

STUDIES OF THE HEAD OF A WOMAN
(Collection Count Greffuhle)

PLATE 44

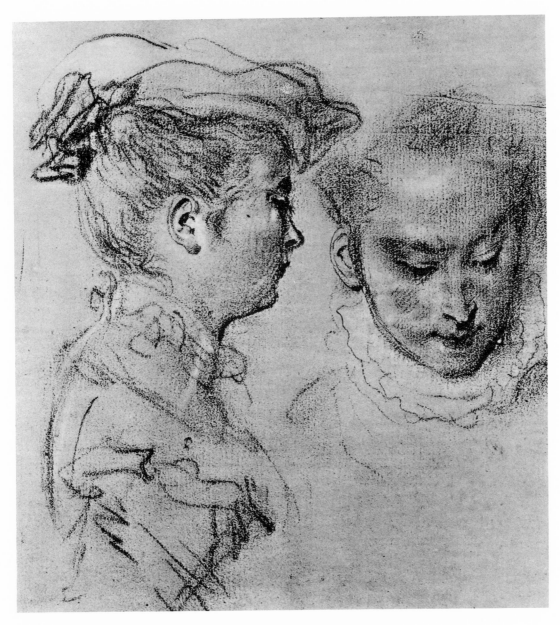

STUDIES OF THE HEAD OF A WOMAN
(*British Museum*)

PLATE 45

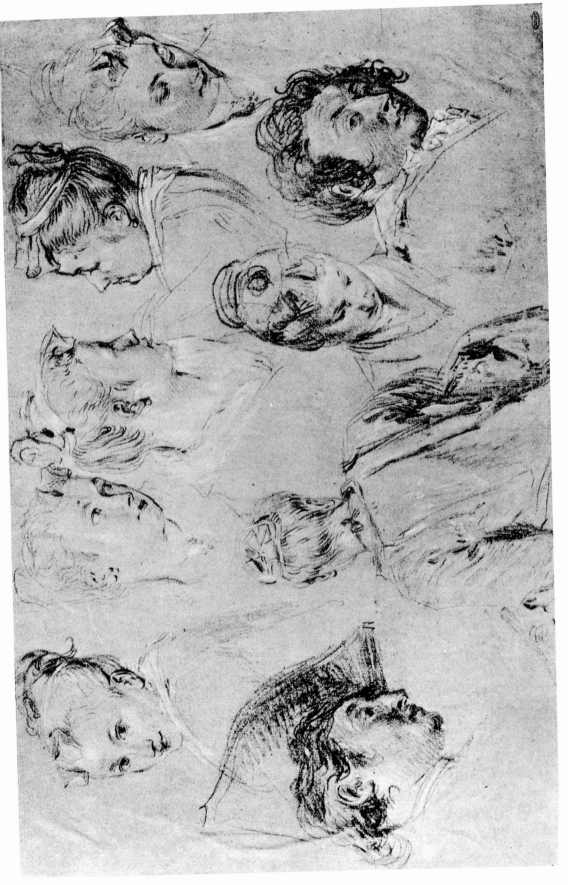

STUDIES OF HEADS
(Palais des Beaux-Arts, Paris)

PLATE 46

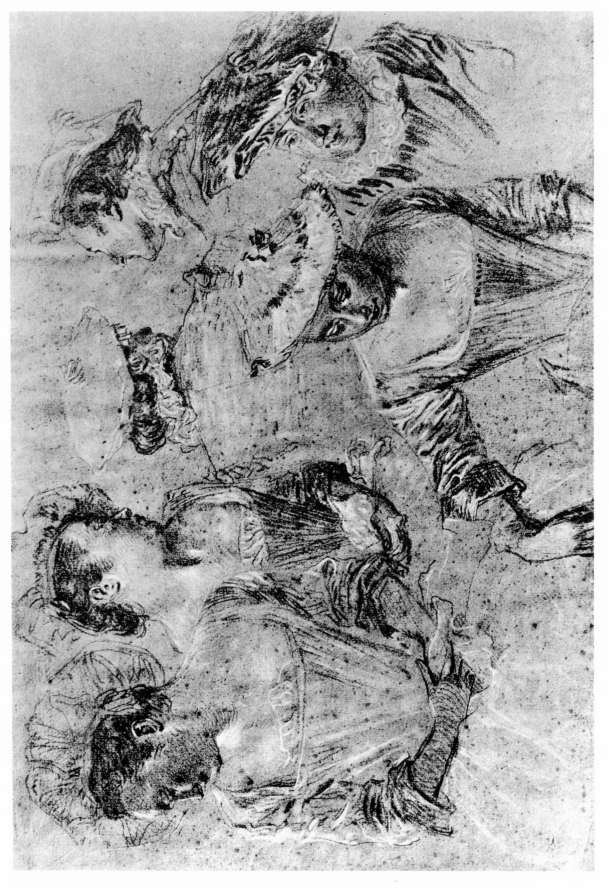

VARIOUS STUDIES
(*Louvre*)
Cf. Fig. 3

PLATE 47

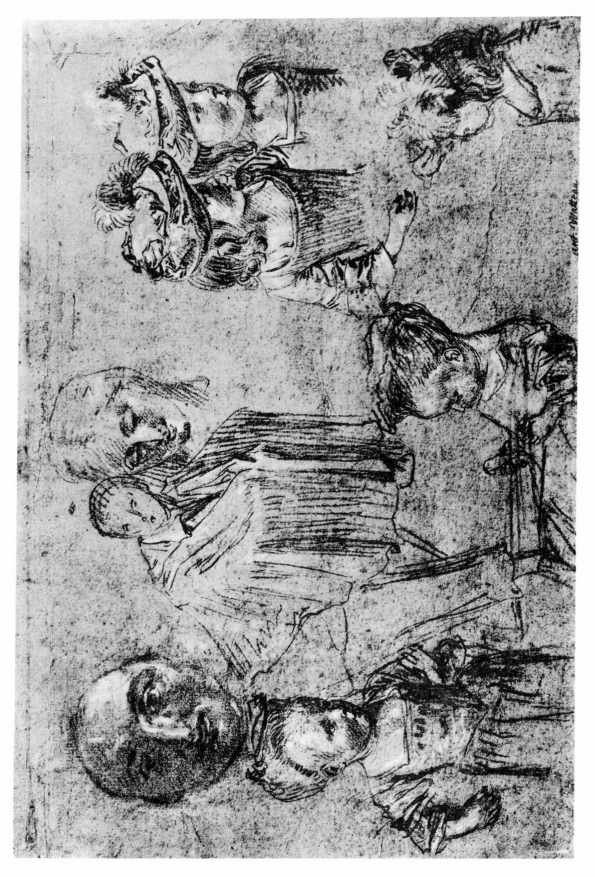

VARIOUS STUDIES

(Louvre)

Cf. Figs. 5 and 8

PLATE 48

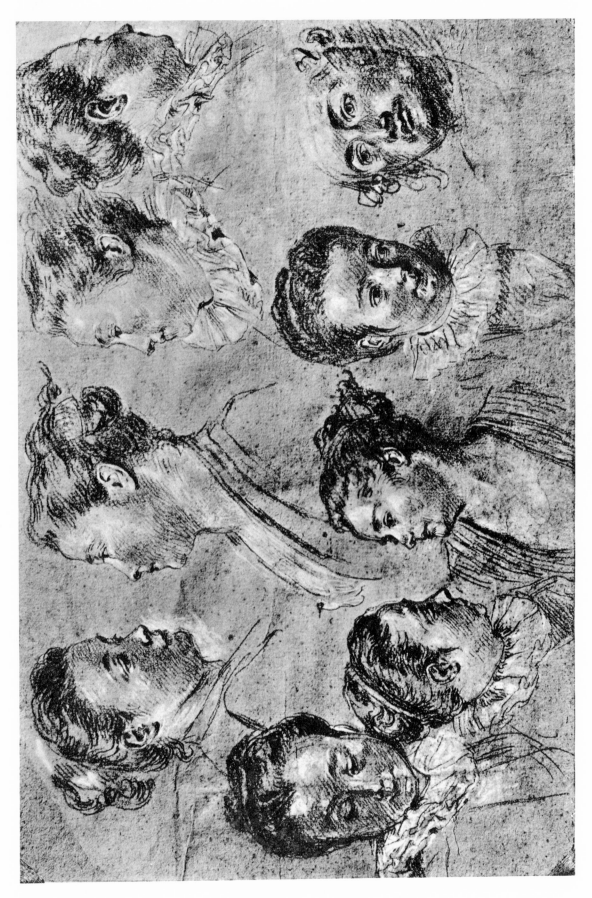

STUDIES OF HEADS
(*Louvre*)

PLATE 49

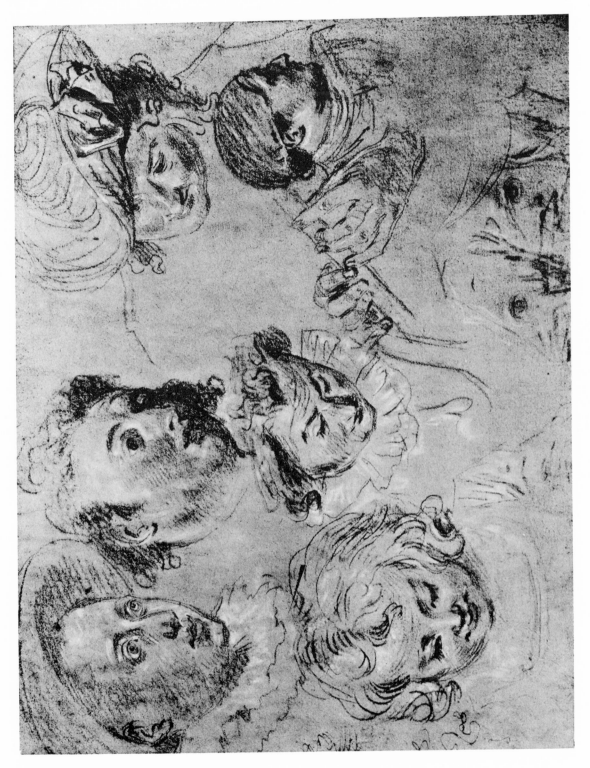

PLATE 50

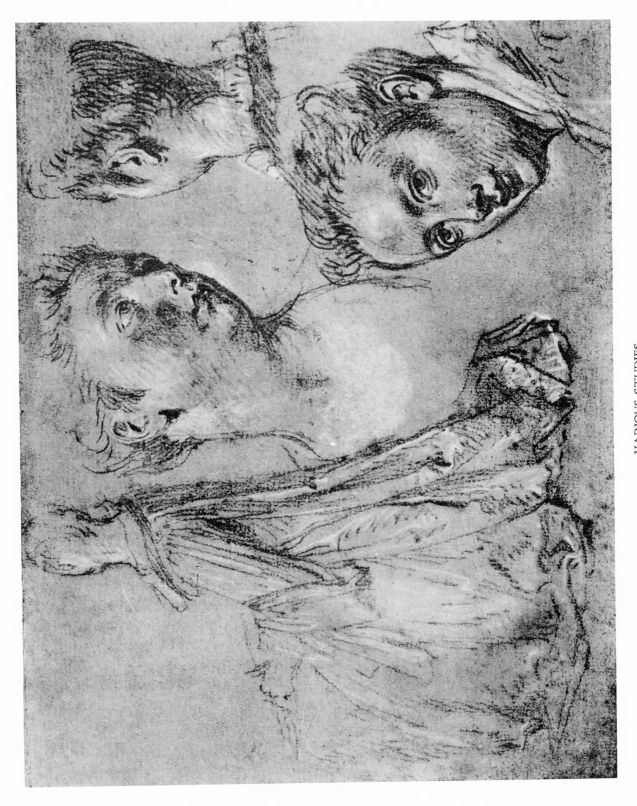

VARIOUS STUDIES
(*Rouen Museum*)

PLATE 51

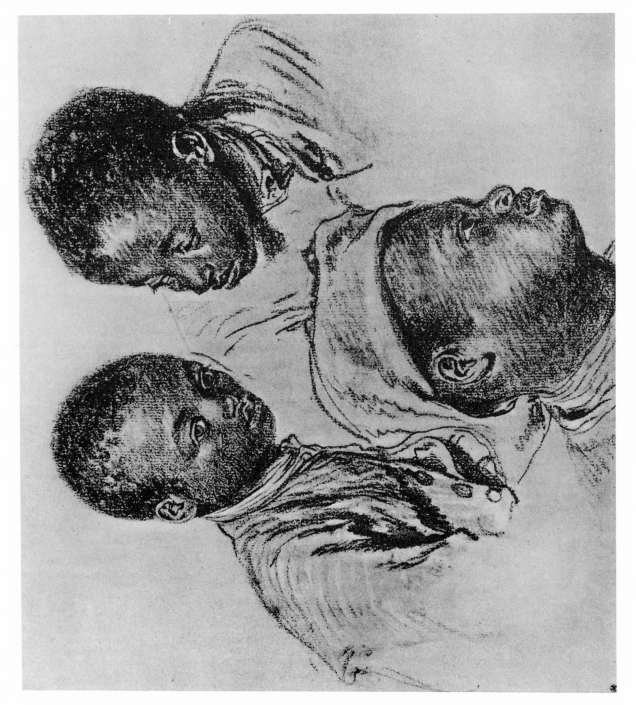

STUDIES OF THE HEAD OF A NEGRO

(*Collection M. David Weill*)

Cf. Fig. 8

PLATE 52

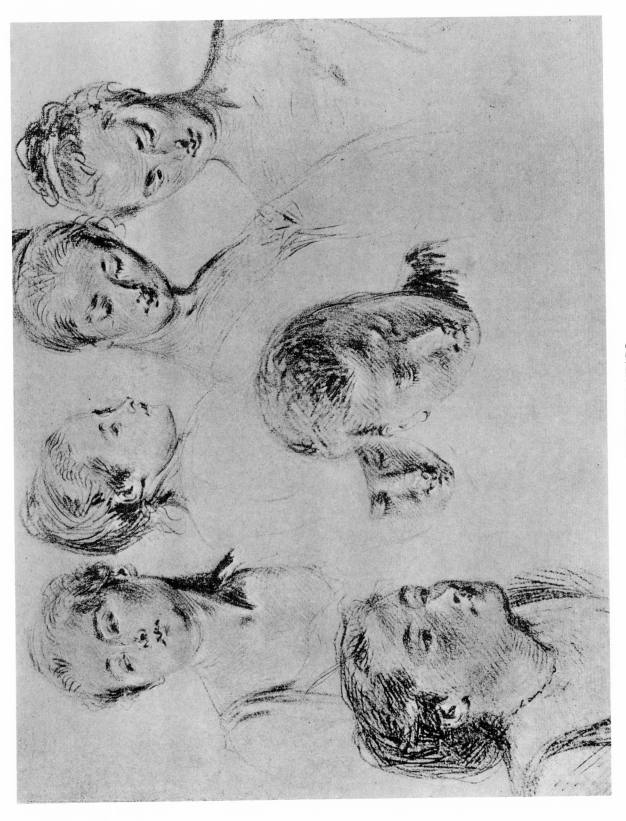

STUDIES OF HEADS
(Collection Mr. Frits Lugt)

PLATE 53

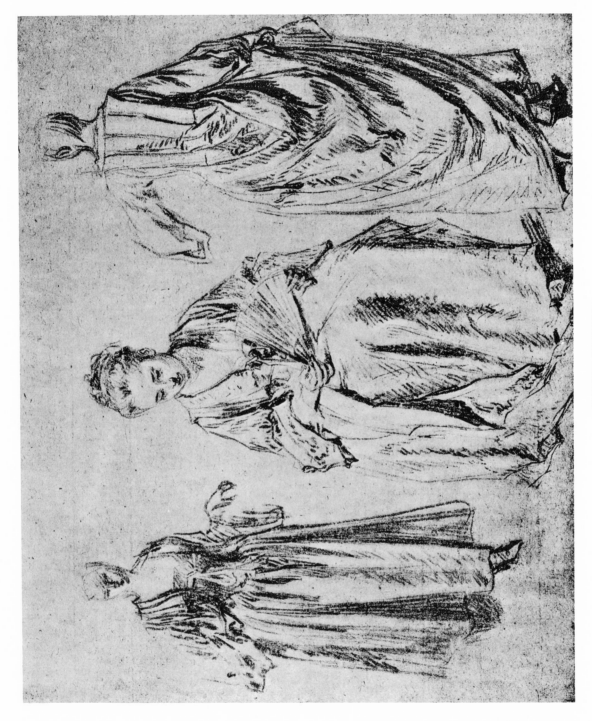

FIGURE STUDIES
(Collection Mr. Mortimer L. Schiff)
Cf. Figs. 7 and 9

PLATE 54

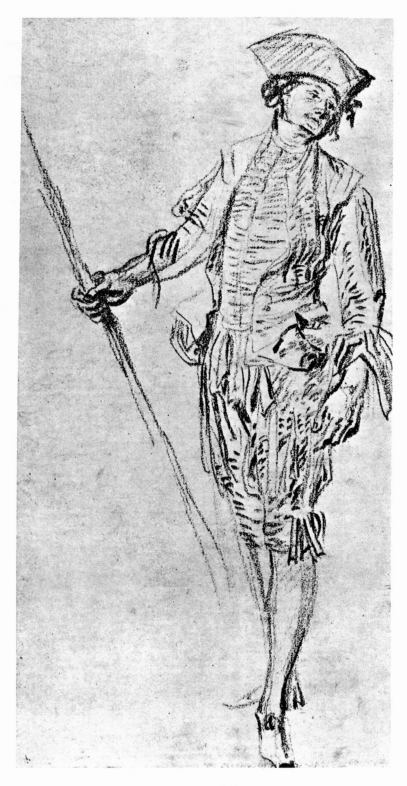

FIGURE STUDY
(*British Museum*)
Cf. Fig. 9

PLATE 55

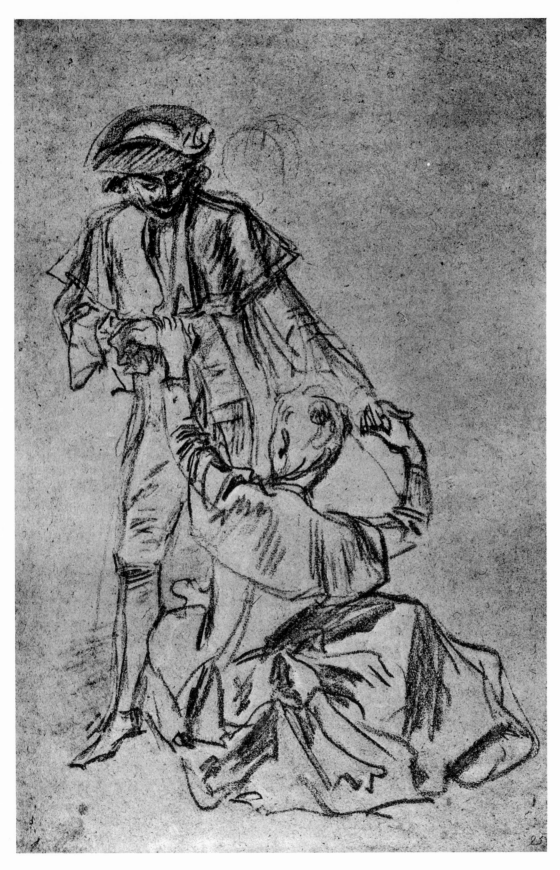

FIGURE STUDIES

(*British Museum*)

Cf. Fig. 9

PLATE 56

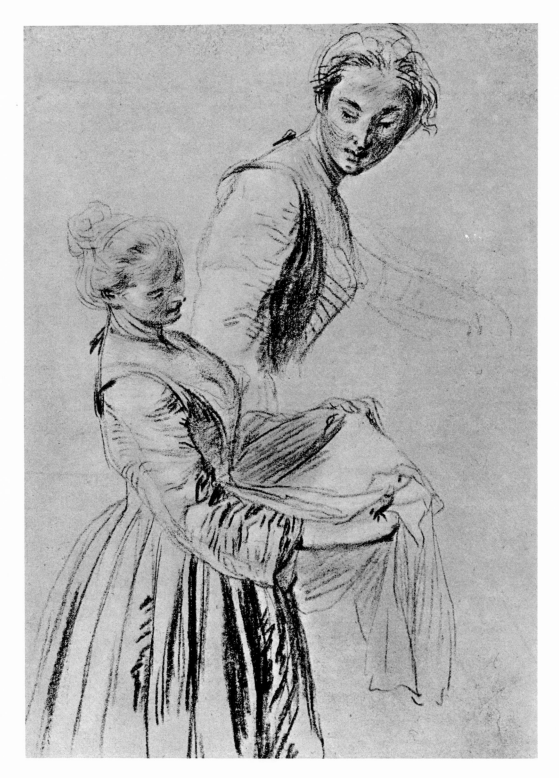

TWO FEMALE FIGURES
(*British Museum*)
Cf. Fig. 9

PLATE 57

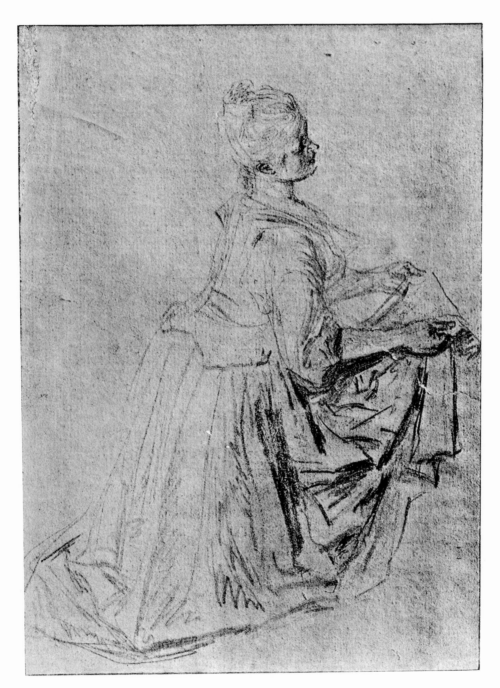

A WOMAN KNEELING

(Valenciennes Museum)

Cf. Fig. 13

PLATE 58

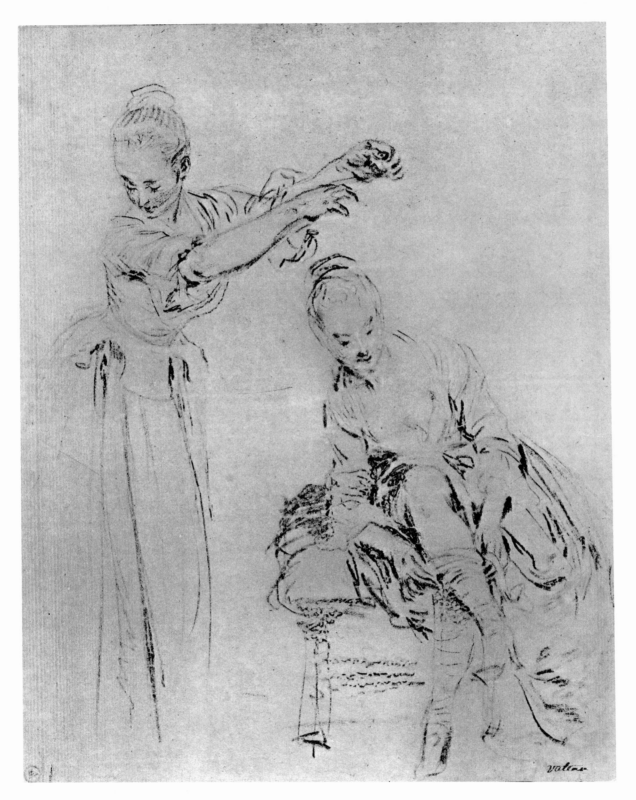

TWO FEMALE FIGURES
(Collection M. Georges Dormeuil)
Cf. Fig. 13

PLATE 59

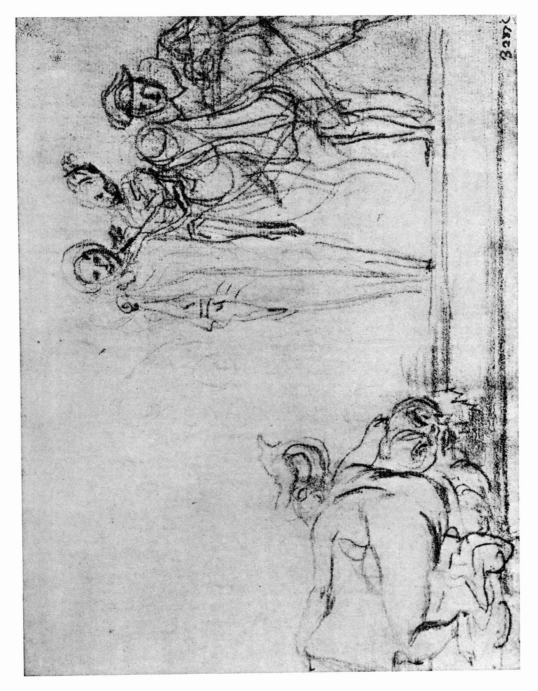

A GROUP OF COMEDIANS
(Musée Jacquemart-André)
Cf. Fig. 13

PLATE 60

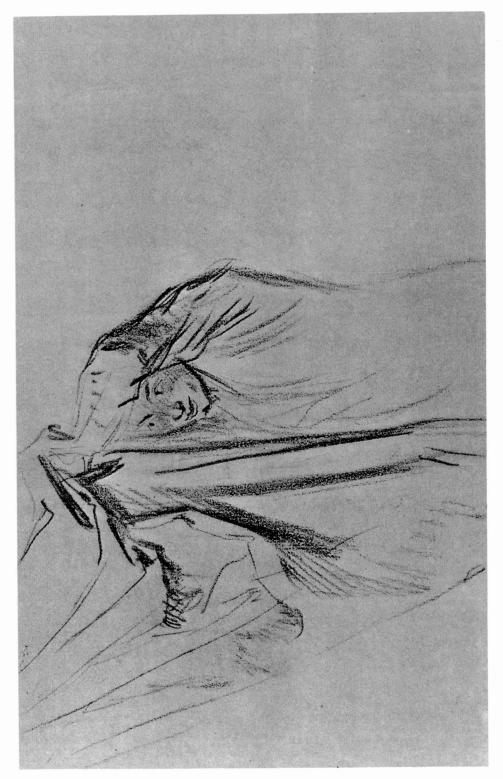

A MAN RAISING A CURTAIN
(*British Museum*)

PLATE 61

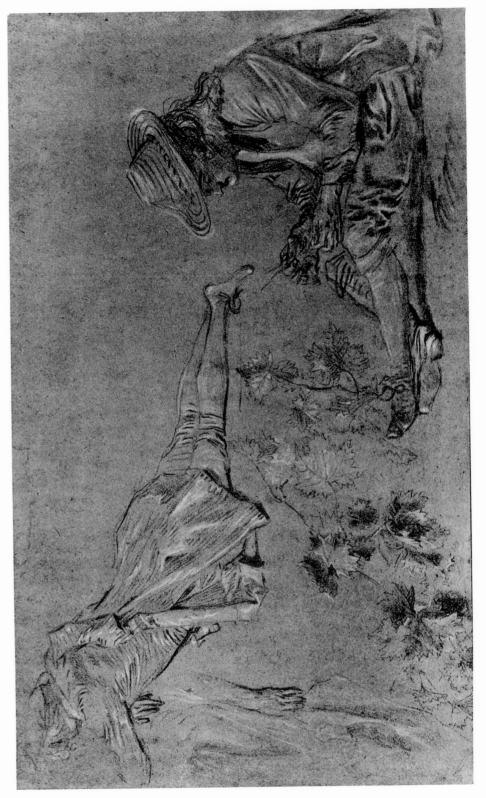

VARIOUS STUDIES
(Palais des Beaux-Arts, Paris)

Cf. Fig. 6

PLATE 62

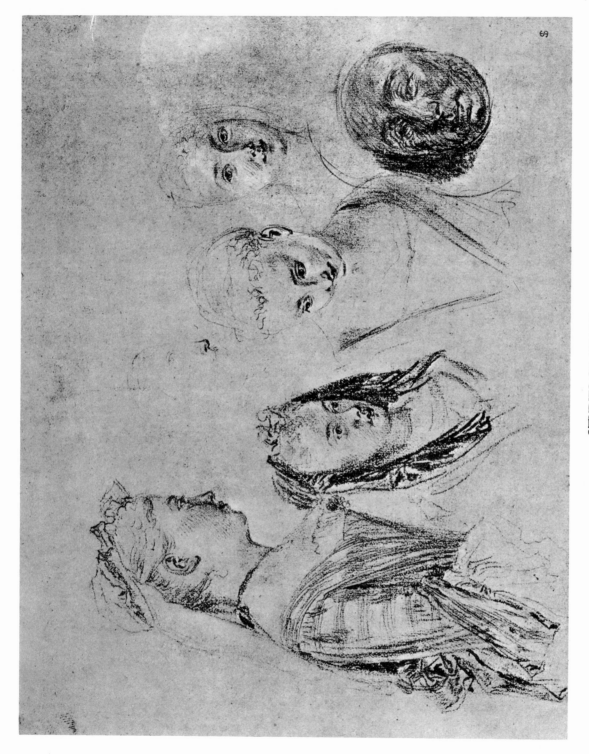

STUDIES OF HEADS
(British Museum)
Cf. Fig. 6

PLATE 63

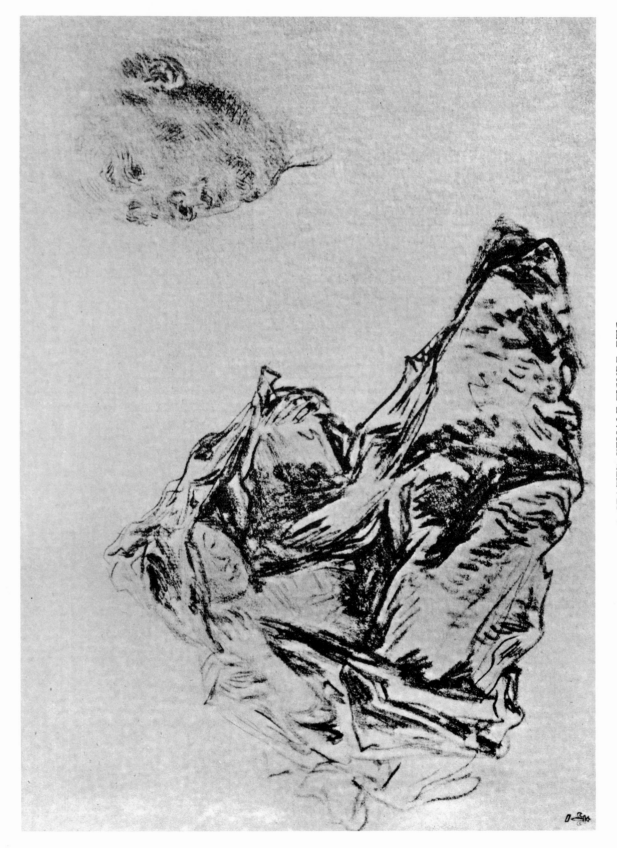

A SEATED FEMALE FIGURE, ETC.
(Musée Condé)
Cf. Fig. 13

PLATE 64

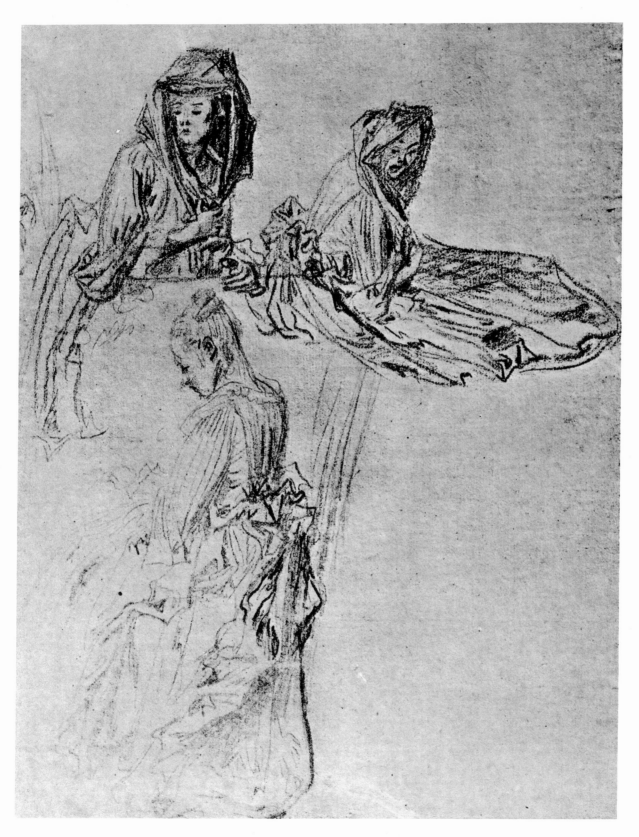

STUDIES OF A FEMALE FIGURE

(Collection Mr. Mortimer L. Schiff)

Cf. Fig. 11

PLATE 65

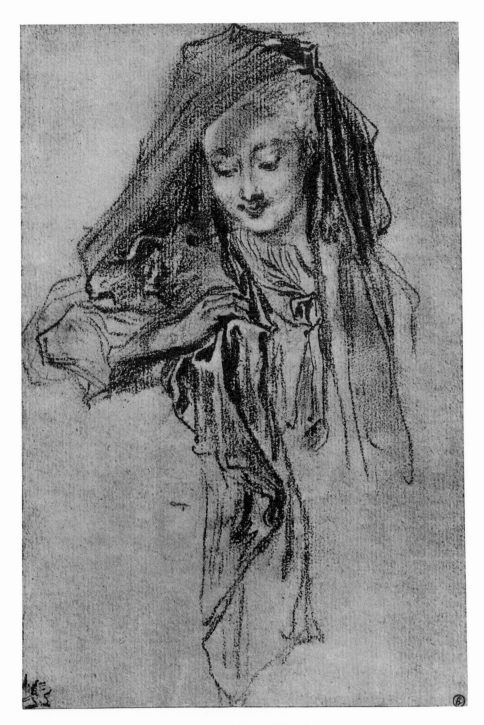

HEAD OF A WOMAN
(Collection M. David Weill)
Cf. Fig. 10

PLATE 66

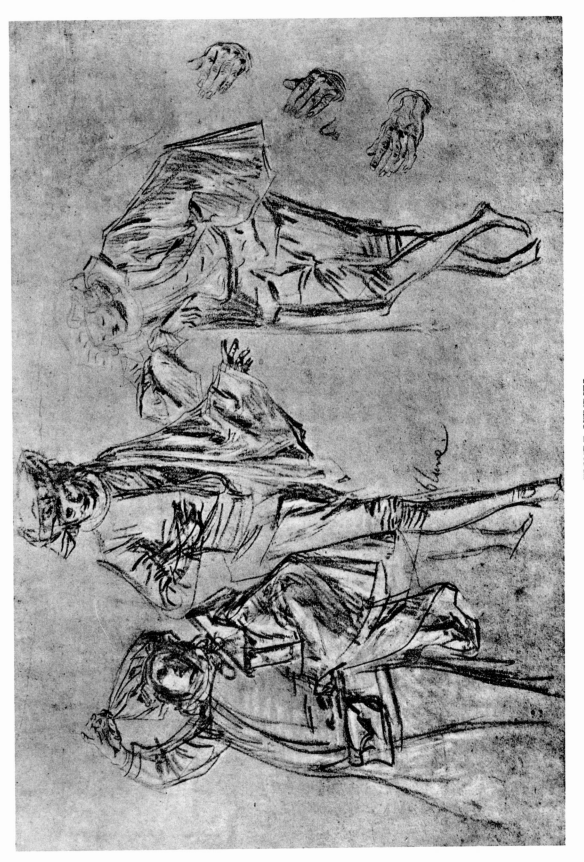

FIGURE STUDIES
(Collection Mr. Walter Gay)

Cf. Fig. 10

PLATE 67

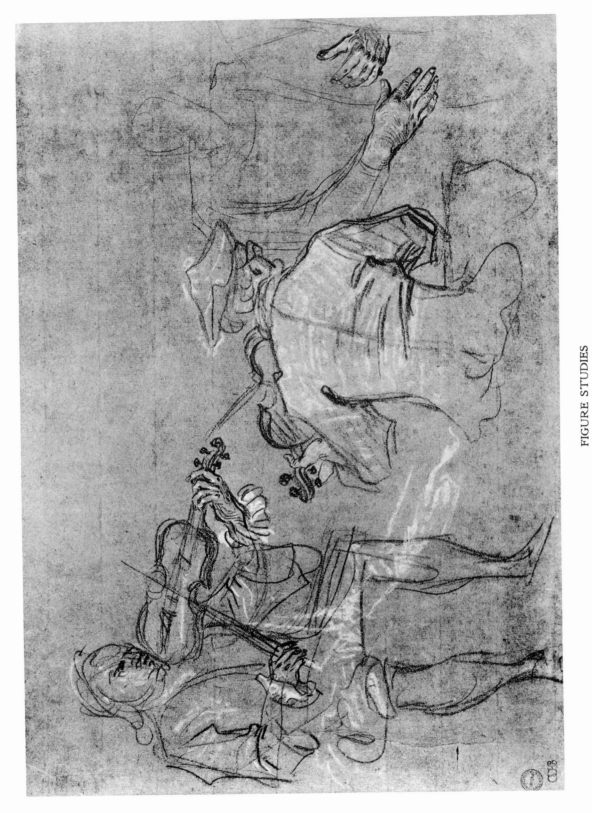

FIGURE STUDIES

(Ashmolean Museum)

'By courtesy of the Visitors and Keeper of
the Ashmolean Museum)

PLATE 68

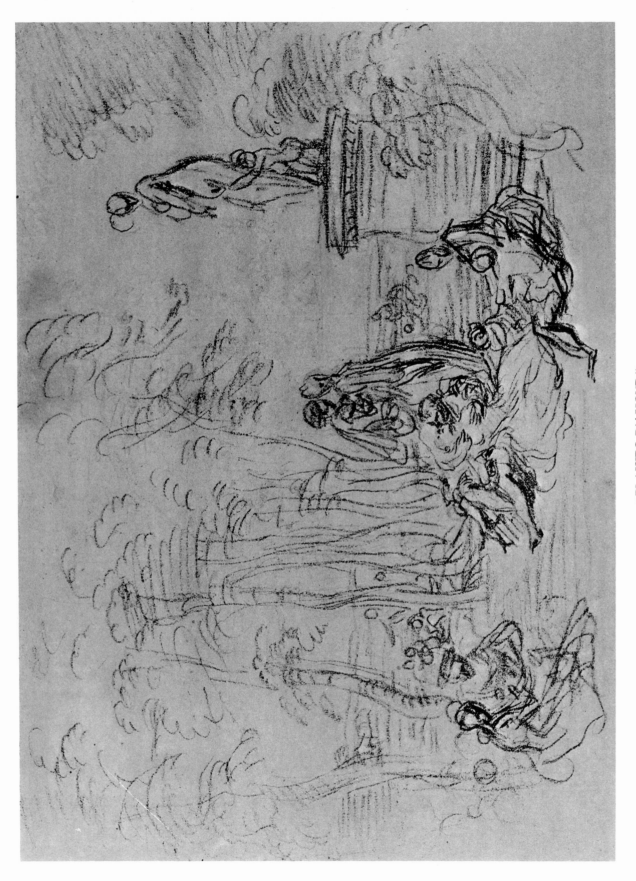

"PLAISIRS D'AMOUR"
(Collection M. Maurice Fenaille)
Cf. Fig. 12

PLATE 69

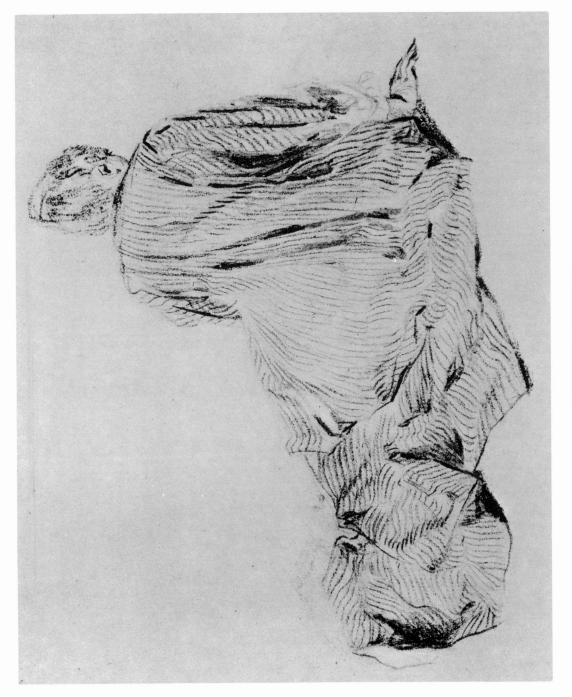

A WOMAN RECLINING
(British Museum)
Cf. Fig. 12

PLATE 70

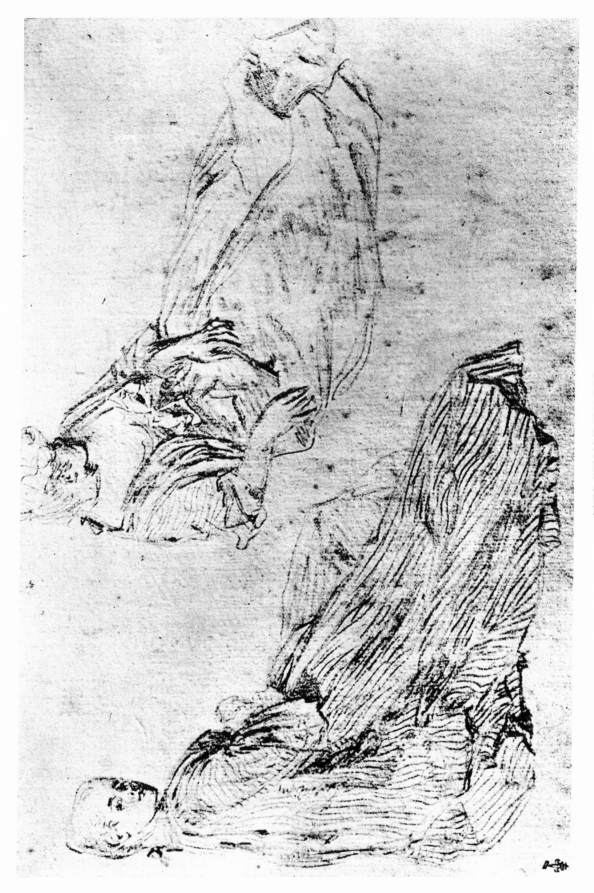

TWO FEMALE FIGURES
(Musée Condé)

Cf. Fig. 11

PLATE 71

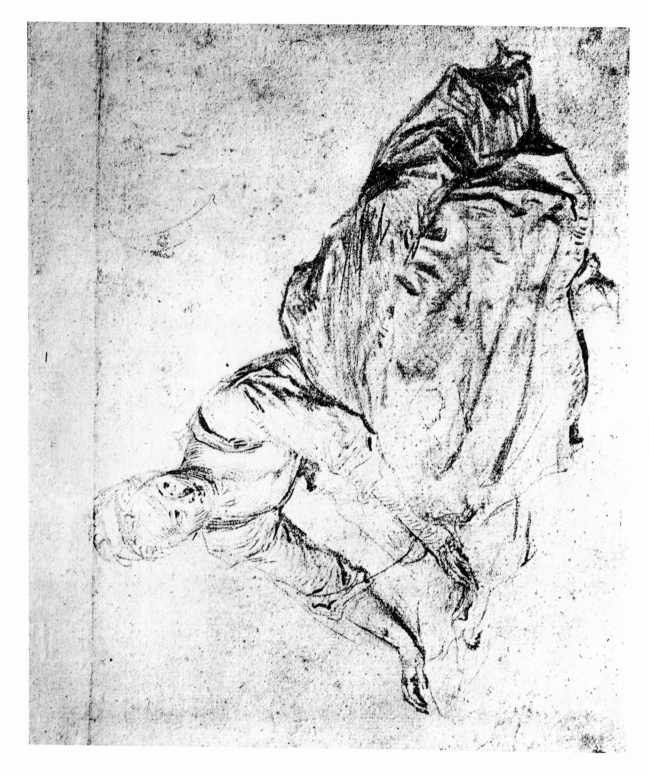

A WOMAN RECLINING
(*Musée Cognacq-Jay*)

PLATE 72

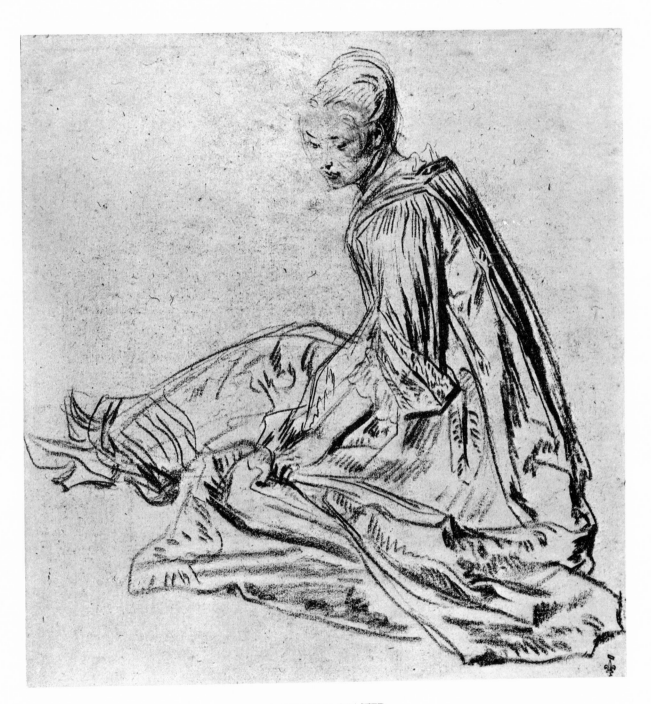

A WOMAN SEATED
(Musée Condé)

PLATE 73

TWO FEMALE FIGURES
(*Musée Bonnat*)

PLATE 74

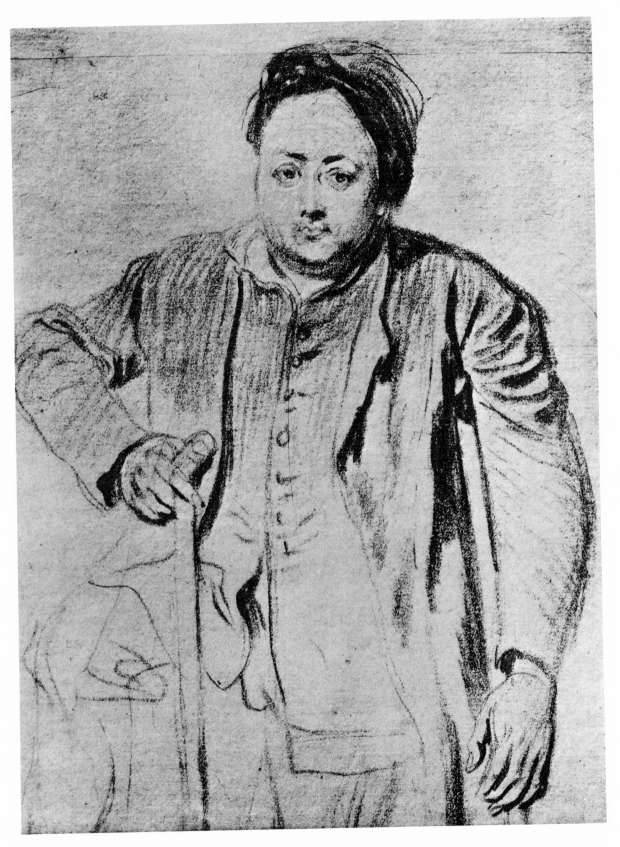

PORTRAIT OF A MAN ON CRUTCHES

(Collection Messrs. Ricketts and Shannon)

PLATE 75

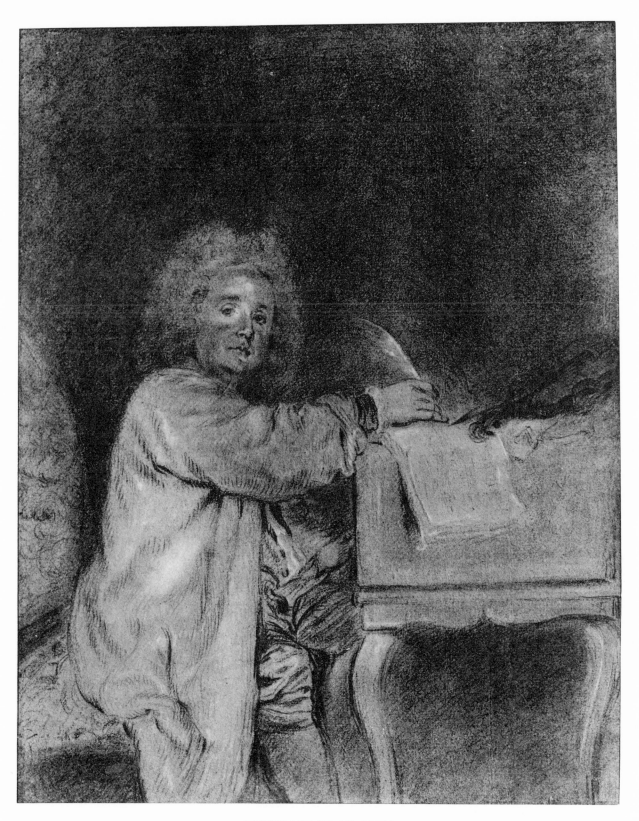

PORTRAIT OF J-F. REBEL

(Collection M. David Weill)

PLATE 76

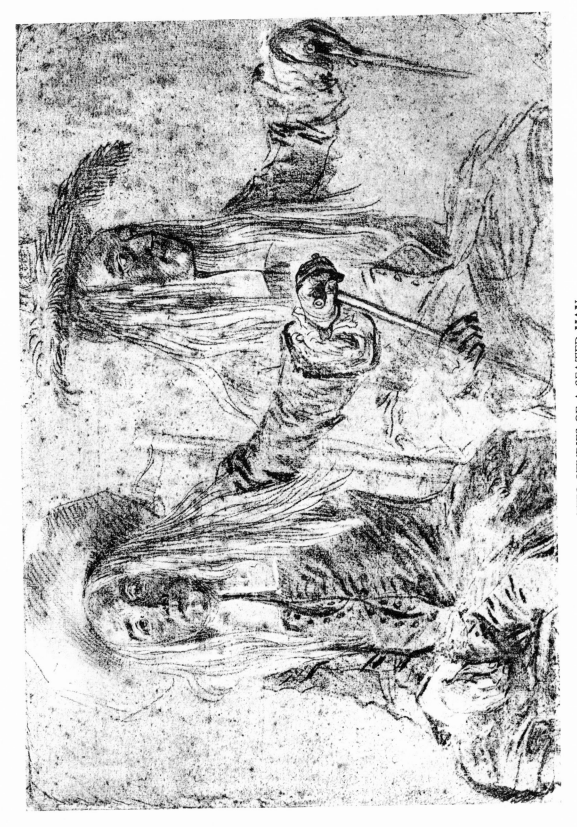

TWO STUDIES OF A SEATED MAN
(Berlin Print Room)

PLATE 77

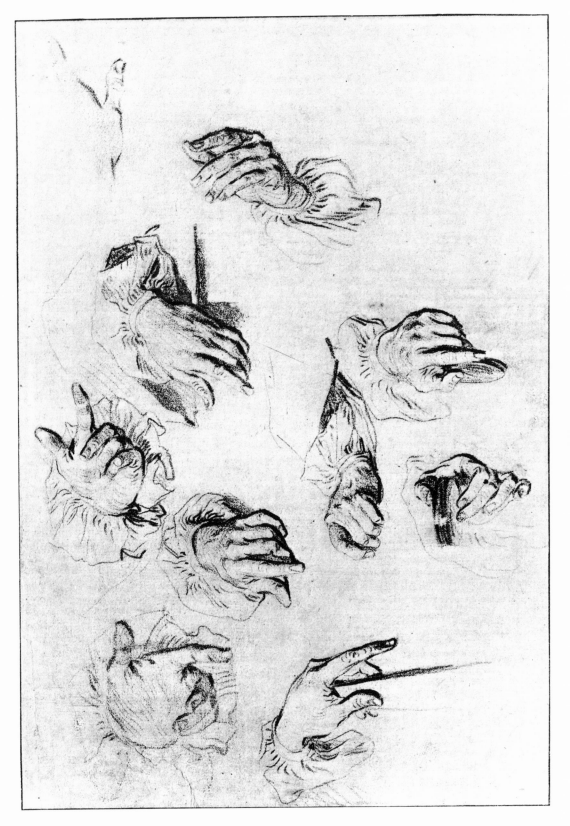

PLATE 78

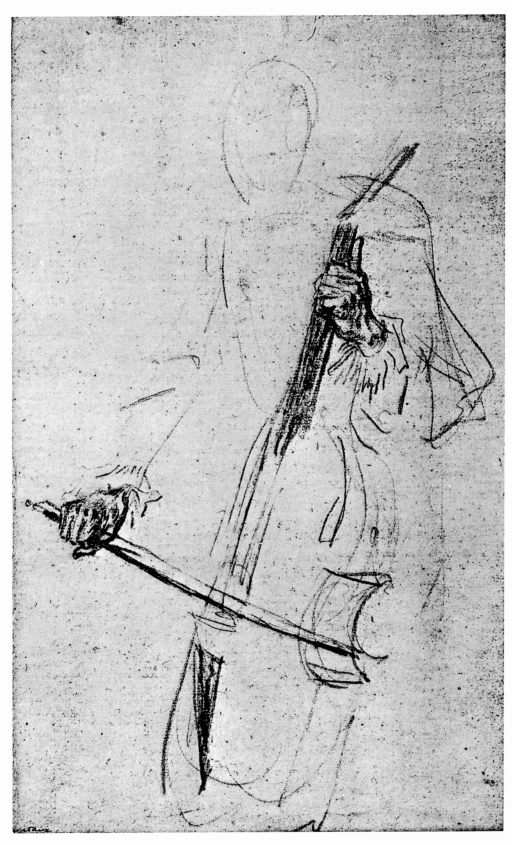

STUDY OF A MAN PLAYING THE BASE-VIOL
(Berlin Print Room)

PLATE 79

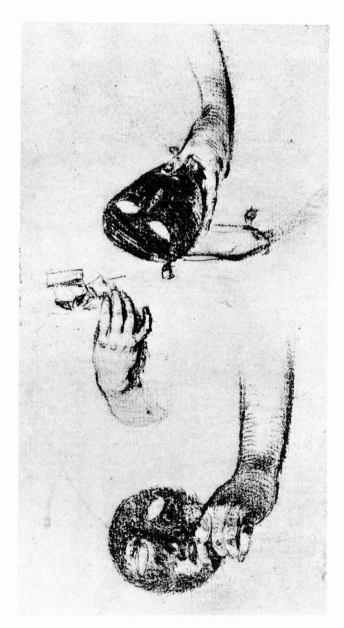

STUDIES OF HANDS
(Berlin Print Room)

PLATE 80

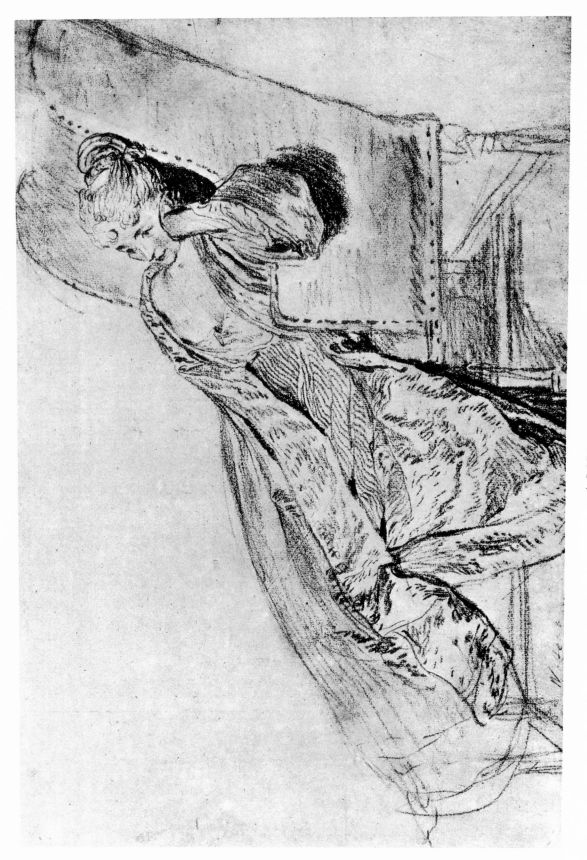

A LADY RECLINING
(*Collection Mr. Frits Lugt*)

PLATE 81

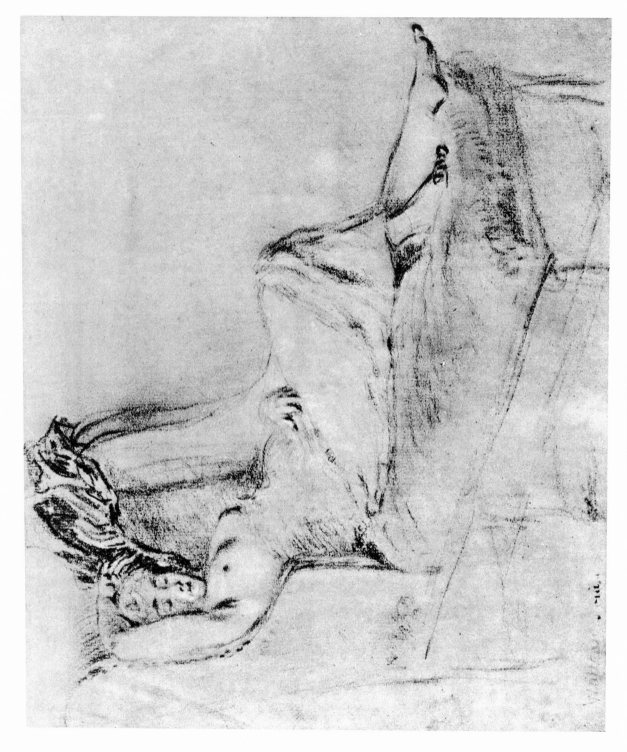

SEMI-NUDE FIGURE RECLINING
(Collection Mr. Walter Gay)

PLATE 82

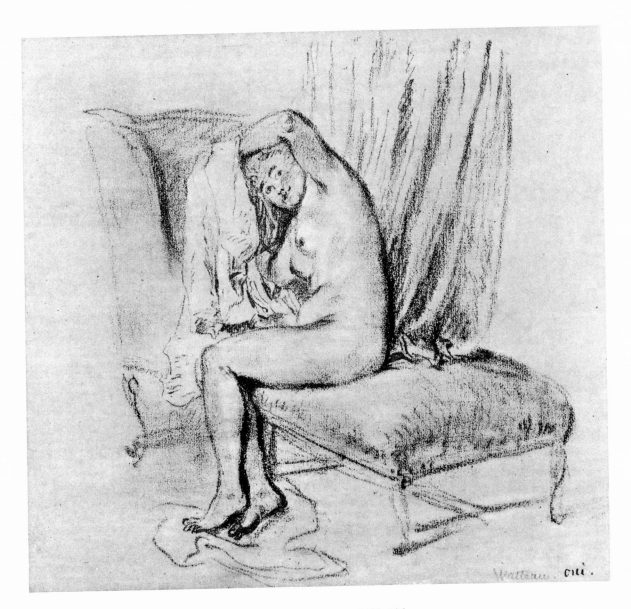

A WOMAN AT HER TOILET
(British Museum)

PLATE 83

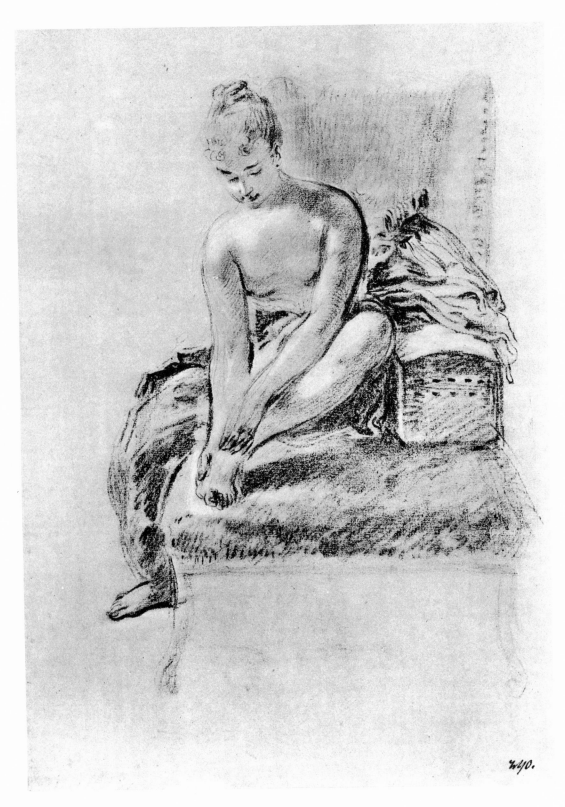

A WOMAN AT HER TOILET

(*British Museum*)

PLATE 84

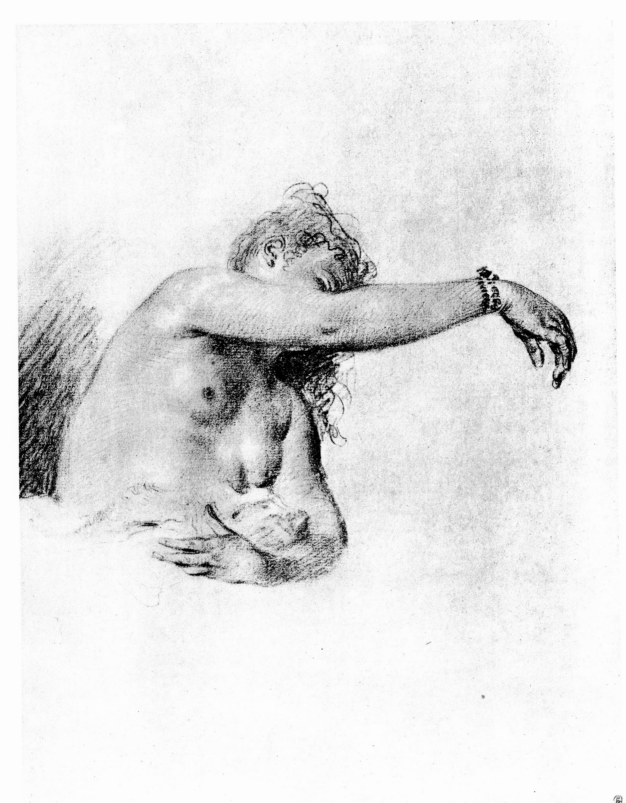

NUDE FEMALE FIGURE
(*Louvre*)

PLATE 85

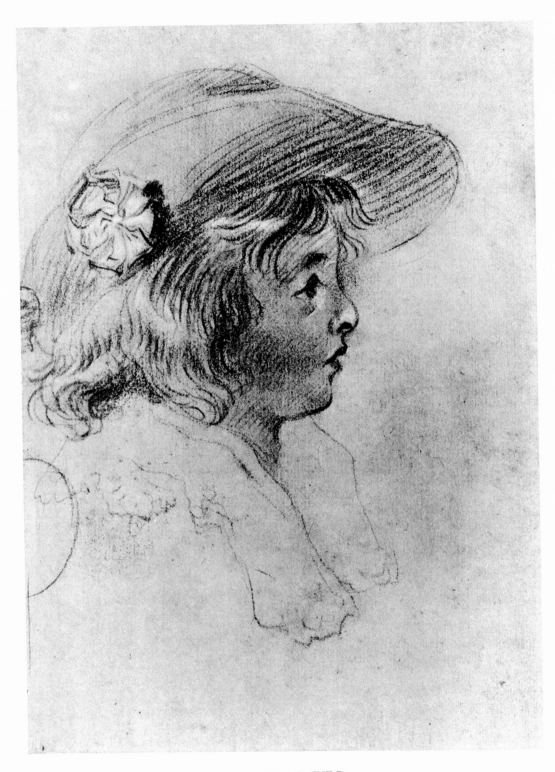

HEAD OF A CHILD
(Musée Cognacq-Jay)
Cf. Fig. 15

PLATE 86

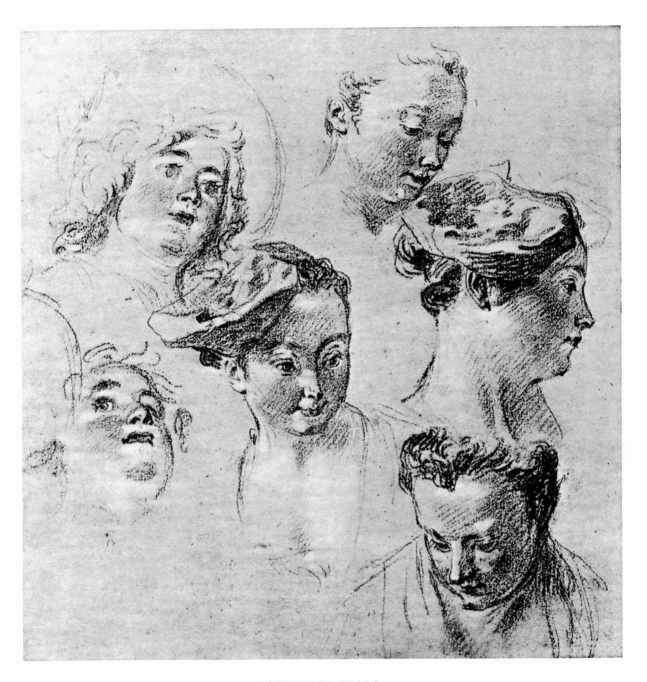

STUDIES OF HEADS
(Collection Mr. Paul Sachs)
Cf. Fig. 15

PLATE 87

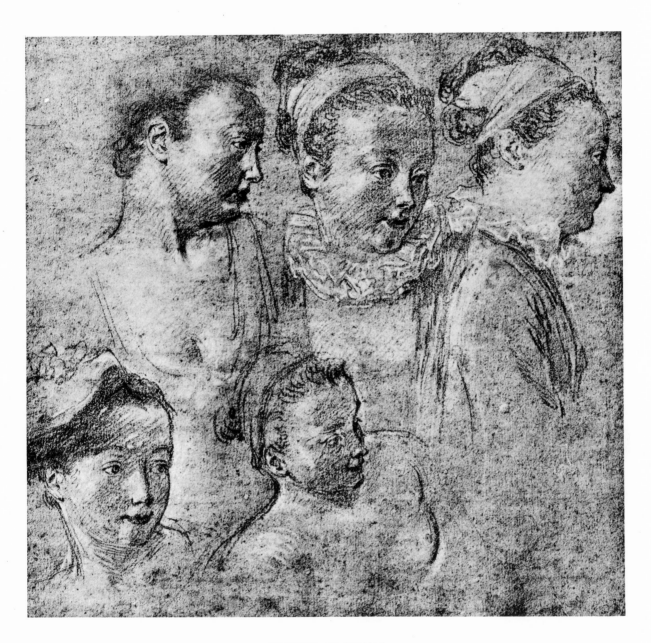

STUDIES OF HEADS
(Louvre)

PLATE 88

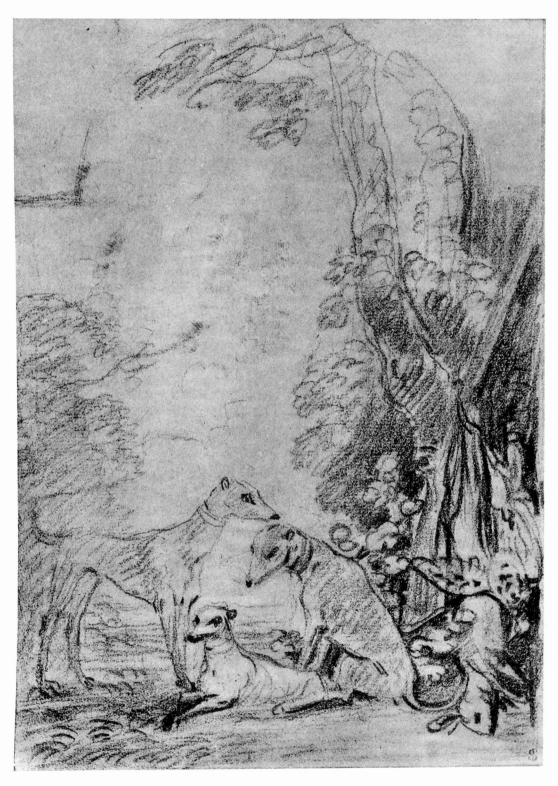

HOUNDS AND DEAD GAME
(Collection Herr Franz Koenigs)

PLATE 89

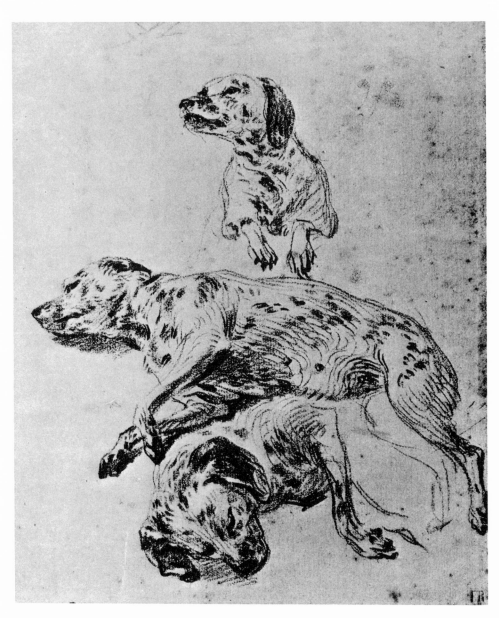

STUDIES OF A DOG
(Musée Cognacq-Jay)

PLATE 90

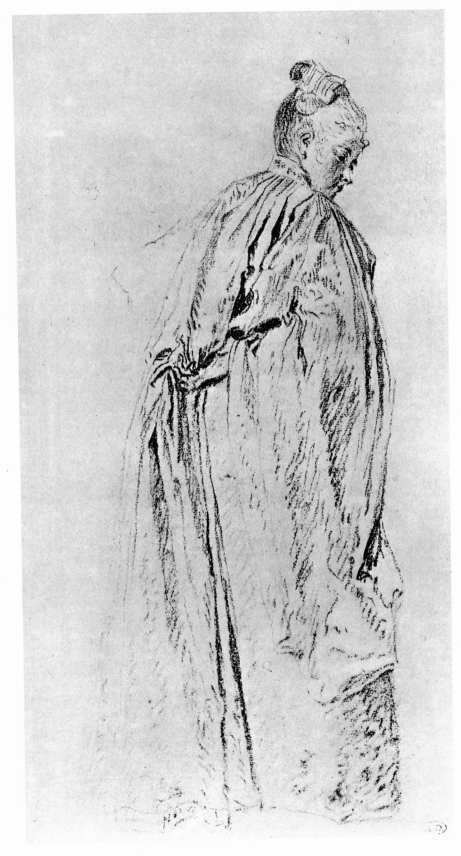

FIGURE OF A WOMAN
(*Musée des Arts-Décoratifs, Paris*)
Cf. Fig. 14

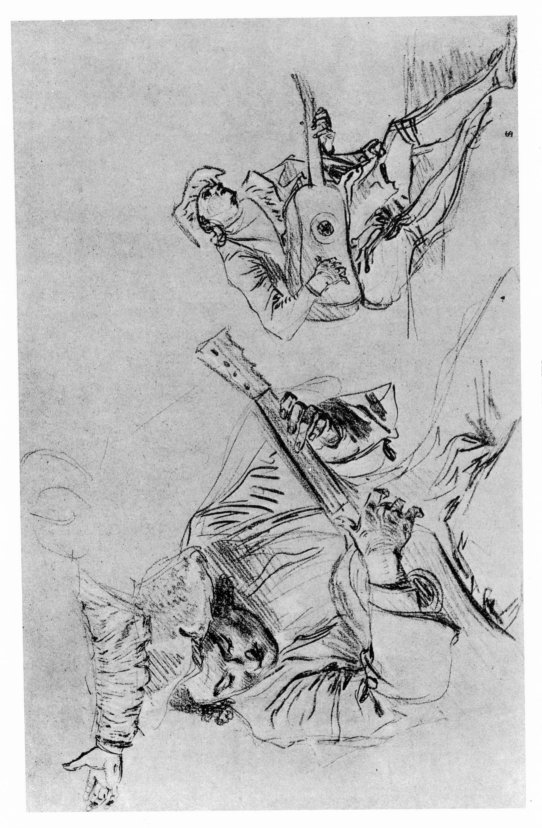

PLATE 91

FIGURE STUDIES
(British Museum)

Cf. Fig. 14

PLATE 92

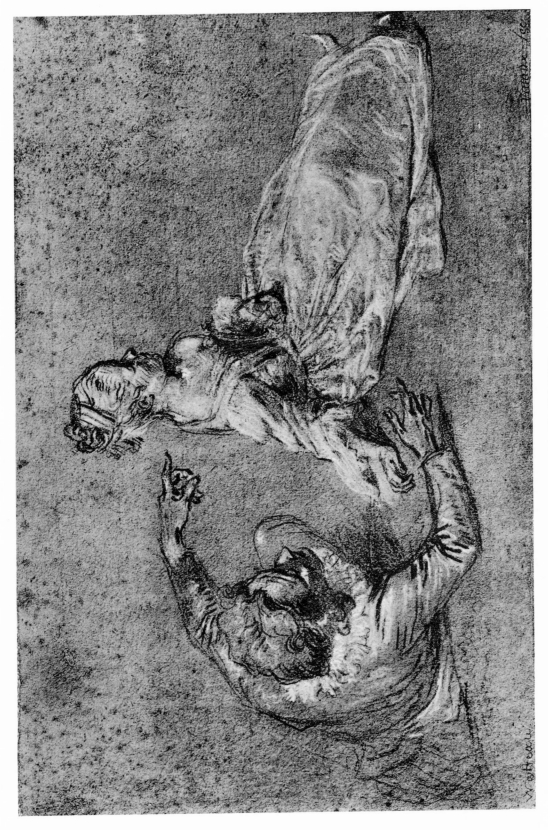

FIGURE STUDIES

Collection Mr. George Blumenthal

PLATE 93

FIGURE STUDIES
(*Louvre*)
Cf. Figs. 7 and 14

PLATE 94

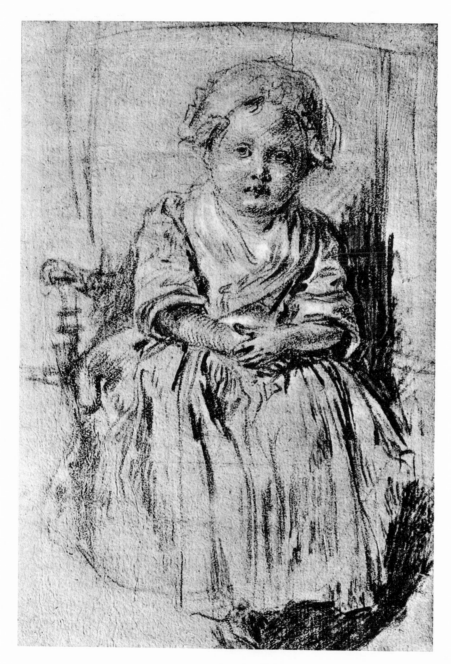

A CHILD SEATED
(Collection M. David Weill)

PLATE 95

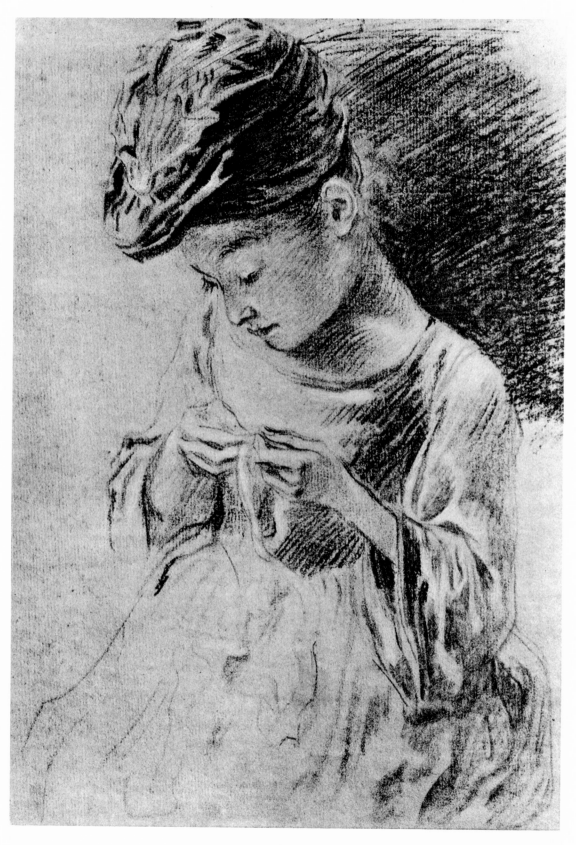

A LITTLE GIRL SEWING
(Collection Rt. Hon. the Earl of Iveagh)

PLATE 96

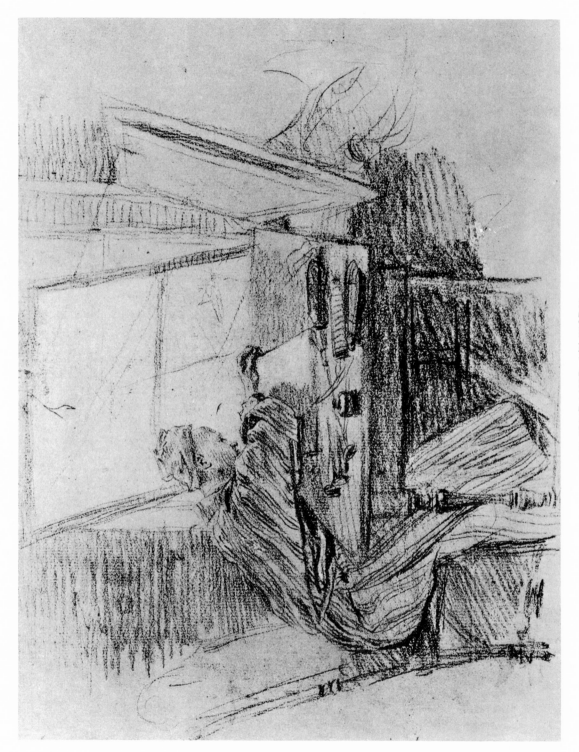

AN ENGRAVER AT WORK
(British Museum)

PLATE 97

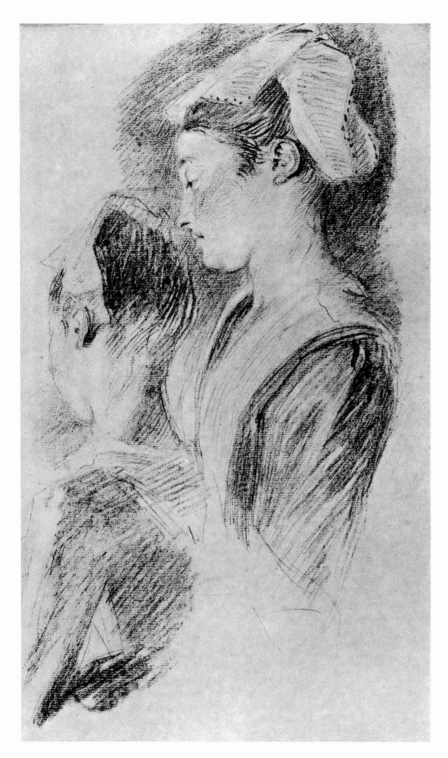

TWO STUDIES OF A WOMAN
(*British Museum*)

PLATE 98

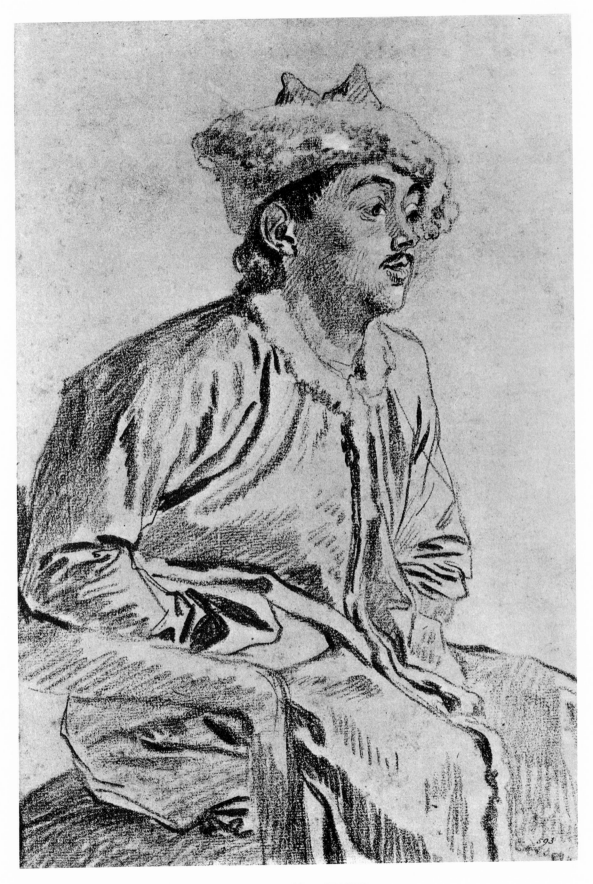

AN ORIENTAL SEATED

Victoria and Albert Museum

PLATE 99

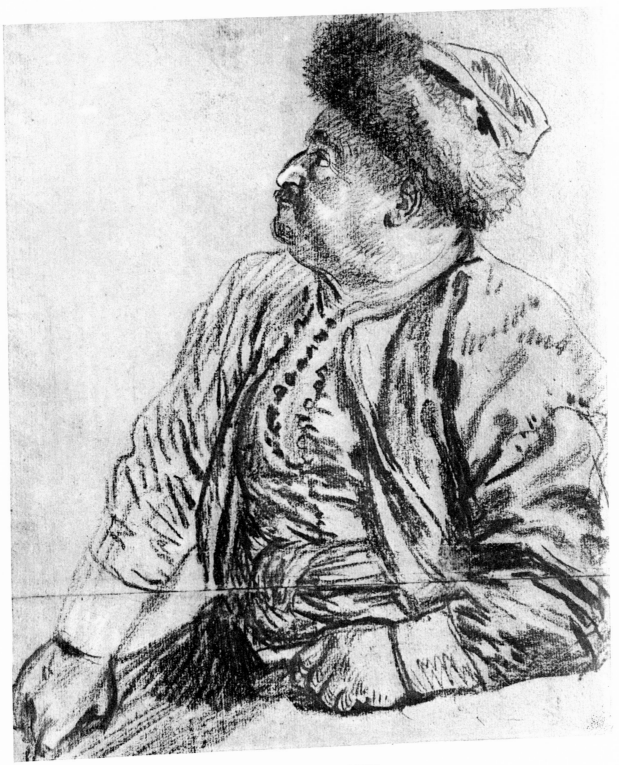

A TURK SEATED
(*Teyler Museum*)

PLATE 100

FIGURE STUDIES
(*Musée Cognacq-Jay*)
Cf. Fig. 16

PLATE 100

FIGURE STUDIES
(Musée Cognacq-Jay)
Cf. Fig. 16